Designs by ERTÉ

FASHION DRAWINGS AND ILLUSTRATIONS

FROM "HARPER'S BAZAR"

Selected, and with an Introduction by
STELLA BLUM
Curator, The Costume Institute, Metropolitan Museum of Art

Dover Publications, Inc., New York

PREFACE

by Eric Estorick

Erté's long association with *Harper's Bazar* came about by flipping a coin to help him decide in favor of *Vogue* or *Harper's*. This lighthearted approach was to continue in the wonderful, gay, imaginative and exquisitely executed covers, designs and illustrations for twenty-two years. It ended very differently, however, due to the overpowering influence Carmel Snow was to have when she became editor in 1935.

No direction was given or influence exerted over Erté during those long years of the fabulous capturing of the times. Indeed, more often the anticipation of fashion makes the covers historical documents. If it is so true, as Diana Vreeland recently said of him, that no one in the twentieth century had a greater influence on fashion than Erté, then his work for *Harper's Bazar* will be of immense value to future writers about our marvelous and terrible times. In fact, the Erté covers for *Harper's Bazar* already are collector's items which are cherished by their owners—and when they have the rare opportunity to get the artist to autograph them, they treasure them the more.

Erté had a totally free hand in planning his work for *Harper's Bazar* until 1920. Then the only obliga-tion was that he was expected to relate four of the covers to the seasonal collections, i.e. a spring cover related to the forthcoming summer collection, a fall cover in anticipation of the winter collection, and two others devoted to furs and cosmetics. In addition to his covers, Erté was the only creative designer on the French scene illustrating his own creations, as distinct from Lepape, Barbier, Martin, Benito and Reynaldo Luza, who were magnificent illustrators of other peo-ple's designs.

Erté's fashion designs were assembled into full pages by Harper's fashion editorial staff. Many of the fashion designs created by Erté in Paris were made for export exclusively for Altman and Bendel in New York, and executed by Poiret's one-time first hand (Poiret having closed his establishment at the out-break of World War I). Thus Erté was during those war years a couturier for export only.

Erté's attitude to the subject of fashion is best ex-pressed in the letters which he was asked to write from Monte Carlo to the editor of *Harper's Bazar* during 1919 and 1920. Extracts from these letters, and some other texts by Erté, appear on page vii.

Published in Canada by General Publishing Company, Ltd., 30 Lesmill Road, Don Mills, Toronto, Ontario.
Published in the United Kingdom by Constable and Company, Ltd., 10 Orange Street, London WC2H 7EG.

Designs by Erté; Fashion Drawings and Illustrations from "Harper's Bazar" is a new work, first published by Dover Publications, Inc., in 1976.
The publisher is most grateful to Erté, to Mr. Eric Estorick of the Grosvenor Gallery in London, and to *Harper's Bazaar* for making this book possible.

International Standard Book Number: 0-486-23397-9
Library of Congress Catalog Card Number: 76-24054

Manufactured in the United States of America
Dover Publications, Inc.
180 Varick Street, New York, N.Y. 10014

INTRODUCTION

by Stella Blum

For twelve years, from 1915 to 1926,* *Harper's Bazar* (*Bazaar* since late 1929) delighted, amused and inspired its subscribers with the stylish fashion fantasies created by the artist-designer Erté (Romain de Tirtoff; "Erté" is the French pronunciation of his initials R.T.). Russian-born (in 1892), working in Paris (he arrived there in 1912), Erté made his American debut with a cover for *Harper's* in January 1915. It was so well received that before the year was out, he was given not only another cover (November) but also a varying number of pages within the magazine. In the following years he steadily contributed cover designs, sketches and his own brand of commentary. (From 1927 to 1936 he continued to do covers for *Harper's* with his usual imaginative artistry, but the fashion element in them was handled as part of an overall abstract design rather than with pictorial realism.)

Not many of the actual costumes Erté designed have survived, but they continue to live on in his paintings and sketches that are valued in themselves as works of art.

Although Erté's popularity in the fashion world (as opposed to the theater) waned somewhat after the 1930s, there has been an enormous upsurge of interest in his work in recent years. His original drawings and paintings have been shown in a series of exhibitions, and he has been the subject of several books. The illustrations in this volume, exclusively from *Harper's Bazar*, naturally concentrate on the fashions.

In Erté's fertile imagination it might seem that every costume he created grew out of a setting, whether it was to be worn for a stage spectacular or in real life, but in actual fact these were two facets of his uniquely creative personality. The costumes for the theater were created in quite another spirit from the dresses, which were wearable outdoors or in different interiors, whereas his theatrical costumes were often constructions. Nevertheless, the clothes he designed, from ball gowns to sports clothes for horseback riding, shooting or skiing—even his bathing suits—had a patina of the theatrical. His designs were like the stuff of dreams and called for the most luxurious fabrics, opulent furs and jewelry set with the finest stones.

With the exception of a few minor detail drawings, Erté's sketches show a highly personal concept of a complete woman: costume, hat or headdress, coiffure, shoes and all manner of enchanting accessories. At times he would even add parts of interiors. He envisioned women not only as ultra-chic creatures for whom money was no object, but also as classical goddesses, music-hall stars, Assyrian princesses, Egyptian queens, harem favorites or such children of nature as flowers and birds. Yet under this veil of fantasy the clothes and accessories that Erté created reveal a sound construction that really works. He was superbly inventive. Most of the clothes he conceived, through the skillful manipulation of lengths of fabrics, required few seams. Many were merely simple geometric pieces ingeniously draped or put together by buttoning, knotting or lacing the various separate parts. Belts, ropes or clasps pulled the garments to the body and gave them shape. To add further richness to the costumes, Erté lavished fringes, tassels, ribbons and beads upon them. Sometimes flat plain surfaces were made more sumptuous by interlacing contrasting textures or colors.

There is a playful, fun-loving side to Erté and he gave it full vent in many of the details on his clothes and in his accessories. Pockets held a special fascination for him; he designed pockets shaped like hands (page 1), a garden apron with pockets for flowers (page 64), a tennis sweater with net pockets to hold tennis balls (page 67); he put pockets on sleeves (pages 55 and 89), on gloves (page 87) and even on scarves (page 106). Some of his hats had animal ears (pages 2 and 8). Headdresses ended in earrings, became necklaces or belts (page 98). Dolls were turned into evening purses (page 78). Tassels opened into fans (page 86). There were all sorts of muffs, including one of fur shaped like a bow (page 111). These are only a few of Erté's

*[Of course, Erté worked for *Harper's* for ten years after 1926, but his contributions during this decade—a few of which are represented in the present volume—consisted of covers and story illustrations, and in this note Mrs. Blum discusses only the fashions.—THE PUBLISHER.]

confections. His oeuvre is full of them. As fanciful as they may appear at first, many are practical and make good sense.

It is a popular notion that women's fashions of the 1920s were all quite masculine and that the dresses were straight from shoulder to hem, ending at the top of the knee. This style, however, did not appear until the second half of the 20s. The silhouette of the earlier years of the decade was essentially very feminine and was in reality a continuation of pre-World War I fashions. Although it is true that as early as 1908 the designer Paul Poiret was designing loose-fitting clothes to be worn over corsetless bodies, the effect of this was one of unconstrained womanliness. Emulation of the male, the next step, evolved later. Unlike the fashions of the late 1890s and early twentieth century, which expressed sexuality explicitly by rigidly defining and obviously exaggerating the female figure, those of the period 1909–1924 tantalized the eye and the mind of the beholder through implicit sensualness. Without constrictions, and unconfined by close-fitting clothes, a woman could conceal or reveal, flaunt or deny her feminine curves according to her whim. She was free within the bounds of her femininity. Erté's esthetic sensibilities were completely in harmony with these fashions. There was nothing masculine in his designs. Even his costumes with trousers, such as the ones for flying (pages 68 and 69) and his pajamas (pages 18 and 110), were exquisitely feminine.

In 1925, when the soft beguiling temptress was displaced by the hard-edged, self-asserting flapper, Erté refused to accept the newcomer. He was out of sympathy with the new simplicity and rising hemlines, and after 1926 turned his main energies to designing for the theater.

Actually, not all women, particularly in America, could wear most of the apparel Erté designed for *Harper's Bazar*, although he produced dresses exclusively for Altman and Bendel for over three years. So popular were his contributions to *Harper's* that women eagerly awaited each issue to see what Erté was up to. Many saved his covers and preserved the magazine drawings in scrapbooks. What was the appeal? Discerning designers and dressmakers could glean ideas for their own creations. The majority of the women, however, were content to enjoy and muse over the esthetic beauty of the colorful covers and the lyrical fantasy of the black-and-white drawings. For some women this art was the door of escape into a gossamer never-never-land where they would be dressed by Erté and be a part of the world of his imagination.

To the memory of my dear friend
PRINCE NICHOLAS OUROUSSOFF,
who collaborated with me in the writing
of the Monte Carlo letters,
extracts of which are published in this volume.
—ERTÉ

TEXTS BY ERTÉ

Extracts of Letters from Erté to the Editor

March 1919 issue

You have asked me to give you for Harper's Bazar a few lines about myself. I do this with great pleasure.

I was born in 1892 within the walls of the Naval School at Petrograd. My father, then Captain, at present Lieutenant-General—retired since the Revolution—belonged to the Navy. My late uncle was Naval Minister, and all the members of our family followed, through tradition, this noble outdoor career.

I am one of the few members of my large family of sailors who, because of my health when a child, have not followed this career. But I have retained a fervent love for the sea, for its great open spaces, which I always hold dear and which frequently inspires me.

I passed the greater part of my childhood surrounded by the sea in the forts of Cronstadt, where my father was Commandant of the School for Naval Engineers. I studied at the College of Cronstadt, and after my graduation I resolved to give myself up entirely to my passion for painting.

To be perfectly frank, painting has fascinated me more than any other study ever since my childhood. I remember that when I was five years old I already drew, and the creation of feminine costumes interested me very much. But it was necessary for me to busy myself seriously with drawing in order to succeed in a life of art. I set aside landscape work and had the honour of becoming a pupil of the celebrated Russian painter, S. E. Repine, in the portrait field. I worked with my master at this kind of painting for three years, and I made a certain number of portraits. Meanwhile I did not forget woman's dress, for my imagination had not stopped working along this line, and when I was fifteen I was a contributor to a fashion magazine in Petrograd, in which my creations appeared with almost every issue.

This little success of mine in my own country did not dampen my desire to go on studying painting. Quite to the contrary a strong determination to work, and to go far along the road of art, was born in me. I remembered always the words of Goethe, who said that "real talent is composed of nine-tenths work and one-tenth genius." I wished to perfect myself in

drawing. The idea came to me to leave my country to go and pursue my studies abroad. Like all young artists of my age I wanted to see the Eternal City, with its classic monuments, and to improve my art among these beautiful surroundings. And I must say that my parents, though sad to see me go, did not oppose my leaving but facilitated my journey and my stay in foreign lands. But it was not in my dreamed-of Rome that I remained, but in Paris, whose artistic life also tempted me.

In Paris it was at Juli[a]n's that I began to work at portraiture. But these academic studies, where routine reigned in spite of the good intentions even of the professors, could not interest me much after the special courses I had been taking with my master in Russia. My imagination, which found no outlet in this kind of painting, was given a free range in the decorative and symbolic composition with which, during all this time, I was busying myself alone—compositions to which I devote at present the greater part of my time.

After two years at the academy I concluded that progress depended wholly on my own original, independent work. And so, little by little, I stopped attending the academy, and, wishing to be entirely independent, I turned to a branch of art which had always attracted me. I thought that if, since my childhood, feminine fashions had so strongly caught my imagination, if in my own country fashion magazines had been able to use my creations with success, then surely Paris, the city of fashion, would be able to judge me truly.

My hopes did not mislead me. I had some successes, if you can call it success, and from my very first appearance among the host of Parisian designers my designs were appreciated by the best houses in Paris and I received commissions. I had so much work that I had no time to draw for the magazines in Paris that made me offers. When I had a little spare time I gave my drawings to a smart publication in existence before the war called "La Gazette du Bon Ton," and also to "La Vie Heureuse."

I left Paris, where I received so many offers and

commissions that I had never a moment for freedom. And now I live in the beautiful south of France, where I can quietly work, where nature inspires me and gives me ideas. I only visit Paris on infrequent trips for a few days.

Besides the models I draw and the symbolic decorative compositions I am so fond of, I have always loved the theatre and wanted to create beautiful things for the stage. I give a great many of my costume sketches and decorations to the Paris theatres. Designing for the stage is the thing I like best. I do a great deal of it, and I study deeply all phases of its history, as well as that of the other arts.

I like to design for the theatre because that gives me an opportunity to give my opinion of a musical or literary work in the language of colors. And I am happy when, with decorations and costumes, I can perfect a theatrical work.

I have personally written the scenarios for many ballets, designed the costumes and likewise the scenery. The war has prevented my collaboration with composers to set them to music, but my ideas set down in painting are vivid enough for me to present them to the American public on the occasion of my next visit to your great country.

You can readily see that my artistic career, begun at the age of seventeen, has not yet been sufficiently enriched with outside impressions. I have worked for nine years to enable myself to advance along the path of art freely and independently. But this success, of which I am proud, will not stop the work, to which I have consecrated my whole life. I am still too young to tell you the minute details of my career, to relate the little anecdotes of artistic life into which I had the boldness to enter at seventeen. Those things told by an old master might interest the public, but I prefer to give your readers my work, for at my age my art, which is my life, is the only language through which I speak with the world.

Perhaps it would interest you to know how I work. You know that I have been living lately in Monte Carlo. My studio in Paris is closed and unfortunately I could bring here only my drawings and part of my library. . . . Erté works at a plain table surrounded by his drawings, and truly my kind of work requires nothing complicated. I seldom have any need for an easel except in an occasional leisure moment, when I wish to paint a portrait of some friend in oils. Paints and water colors, mixtures of my own composition, and a pen call for only a large plain table and— the sun. The sun never fails me here. My table is always turned toward this eternal source of ideas. Sometimes, tired by the detail of a design, my eyes are rested by gazing upon the beauty of the countryside unfolded before me. My villa is perched on the rock which dominates the Principality of Monaco and the view is marvelous. . . .

I begin my day early with a long walk along the seashore or in the mountains, and in the course of these morning walks I find my ideas for the day's work. I take back to my studio bits of the beauty of nature and the strange symphonies of her colors. I work while the sun shines, at night I never draw. My evenings are divided between music and books, for I am very fond both of music and of the dance, and improvised dances founded on beautiful music have given me unforget[t]able moments.

That is how I work. Relate it, if you find it interesting. In my work, as for instance in the covers for Harper's Bazar, I portray symbolic themes where life is interpreted by the language of my art; for, in my opinion, every event of life, every action of nature is explained satisfactorily by the emotions within me. I show this comparison between reality and the symbols my imagination creates in the form of color, for I believe that colors, taken from nature's inner life, have just as much meaning as music or the dance.

. . . Being an ardent lover of beauty, I discover harmony of color in the very source of everlasting beauty—in Nature, who is my only teacher.

Perhaps your readers believe me a modernist. I should tell you that I belong to no school of art, and the particular style I use in my drawings serves only to display the beauty of their themes. I am individualistic in art.

You ask my opinion on fashions. I do not recognize the mode. I love the luxury and the beauty of fashions, and I believe that feminine clothes should serve to adorn woman's charm—not to conceal that which is beautiful. In short, woman's costume should be individual.

The mode is more or less a routine matter. But you say that it changes frequently. Yes, but it makes me dislike it to see, during a whole season, women of all types of figures in crinolines or, perhaps, in tight skirts.

You have mentioned that during the time I have contributed to Harper's Bazar, I have not followed the trend of fashions, but that among my creations each woman can select something suited to her, without adhering strictly to the mode.

Just consider how most boring it would be if, during a whole season, you met women all of the same type who said the same things, had the same ideas! I experience the same feeling when I see women dressed alike.

That is why I do not like the mode which, in its efforts to create a paradise of feminine beauty, succeeds in producing just the opposite effect.

I am individualistic in my creations of feminine fashions.

Harper's Bazar and its readers know well enough the nature of my work, the principal aim of my art, so that I need hardly add more upon this subject. Besides, that should be left to the impartial critic. I can only say that on the path of art, which is as long as

life, one advances constantly toward perfection, toward the ideal—and I am sure I shall be no exception to this splendid rule.

May 1919 issue
Woman's dress is designed to enhance her beauty—and sometimes to hide Nature's defects. Her dress should be adapted to her individuality and should be as much a part of her as her coiffure, the color of her hair and the tint of her complexion. Everything that I create in the domain of fashion is intended for women who are clever enough to choose according to their charms—or the absence of them. We may some day see a couturier who will exhibit his collection with the labels, "For Young Girls," "For Stout Women," "For Women of Fifty," et cetera; but I don't think we shall ever see a couturier who will tell his elderly customer that a certain dress worn by a pretty model would be ridiculous on her.

Another thing which displeases me is to see fashion creations with details that are absolutely of no use. For instance, a row of buttons which do not button, or a little piece of embroidery sewn—Heaven only knows why!—on the corner of a coat. In my opinion, every detail, every accessory, should harmonize perfectly with the principal theme of the toilette, and every fashion should have a purpose. A button that does not button is anathema to me.

June 1919 issue
France, who has always been the creator of fashion and the inspiration of taste and refinement, has had many victories in her past, but the history of dress makes no mention in its annals of the "Victory mode." We have had the "Directoire," the "Consulate," the "mode of the Revolution," the "First Empire," and so forth. But no one ever thought of christening a change in style with the name "Victory."

Victory is the fruit of the gigantic efforts of the people; a fruit matured through sadness and suffering. As for style, it is but a passing flower upon the tree of civilization—a flower of elegance, beautiful only for a brief moment; and one must remember that both fruit and flower cannot be plucked at the same time. Certainly victory should refresh the weary soul and fill it with joy—and if there are those who wish to show their joy in raiment, as one shows sadness by wearing mourning, one can say nothing against that. When you meet in the streets of Paris a celebrated actress wearing a hat with an enormous French coq upon it, you think it's amusing, and that's an end to it. But when you are shown, at the couturier's, a "victory exhibit," it is a shock to you to realize that victory has already been commercialized.

September 1919 issue
As one gazes at these costumes [the toilettes worn at the races in Paris] one can but regret that during the five long years of ordeal French women have forgotten how to dress for open-air festivity. One might believe one's self in a formal salon at tea hour, but hardly on the race-track in broad daylight, for, despite the force of the sun's rays and the occasion, almost every woman present was dressed in black or dark gray taffeta. Hardly a meter of linen or muslin was to be seen, and almost no pale colors; but everywhere the duller colors, heavy fabrics and fur capes.

The folly of the moment is the plume of coq, which completely covers many hats, and so often droops far over the eyes. The evening gown itself cannot escape this obsession, and a bouffant tulle surface is sometimes covered with applied coq feathers. A veritable monstrosity is such a gown! Feathers as garniture can be both charming and elegant, and are used often with happy effect this way—it is a favorite treatment of my own, in fact, but for the moment the bizarre method prevails and not the elegant. Of the same type is a flowered gown. Imagine a skirt covered from belt to hem with fluttering muslin petals of many shades! Would you not think that its wearer had just stepped from the stage of a concert hall? These bizarre styles are far too elementary to be really lasting, and one knows that in a few weeks they will have taken flight.

With falling temperatures, too, that absurd abomination, the stockingless foot and ankle, will have vanished, or so one hopes. Whence this ridiculous and hardly decent fashion? An industrial journal gives answer; "It hails from America." I hesitate to question the authenticity of any statement made by so excellent a publication. I can only add that up to this hour I have come across no allusion to the subject in any American paper.

October 1919 issue
Although there are so few beholders, there are many exquisite toilettes [at Monte Carlo]; toilettes that one enjoys, for here they may be seen in all their details. In my opinion the short seasons in the various watering-places are infinitely more valuable to the development of fashion than are the longer seasons in the great cities, for the conditions of life in these suburban outposts exact from the leaders of society a constant variation in dress. A woman who appears several times consecutively in the same gown at the casino of one of these fashionable resorts is no longer spoken of by her name, but is the wearer of this color—of that cut. And where lives the woman who would risk such subversion of individuality!

Perhaps the Government has authorized the reopening of the gambling resorts for this very reason, for many of the industries from which the wealth of France is derived are inseparably bound up with the dressmaker's art. In this connection I quote from one of the daily Parisian papers this pleasantly paradoxical idea—"If France has until now been the advance guard of civilization, it is because her production of lace has always exceeded her production of

household linen."

And what are these lovely toilettes that I so admire in Monte Carlo? To my great gratification they are not laden with elaborations which deform the figure, but are simple; quite unlike, in fact, many of the models recently seen in Paris. Even when the fabric is ornate, the silhouette itself remains unbroken; for example, a gown of black crêpe de Chine entirely covered with black embroidery in Mongolian design is cut on chemise lines and is simply girdled with plain fabric, fringed at the ends. Crown this costume with a wide-brimmed hat of black velvet, and though not bouffant, you will be most distinguished.

Hats of transparent effect are quite the mode and share the honors with those of dark-hued velvet, whose somberness is enlivened by flowers or fruits in delicate colors. Perhaps the most popular shape of all is the mousquetaire, with brim turned up abruptly on one side and with plume drooping debonairly on the other.

Among the costumes lately come to enliven the Casino was one of white linen trimmed with black astrakhan. Bizarre, you say?—to be sure, and a combination more appropriate for a tropical resort in winter than for October, but we all liked it.

Again one is struck by a decided Scotch tendency, which is seen in the use of plaid or striped skirt with plaid bodice or jacket. The soft woolen fabrics of which these are made have delightfully cozy names such as *Burezilian*, or *Bure de Tella*. The most artistic and wearable of these effects is obtained through the use of subdued green and blue plaid for the skirt, with plain blue or green for the jacket, which may be bordered with silk braid or twist and may boast a tiny breast pocket on one side.

Cloak-capes, so very convenient for both daytime and evening, are everywhere. I confess to a weakness for these pliable wraps, but I am compelled to admit that the wearer must have a certain talent for wearing them, or the silhouette lacks distinction. Many of these capes are trimmed with fringe; in others drawn threads give a semi-transparent effect to certain parts of the wrap. I have used this mode of trimming for some time in cloth, silk and cotton fabrics as an alternative to open insertion, and I shall continue to use it, for I am convinced that new and attractive results can be achieved by means of it.

January 1920 issue
The vintage time draws to a close, and active preparations are now under way for the most brilliant of seasons. This winter will mark the first organized effort at gaiety since the dark night of war, and one is convinced that not even soaring prices will restrain such travelers as once sought the Côte d'Azur, in order to taste its midwinter pleasures and to luxuriate in its Eden-like beauty.

Already we are planning to revive the masked ball in all its mad gaiety and badinage, and very delighted we shall be to attend it after such a long lapse of time. But why not revive it without its banality of stereotyped characters and traditional costumes? Why not enliven it with variety?

The domino—aha! The traditional *loup*, which altereth not! In Venice until the fall of the Republic, it was commonly worn in the streets. There reigned in the enchanted city at this decadent epoch a strange corruption of manners, and the mask was a necessity. At every entrance hung the black domino. Rich and poor alike donned it, in order that they might sally forth enveloped in anonymity. But frankly, do you not find this mask of black, which cuts the face in two, very ugly? Why, in hiding one's identity from prying eyes, hide one's beauty as well?

I suggest masks that cannot give to the human face a repulsive ugliness, since they are in themselves exquisite little trifles. Imagine, then, a mask of pearls which covers the upper part of the face—would it not be entrancing with an Oriental costume? Hindu, by preference? Or a mask of black aigrettes—charming with no matter what costume—and then the embroidered veil which shows only languishing eyes after the manner of the Moslem woman's yashmak? One could invent endlessly the most original creations, if women, the final arbiters in fashion's realm, would but consent to throw off the yoke of tradition. There are, needless to say, among traditional costumes those which are forever elegant, but the greater number are grotesque, when submitted to modern eyes. The historic domiño, with its enormous sleeves[,] was a necessity when rapier and sword, hoop and flounce had to be concealed, but now, men are uniformly clad in black and wom[e]n narrowly skirted!

"But," argue some, "the domino gives to the fête an air of mystery." I reply, "Then one may attain this illusion by means of a domino of distinguished cut, a domino which shall not make one's figure look like a shapeless bundle."

So much for the *bal masqu[é]*; now let us consider a second mania of the moment—the quest for a new line in feminine apparel. That one should search for it does not amaze me in the least, but that which does amaze me is that one should find it, as one does. The new line! . . . But does it, can it, exist?—there is nothing new in the geometry of the human body. The ideal is the body itself, and, if the ancients understood this, it is surely a disgrace that our super-refined modernity cannot comprehend it. The apparel of woman should be always an exquisite embellishment for her body, and every effort of the artist who designs the dress of woman should be directed to this aim alone. I hardly advise that the modern toilette should be made up of Grecian draperies; I do affirm that a modern gown should be built upon lines which shall not deform the wearer's figure. This is the only way in which progress in woman's dress and the apotheosis of elegance can be achieved.

Monte Carlo is once more deserted, for the season is completely at an end. The foreigners, so numerous during the winter just past, have abandoned this corner of Europe for the brief seasons in the mountains or on the sandy beaches of the ocean. . . .

The bourgeois have their own amusements; they don the "salopette" (the workingman's costume of blue linen) in order to combat the high cost of living. This costume, associated with physical toil, which one is used to see spotted, soiled, saturated with perspiration and sometimes with blood, now promenades the streets of Nice and Paris fresh, crisp and spotless. One sees it often worn by a man who would be incapable of driving a nail; and the laborer on his return at nightfall in his citizen's clothes, his work over for the day, stops nonplused before this crowd of blue phantoms and laughs slyly at this game of the bourgeois. As a protest against the high cost of living, one dons the livery of the workingman, of the workingman who has contributed so largely to the costliness of living, and one marches across localities indicated as being in the range of the apparatus of the cinematograph, and one says to oneself—"We are few in number, but the films of the cinema will spread our audacious innovation throughout the entire country." But is it an innovation—a new French mode? No, it must be at least four months since this infantile protest, born in America, crossed the ocean and arrived in France. I do not know what form it took in America, but here it took a ridiculous form. I have seen at Monte Carlo an individual in a "salopette" made of heavy silk with a matching hat. For this absurd outfit he had paid more than for a complete costume made by a leading tailor. I have seen, as well, several people arrayed in the ordinary "salopette" seated about the gaming tables of the Casino. There in the temple of chance, disguised as laborers, they entered their protest with the aid of this dress against the high cost of living, taking part in the game of hazard at the same moment. Ridiculous protestation! Could one call it a mode? In any event, it is a mode which can hardly endure, for the first winds of winter will compel these wearers of the "salopette" to exchange it for a town costume of greater warmth. But while awaiting winter one amuses oneself as one is able. N'est-ce pas?

In contrast to the inæsthetic "salopettes" one notes the grace of the light feminine toilettes that one sees about one. Summer allows women to array themselves with distinction while expending even less than in winter. I dislike intensely those summer frocks which are overburdened with useless ornamentation. For example, I have seen frocks made in sports feeling and with bretelles completely covered with heavy embroidery, or delicate gowns ornamented with large leather flowers. I ask myself why one should surcharge simple frocks with an abundance of useless adornment which serves only to cut the elegant lines of these filmy creations. I hold that each ornament, each touch of embroidery on a gown should have a distinct *raison d'[ê]tre*, an idea which springs logically from the underlying idea of the toilette itself, and following this thought offers no impediment to the simplicity and beauty of its lines. It is this ideal which I develop in all of my creations. Each gown should be created in such fashion that all of its details are in harmony with each other and with the principal idea. It is like an architectural creation, where each ornament must be in its place and in perfect harmony with the ensemble of the edifice. Take any ornament of an artistic structure and transport it to another place—the edifice may stand, to be sure, but its beauty, which expresses itself in perfect proportions and lines, will be ruined.

Since new necessities give rise to new modes, be it in architecture or dress, the creator of clothes seizes upon the coming sport—aviation—and composes to meet its exigences many interesting costumes. I find myself inspired by the thought of these flights through blue ether; the woman who attempts them must be protected from low temperature and high winds, and at the same time must be endowed with allurement.

One costume of my fancy . . . [page 68 in this book] is vested in light gray buckskin and trousered in mole. Each trouser leg extends into a gray buckskin gaiter, while buckskin gloves protect the hands of the wearer. Tabs of buckskin and buttons of mole attach the buckskin vest to the trousers at the waist-line, as they do the gloves of buckskin to the mole cuffs, and the gray gaiters to each trouser leg. The bonnet of mole has two ends which may be wrapped about the throat, while above the brow is a visor in which are placed protecting ovals of glass and, should the wearer care to, it may be drawn down in order to mask her face.

For less frigid altitudes is a second costume of knitted violet wool [page 69, left]. . . . It is composed of a long blouse which extends upwards to coif the head and downward to protect the closely trousered knees. Hands and feet are gloved and booted in soft brown leather; the blouse, which slips on over the head, is provided with a short slit in front and in addition with a slip-on hood, the oval opening of which allows the wearer's face to peep through, while the hood proper swathes the head, brow and ears. Two long scarf ends enfold the throat. Pocket flaps, boots and gauntleted gloves are each finished and held in position by repoussé leather motifs and a loop and button of leather. Again . . . [page 69, right] I have expressed the *costume pour l'aviation* in terms of natural chamois and rich brown beaver. Trousers and blouse are of chamois, the last extremely capacious and made to slip on over the head. It is laced down the front with cords of chamois, each of which is tipped at the ends with *aiguillettes* of lapis lazuli.

Fascinating as are these costumes *pour l'aviation*, there are other diversions the needs of which one must consider as autumn approaches. One projects

a vision of the coming season—its balls, dinners, operas. No article of attire requires more thought than the *manteau du soir*; therefore a perspective of several weeks on its construction is greatly to be desired.

Black relieved by color or metallic adornment is of perennial value for this type of cloak. I have designed a wrap composed of an extremely long strip of black satin, lined with violet satin. At the back its ends are reversed . . . and are then attached to the *manteau* at the waist-line. Across this line of attachment a large bird is embroidered in gold thread and red, violet and black silk. A woman wearing this exotic wrap would add a final and exquisite charm were she to encase her feet in sandals made of silver ribbon. Again of black satin I compose a sleeveless wrap. The missing sleeves I replace with two extremely long strips of satin, upon which are embroidered in golden threads the broadest of stripes. These embroidered strips are long enough to trail upon the floor and hence are double faced. They are attached to the waist-line in the back . . . , the point of joining being concealed by a round embroidered motif of gold.

I draw inspiration from these sumptuous wraps, for through them I see a season of superb gaiety.

Descriptions of Cover Designs

The contents pages of many issues of Harper's *featured a description by the artist of his cover for that month. Reprinted here are the descriptions of the eight covers reproduced in color in this volume. (The January 1918 issue did not use Erté's own words, and is merely paraphrased briefly here.)*

January 1918 issue
[This represents the spirit of France arousing wealthy, indolent America for a greater effort in the European war.]

December 1918 issue
"Winter." The scene is in the corner of a park— snowflakes are quickly covering the ground with a thick, white blanket. Standing out against the sky laden with snowflakes is a statue of Love, already partly covered with snow and ice. "Love," which has inspired the world with ardent sentiments, is now cold, and here under this white covering, deserves our pity. On the pedestal of the statue is a heart carved in the stone, pierced by an arrow, and on it are the names of two lovers who pledged their love to each other at the feet of Cupid. Surely this promise was made when the flowers were in bloom, or when the nightingales sang, one moonlight night, or when that winged youth smiled at them from his pedestal. But now it is Winter. She has come to the statue in this corner of the park which is so dear to her, and so covered with snow. And near the heart pierced by the arrow, a perpetual symbol of their pledges, she reads his last letter. But, like Winter's breath, this letter is cold; his heart is cold, too, just like the heart of marble on the pedestal. Those sweet thoughts and tender promises have taken flight for a far-off country, just like the nightingales which had once joined them in their love song. And then her heart chills and she tears the letter into bits; the tragic white pieces, fluttering like ghostly butterflies, are carried away by the icy wind, and mingle with the snowflakes. It is Winter. Love is cold.

February 1919 issue
"Presents from Europe." When knights of old went forth to battle they used to send their fair ladies captured jewels and gold. Conquest was the object of their wars, riches the reward of their victories. Our struggle has been a struggle against an unrighteous force—for the freedom of the world. On the Old World's soil, valiant knights of young America think ever of those they have left at home. But what presents can they—who have not gone for booty—send? In my design the package contains dolls. Not dolls for children to play with, but precious symbols for the rejuvenated world. Here is an Armenian woman who is hiding horrible scars which her people received during centuries of rule by their despised tyrants. Here, a lace maker of Bruges whose gaiety has been killed by the invader; and there a loyal Alsatian who, defying punishment, wears a tri-color cockade in her hair; a Moldavian, who despite oppression has never lost hope; and a Slav, for years crushed by foreign rule, but who has desperately struggled for freedom. The last, which the young woman holds, is a Pole, in her pretty costume of the 17th century, when her country was free—now, we see her released from her bonds— by the young American. Beyond the window, the boundless ocean. A ship leaves for the liberated countries, the white gulls, like doves, soar above the water —messengers of good news.

March 1919 issue

"New Bridges for the Seven Seas." On steps of gilded mosaic stands a woman wrapped in rich robes of gold and facing the sunrise of a new world era. The woman is Civilization who, freed at last from the cruel yoke of war, can turn once more to her fruitful peace-time arts. You may imagine her as standing at one of the thousand points where the earth juts out into the sea, launching with high hope her latest conqueror of the elements and of distance—the aeroplane. Born in days of peace, but tested and matured through the war, these great instruments of progress will serve civilization as new bridges across the seven seas. Out of reach of rocks and shoals and monsters of the deep, speeding with their rich cargoes from the far east to the far west and from the north pole to the south they will draw together and unite the four corners of the world.

May 1919 issue

"The Snow of Summer." The snow of summer is the pollen of the flowers, which floats off into space that it may fulfill the supreme law of life. In mid-summer, when Nature is at her ripest, the fields send forth myriads of pollen grains which carry new life in their pretty white tufts. . . . On a reddish crag stands a young woman. Her filmy black dress and her orange scarf, swept by the summer breeze, are blown into ever-changing folds. A gust of wind carries off from the grassy crag a multitude of white dandelion "thistle-down," which covers the girl's dress like snow and darts up towards the azure sky in mysterious flight. . . . Summer snow is a symbol of fertility. It signifies the fruitfulness, the beauty, the bold and unexpected impulses of life. It is an offering from Nature to the creative Deity.

November 1921 issue

"Autumn." Each season, like Life itself, is made up of moments of gaiety and sadness. Autumn, in particular, is considered the personification of sadness. But it is not only the season of rain and melancholy, but also the joyous time of the vintage. In bygone days, this season was always a festival period, and then autumn did not seem a phantom of gloom, but rather a Bacchante with locks of gold, the color of the sun.

Painted on the black vase, we see this Bacchante—she dances, she flits over the ground, she is enmeshed in the gold of her hair which resembles the disk of the mellow autumn sun. After the vintage this black bowl will be filled with life-giving wine, and the sprite will dance into all hearts and enfold them in her radiant warmth. For autumn was welcomed in this way in olden times with the beautiful old pagan customs.

However, the black bowl is not filled with wine; instead, it holds a yellow chrysanthemum, dying, with falling petals which show that autumn has come. Nature weeps; her tears fall to the ground, where in a careless mass are gathered the discards of her splen-did wardrobe. She weeps as a woman who has lost something she loved. But Nature will not grieve long, and will soon don other garments. We also must think of winter clothes, now that our filmy summer ones have been cast aside.

August 1922 issue

"The First Gown." The eternal story of the first temptation always interested me, and I used to try to decide on which chords of the feminine soul the Prince of Darkness had to play, when disguised as a serpent, in order to make woman fall into the abyss of disobedience to the Creator's laws.

Once I dreamed of our ancestor, Eve, and this is what I saw: The serpent which became the embodiment of wisdom, thanks to the Evil One, had commanded the birds, who were in his power, to bedeck Eve with flowers. Although almost entirely concealing her form, her neck and arms were left revealed in quite a modern décolletage, and when, finally, the birds encircled her head, suggesting an unusual coiffure, Eve began to believe herself a superior being.

Urged by the Tempter, she wandered to a mirror-like pool where, like Narcissus, she admired herself, and with primitive coquetry, contemplated her beauty, and the words traced over her pliant body by the serpent—"La Première Robe."

So now I see a charming young person—perhaps one of the readers of these very words—gazing in a mirror, an actual mirror. What she sees, I also see: there are flowers covering her gown, but they are artificial, being merely embroidered. Then, there is an artificial bird in her coiffure—quite different from those which the Tempter summoned to the Garden for Eve. But this modern gown has almost exactly the same décolletage as the first gown Eve wore, and always . . . always, there is the same serpent, invisible to most people, with that diabolic glint lurking in its eyes.

June 1923 issue

"The Most Wonderful Trip." A woman rides on the back of an exotic, fairy-like bird, and the breeze of the aerial journey makes her thin garments flutter. She looks down to earth, which appears amid the clouds, in her dream, and sees unknown towns, mountains, rivers, and lakes unfolding themselves before her wondering eyes. It is a dream, and it is the most wonderful trip that she is making! In reality, it is the fragrant air of June, and the fresh foliage which will call her from the large, smoky cities to lovely country landscapes. All the perfected means of motion will be at the disposal of the charming traveler; she has only to choose. But, stretching out either on the cushions of an automobile, or in a deck chair on board a transatlantic steamer, she will see nothing more beautiful than that which she discovered while with the bird in her dream.

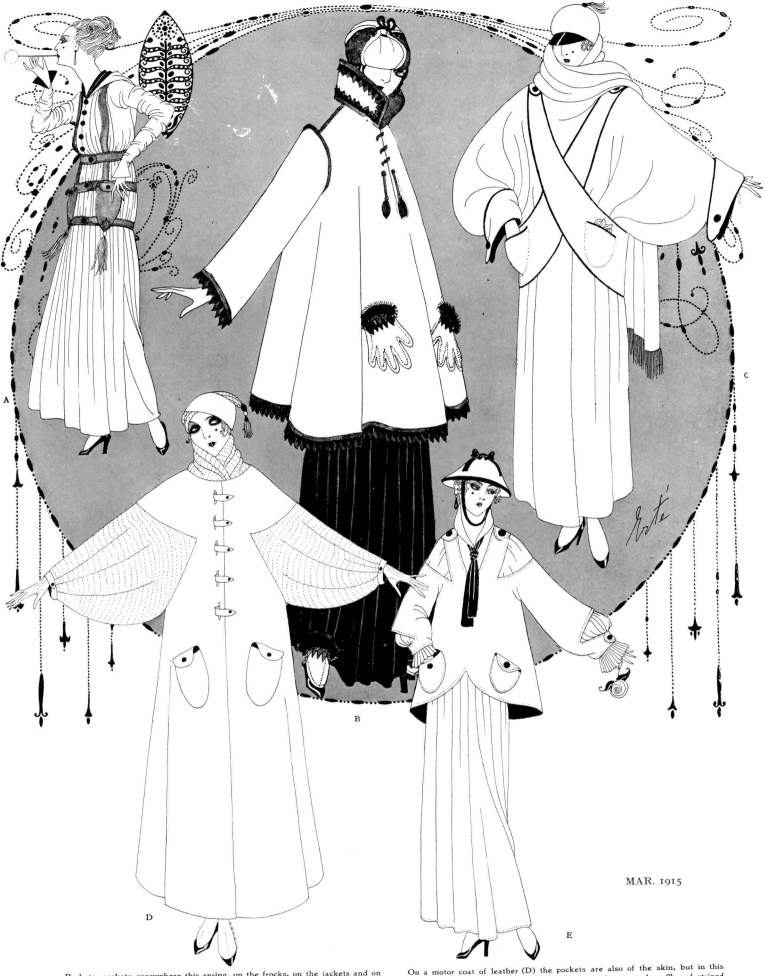

MAR. 1915

Pockets, pockets everywhere this spring, on the frocks, on the jackets and on the great top-coats. Like beacon lights the old red chamois skin pockets stand out against the taupe satin background of the simple little afternoon frock (A). Straps of the chamois skin, and a hood of black satin dropped across the back add to the charm of this gown. On a jacket of white chamois skin (B) the pockets are in the shape of gloves outlined in black and red leather to match the trimmings of the garment. She hides her face behind the high collar.

On a motor coat of leather (D) the pockets are also of the skin, but in this model they are second in importance to the great sleeves and muffler of striped silk tricot. On a motor coat of beige-coloured cloth (C) the pockets are a part of the bretelles. These are of orange leather piped in dark green leather. Buttoned pockets add chic to the bodice of vague outline in this gown of green and écru cloth (E). From this model one may glean a clear understanding of the new silhouette for the spring.

1

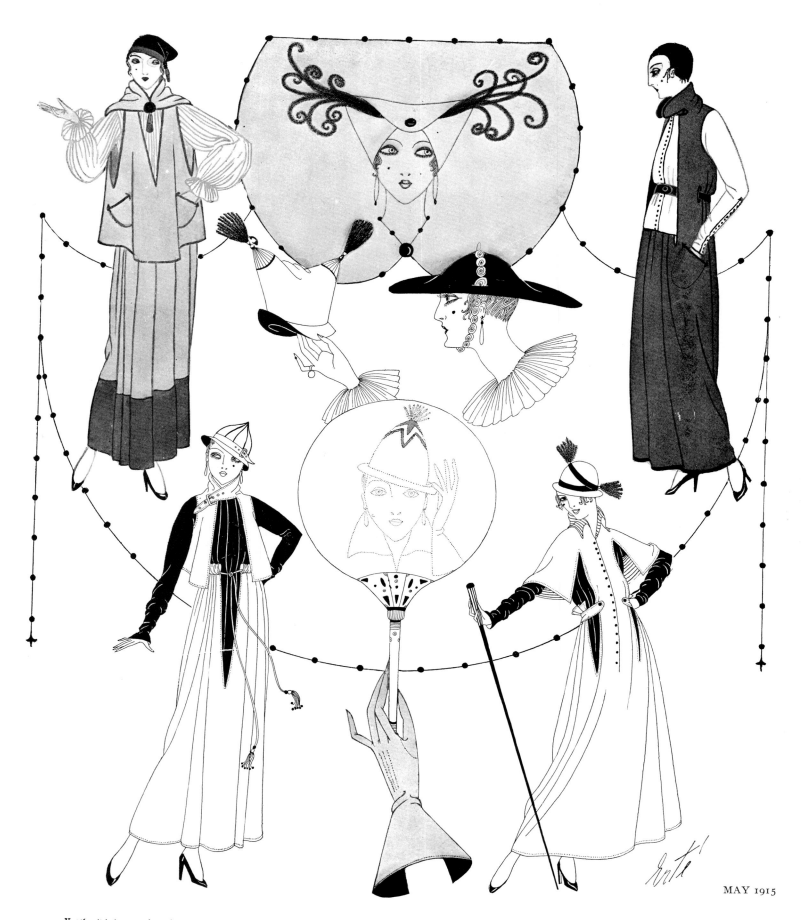

MAY 1915

Youth—it is in every line of the frock shown in the upper left-hand corner. It is in the nonchalant and vague cut of the jaunty little jacket cleverly slashed to reveal the plaited linen blouse; it is in the two pockets reminiscent of the schoolboy's most cherished possession; it is in the great collar which hugs the neck, and it is in the plaited skirt deeply hemmed by the green cloth. There is the same happy, inconsequential spirit in the frock reproduced in the opposite corner. Exploited in green cloth, it is the very acme of simplicity, that baffling, evasive simplicity which demands the hand of an artist. The collar, though high, is opened in the front to give comfort, and the waistcoat is of white linen.

For the spring days there is the robe tailleur, sketched just below, which is at its best when developed in blue serge. A relieving touch comes in the black and white silk collar and cuffs, and in the black satin doublet.

Another jaunty costume of dark blue serge and black satin appears in the lower left corner. Again the spirit of youth has been captured in the sleeveless bolero drawn through a buckle at the throat, the sleeves being of the black satin. There is just a suspicion of shirring at the waist-line. Lisere straw has been twisted into shape for the hat, and a crown of dark green leather added.

Green straw has been folded into the semblance of an envelope to form the hat shown at the top of the page, and sprays of black Paradise shoot out from the openings. Below are two hats, both intended for the bright days of summer. One of white silk is faced with black satin, the two embroidered stick-ups terminating in tiny black aigrettes. The other of black velours is faced with white straw and garlanded in roses. Of unmistakable Chinese origin is the white straw hat in the circle, with orange, black and white ribbon and black aigrettes.

2

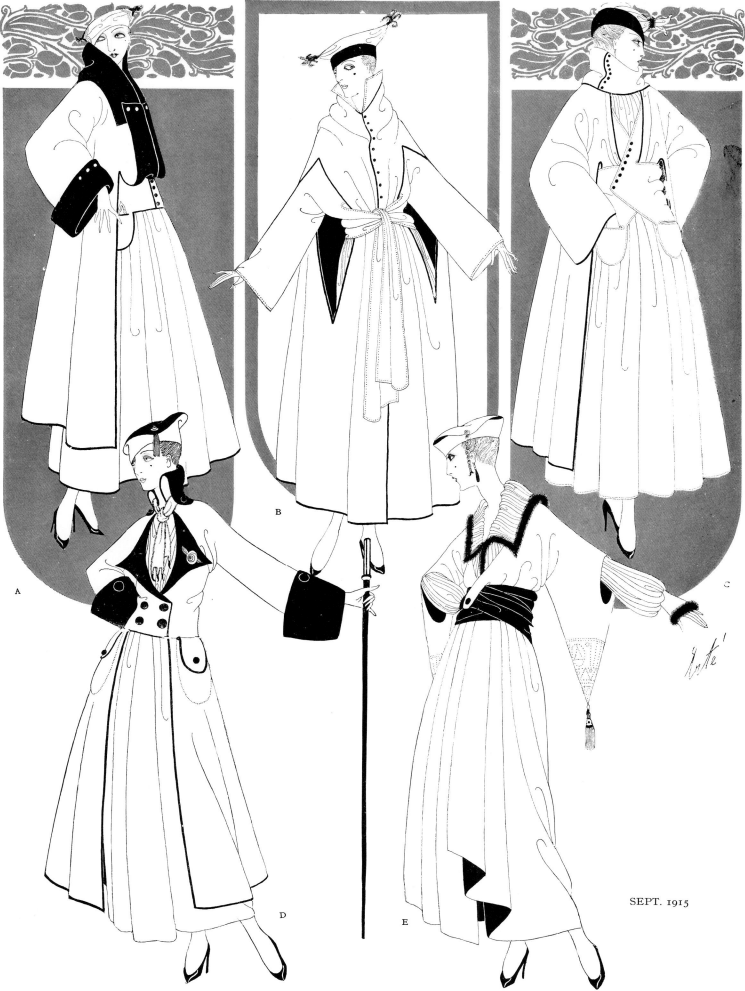

SEPT. 1915

'Tis the coat that counts in this ceremonious day of grace. And to hold its own it must be original and long and voluminous. It may be modeled on the lines of the redingote of Louis XVI. (D), or it may be very long and very flaring as the blue veloutine garment (A). Again it may be a clever combination of two materials, say a marron cloth lined in black satin with a shorter vêtement and sleeves of grey cloth (C). On the long coat of beige velours de laine (B) the contrast is introduced in the gilet of white cloth buttoning in a diagonal line. The last sketch (E) shows an afternoon frock of "craie" cloth lined in violet satin.

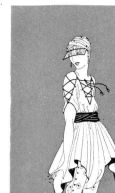

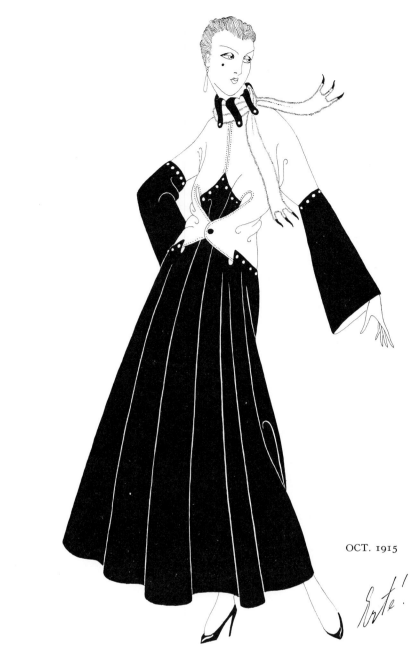

OCT. 1915

Above left, and right: Bathing costumes. Above right:
In this cloth and velvet frock a piece of the velvet,
attached above the elbow, adds a flaring deep cuff.
(Reproduced from the original drawing.)

JUNE 1915 JUNE 1915

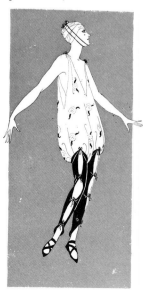

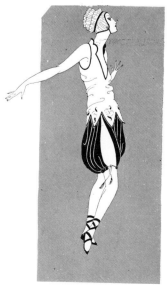

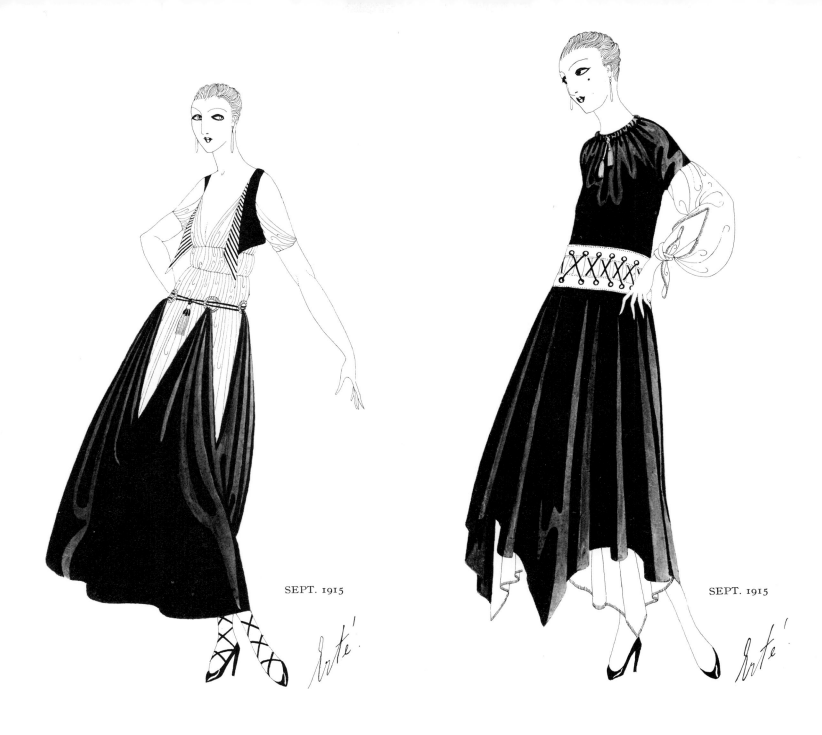

SEPT. 1915

SEPT. 1915

JUNE 1915

JUNE 1915

Above left: Costume in white, old rose, black and white strip, and silver. (Reproduced from the original drawing.) Above right: Gown in white crêpe de Chine and black satin, with knotted sleeves. (Reproduced from the original drawing.) Left: Bathing costumes.

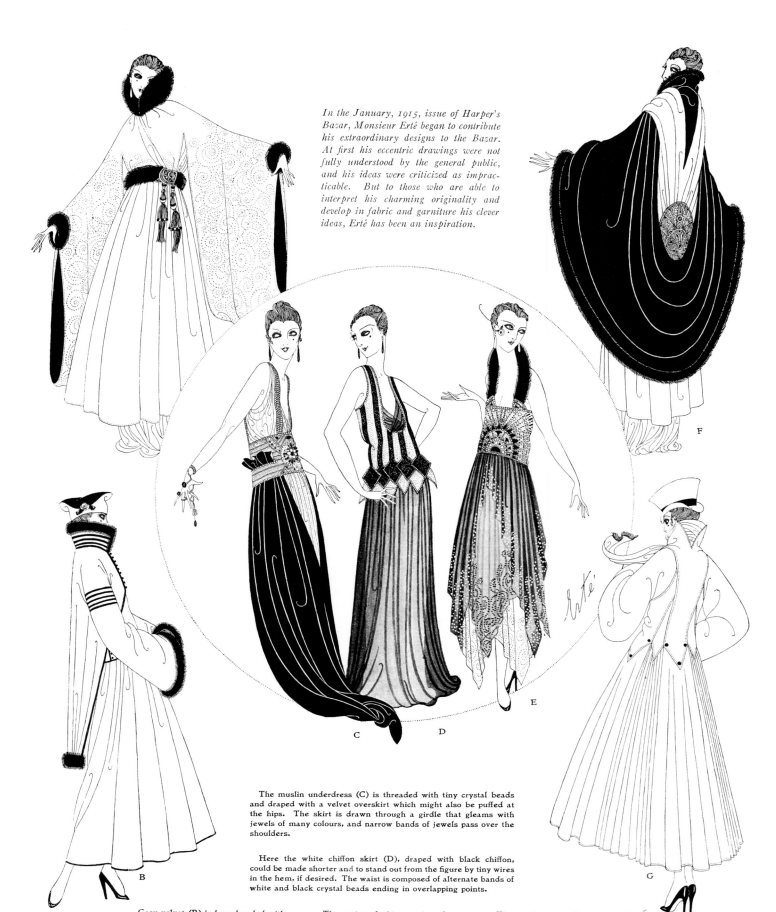

In the January, 1915, issue of Harper's Bazar, Monsieur Erté began to contribute his extraordinary designs to the Bazar. At first his eccentric drawings were not fully understood by the general public, and his ideas were criticized as impracticable. But to those who are able to interpret his charming originality and develop in fabric and garniture his clever ideas, Erté has been an inspiration.

The muslin underdress (C) is threaded with tiny crystal beads and draped with a velvet overskirt which might also be puffed at the hips. The skirt is drawn through a girdle that gleams with jewels of many colours, and narrow bands of jewels pass over the shoulders.

Here the white chiffon skirt (D), draped with black chiffon, could be made shorter and to stand out from the figure by tiny wires in the hem, if desired. The waist is composed of alternate bands of white and black crystal beads ending in overlapping points.

Grey velvet (B) is here banded with cords of satin in a slightly lighter shade. The very high collar is bordered with black fox, as are also the muff, sleeves and end of coat.

The waist of this evening dress (E) is almost covered with elaborate embroidery in stones and pearls, and a novel feature is the band of fur that extends around the neck. The skirt hangs very full in three pointed sections. The first is of white chiffon embroidered in orange beads, the second is of orange chiffon embroidered in jet, and the third is of black chiffon embroidered in white, appearing almost taupe over the other colours. The top skirt could be wired in pannier effect if desired.

The evening wrap of sea green velvet (F) has draped over it a cape of black velvet bordered with skunk. Black velvet forms the collar, and a fan disc of embroidery ornaments the back.

Rarely has evening wrap been devised that gives more splendid opportunity for the display of gorgeous embroidery or brocade (A). The large Japanese sleeves glimmer with gold and silver threads; the skirt and upper part of waist are of plain blue velvet. Silver fox is used in trimming.

NOV. 1915

This smart trotteur of black velvet (G) has its many seams outlined with black satin and the points of the very unusual jacket ornamented with buttons of velvet. The velvet collar is split to allow an inner one of black satin to show. The full skirt is laid in plaits under the narrow points at the back.

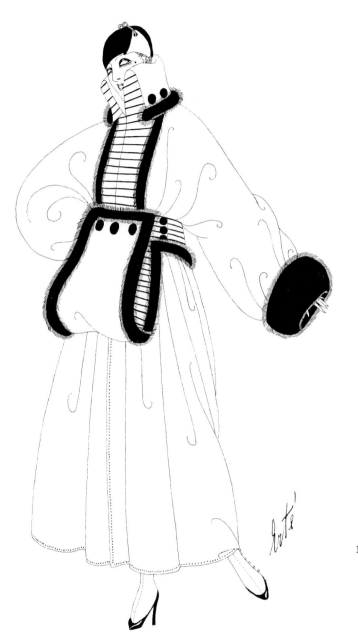

DEC. 1915

This coat of velours de laine is ornamented with bands of soutache braid and skunk. The belt continues down the front like an apron which is turned up to form a muff and fastened with buttons. (Reproduced from original drawing.)

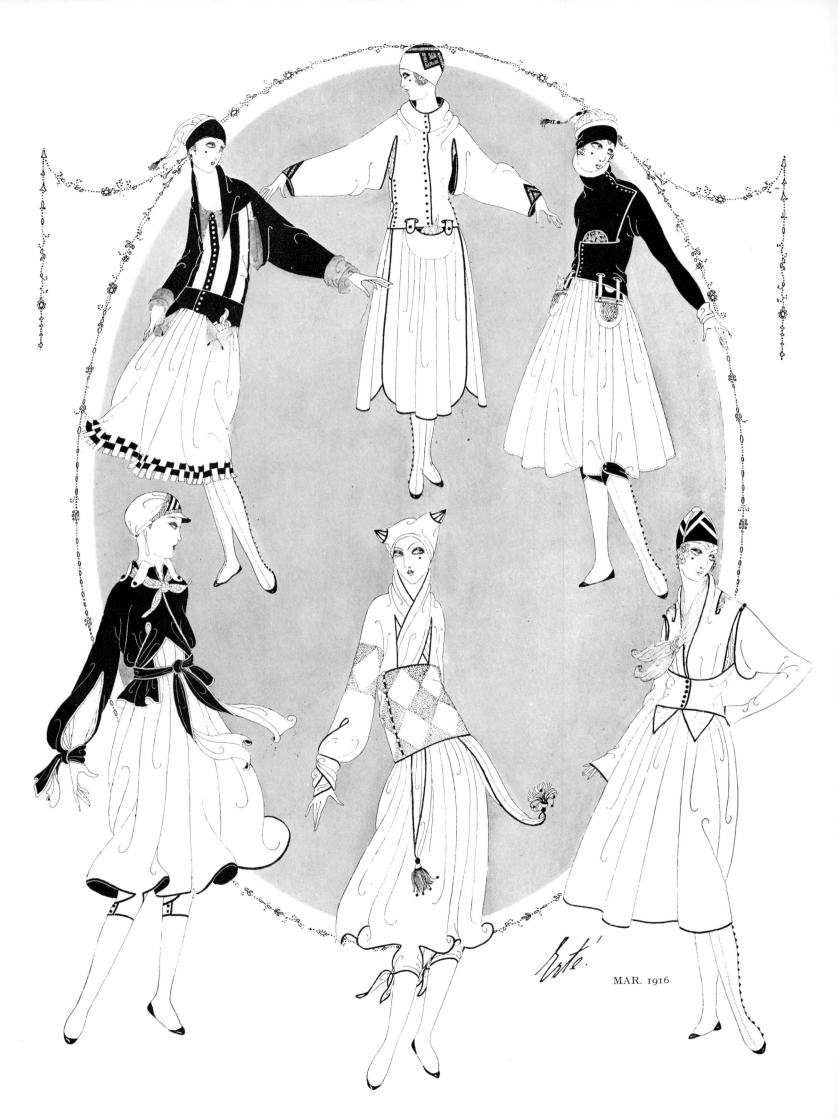

MAR. 1916

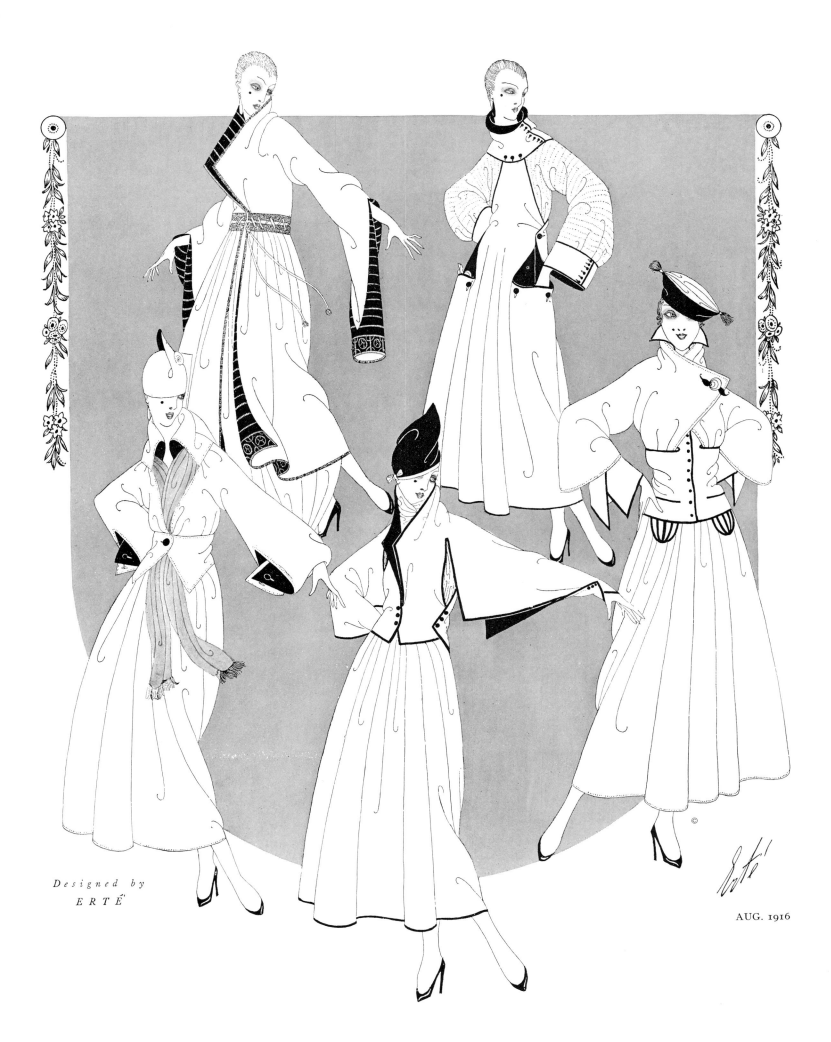

Designed by
ERTÉ

AUG. 1916

9

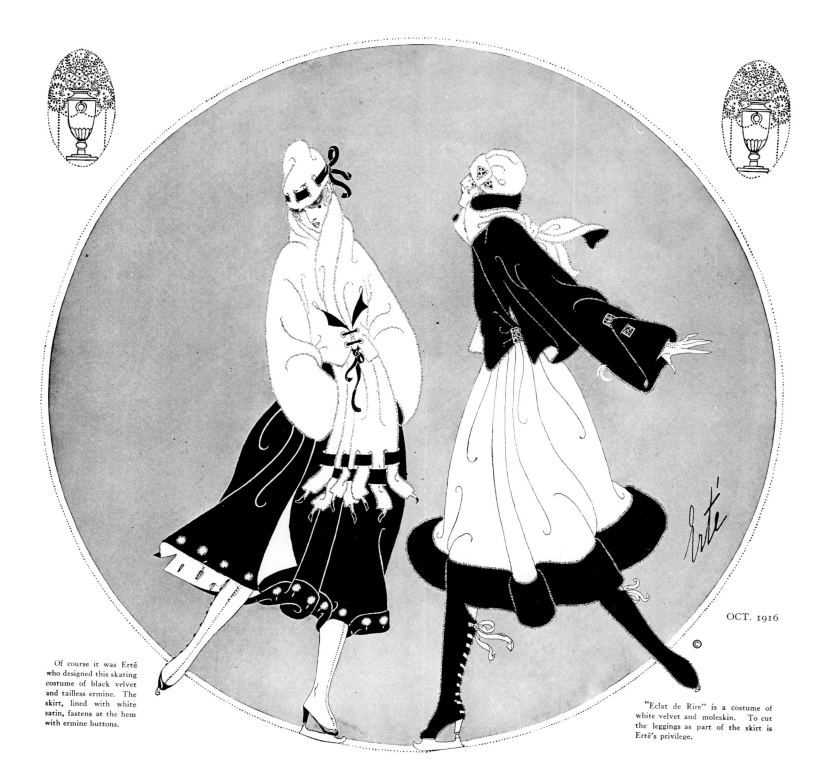

Of course it was Erté who designed this skating costume of black velvet and tailless ermine. The skirt, lined with white satin, fastens at the hem with ermine buttons.

OCT. 1916

"Eclat de Rire" is a costume of white velvet and moleskin. To cut the leggings as part of the skirt is Erté's privilege.

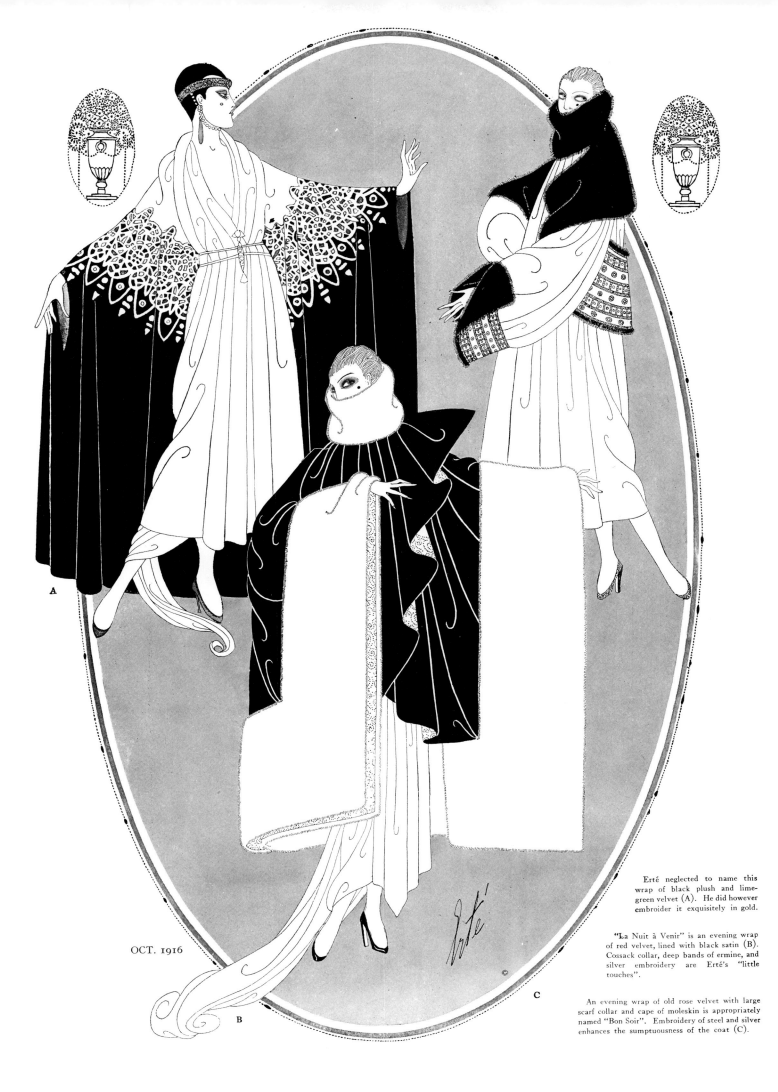

OCT. 1916

Erté neglected to name this wrap of black plush and lime-green velvet (A). He did however embroider it exquisitely in gold.

"La Nuit à Venir" is an evening wrap of red velvet, lined with black satin (B). Cossack collar, deep bands of ermine, and silver embroidery are Erté's "little touches".

An evening wrap of old rose velvet with large scarf collar and cape of moleskin is appropriately named "Bon Soir". Embroidery of steel and silver enhances the sumptuousness of the coat (C).

A handsome evening gown of old rose velvet is justly named "Souvenir de la Cour". Jet and steel embroidery makes an effective decoration.

In creating this opera coat of blue velours Erté's imagination ran riot. The grey satin lining is embroidered in silver, old rose, and steel beads (centre). The collar is formed of bands of ermine and mole, and bands of mole finish the edge of "Quatre Heures du Matin."

"Le Lis du Noir" satisfies one's craving for beauty. Because of its name, Erté creates it in metallic and black satin, and embroiders it with diamonds and pearls.

OCT. 1916

E—"Austérité" is a blue velvet costume embroidered with violet silk and faced with violet satin. Kimono sleeves are attached to cuffs of violet embroidery.

H—"Samurai," an evening wrap of black velvet, is cut appropriately à la Japanese. Tissue, embroidered in coloured silks, and metal with skunk bands forms collar and girdle.

F—"Samoyed," a tailleur of grey velvet is faced with white cloth. The trimming bands are of cut-out cloth and light blue embroidery.

G—"Ma Patrie" is symbolized by Erté in an afternoon dress with black satin skirt and crêpe de Chine blouse, embroidered in black and white and edged with skunk.

J—"Souvenir d'Enfance," declares Erté, is this blue velvet faced with white chamois.

NOV. 1916

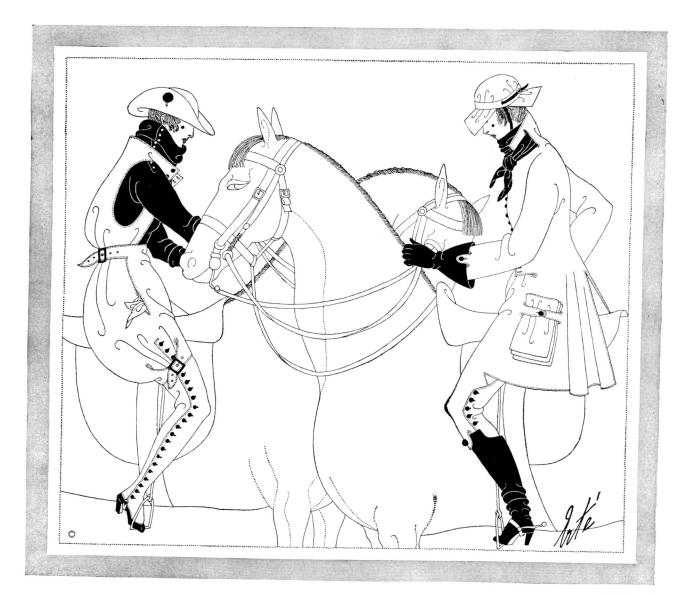

DEC. 1916

Striking indeed on the bridle-path will be
"L'Amazone du Démain" in a suit of grey chamois
with cardigan of blue silk. The gaiters, which are
in one with the breeches, fasten with conspicuous
blue buttons.

Erté's "Promenade Matinale" is a striking habit
of beige cloth with breeches cut in one with the
skirt of the coat. The black silk stock wraps about
the neck and is knotted in the front.

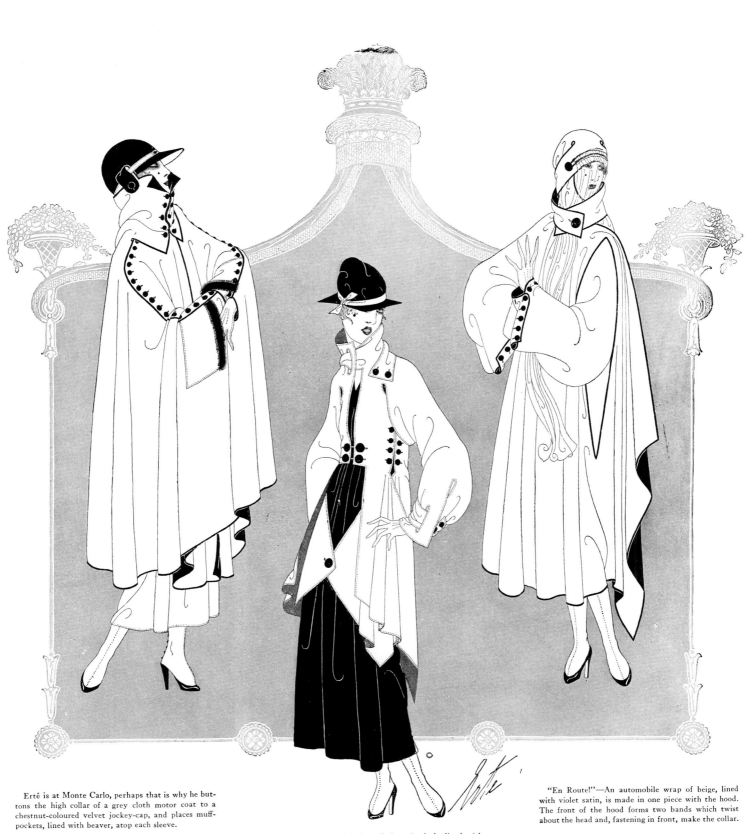

Erté is at Monte Carlo, perhaps that is why he buttons the high collar of a grey cloth motor coat to a chestnut-coloured velvet jockey-cap, and places muff-pockets, lined with beaver, atop each sleeve.

A long pointed jacket of chamois cloth, lined with blue satin, glorifies a simple little robe of black satin.

"En Route!"—An automobile wrap of beige, lined with violet satin, is made in one piece with the hood. The front of the hood forms two bands which twist about the head and, fastening in front, make the collar.

JAN. 1917

"J'Adore Ça" is Erté's appellation for this daytime
dress. It is very aptly named, for who would not love
to own a frock of marine blue serge faced with
black satin and laced with green? (Reproduced from
the original drawing.)

FEB. 1917

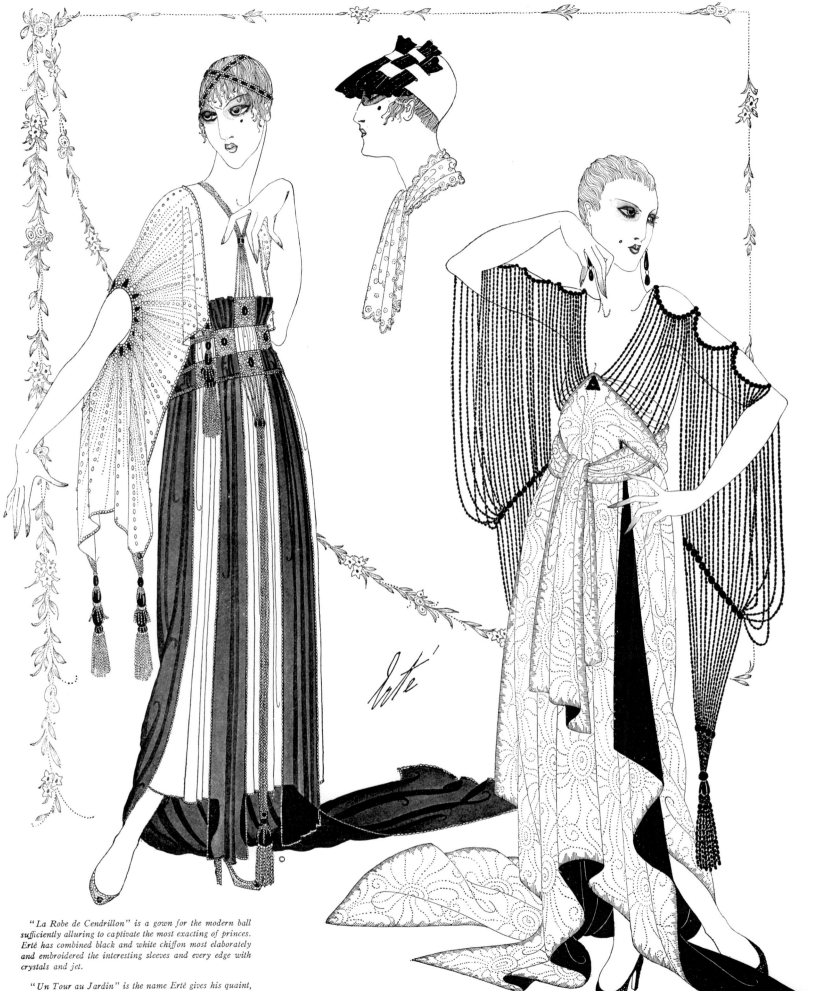

"La Robe de Cendrillon" is a gown for the modern ball sufficiently alluring to captivate the most exacting of princes. Erté has combined black and white chiffon most elaborately and embroidered the interesting sleeves and every edge with crystals and jet.

"Un Tour au Jardin" is the name Erté gives his quaint, close-fitting hat of grey Tagal straw, which is cut and latticed with quillings of old rose taffeta.

Who but Erté could originate such a gown as "La Richesse"? The bodice and sleeves are strings of jet, while the skirt with its various trains is silver brocade faced with black chiffon velvet.

MAR. 1917

17

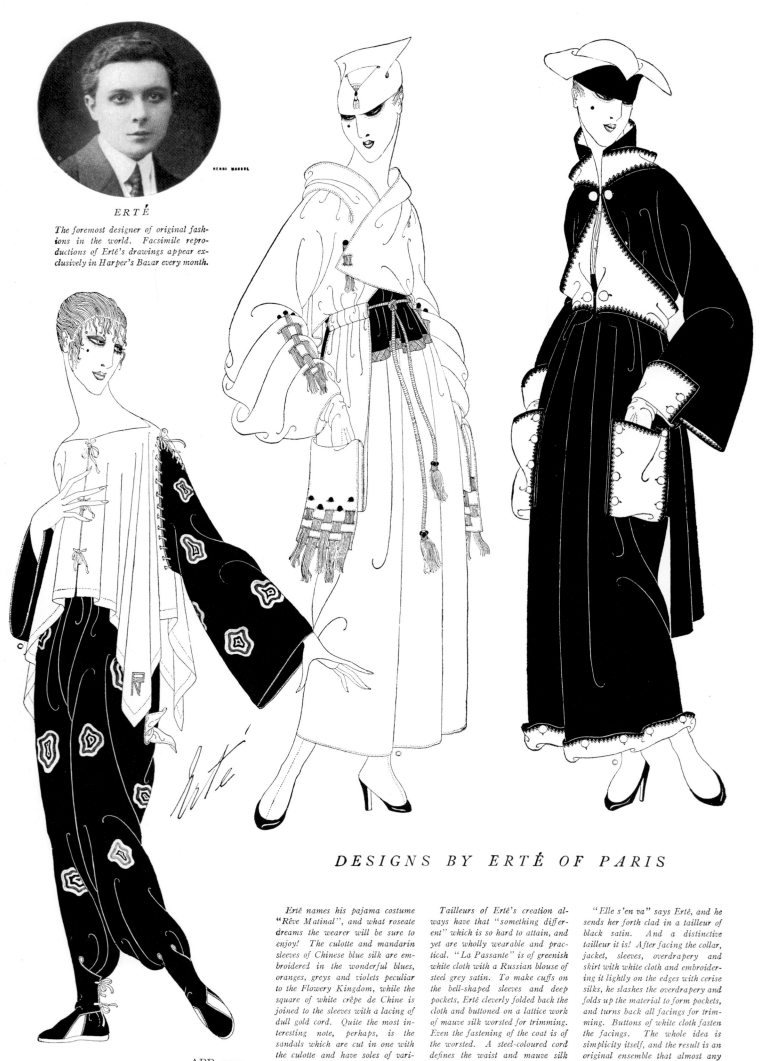

ERTÉ

The foremost designer of original fashions in the world. Facsimile reproductions of Erté's drawings appear exclusively in Harper's Bazar every month.

APR. 1917

DESIGNS BY ERTÉ OF PARIS

Erté names his pajama costume "Rêve Matinal", and what roseate dreams the wearer will be sure to enjoy! The culotte and mandarin sleeves of Chinese blue silk are embroidered in the wonderful blues, oranges, greys and violets peculiar to the Flowery Kingdom, while the square of white crêpe de Chine is joined to the sleeves with a lacing of dull gold cord. Quite the most interesting note, perhaps, is the sandals which are cut in one with the culotte and have soles of vari-coloured woven straw.

Tailleurs of Erté's creation always have that "something different" which is so hard to attain, and yet are wholly wearable and practical. "La Passante" is of greenish white cloth with a Russian blouse of steel grey satin. To make cuffs on the bell-shaped sleeves and deep pockets, Erté cleverly folded back the cloth and buttoned on a lattice work of mauve silk worsted for trimming. Even the fastening of the coat is of the worsted. A steel-coloured cord defines the waist and mauve silk embroidery finishes all edges.

"Elle s'en va" says Erté, and he sends her forth clad in a tailleur of black satin. And a distinctive tailleur it is! After facing the collar, jacket, sleeves, overdrapery and skirt with white cloth and embroidering it lightly on the edges with cerise silks, he slashes the overdrapery and folds up the material to form pockets, and turns back all facings for trimming. Buttons of white cloth fasten the facings. The whole idea is simplicity itself, and the result is an original ensemble that almost any woman could wear.

18

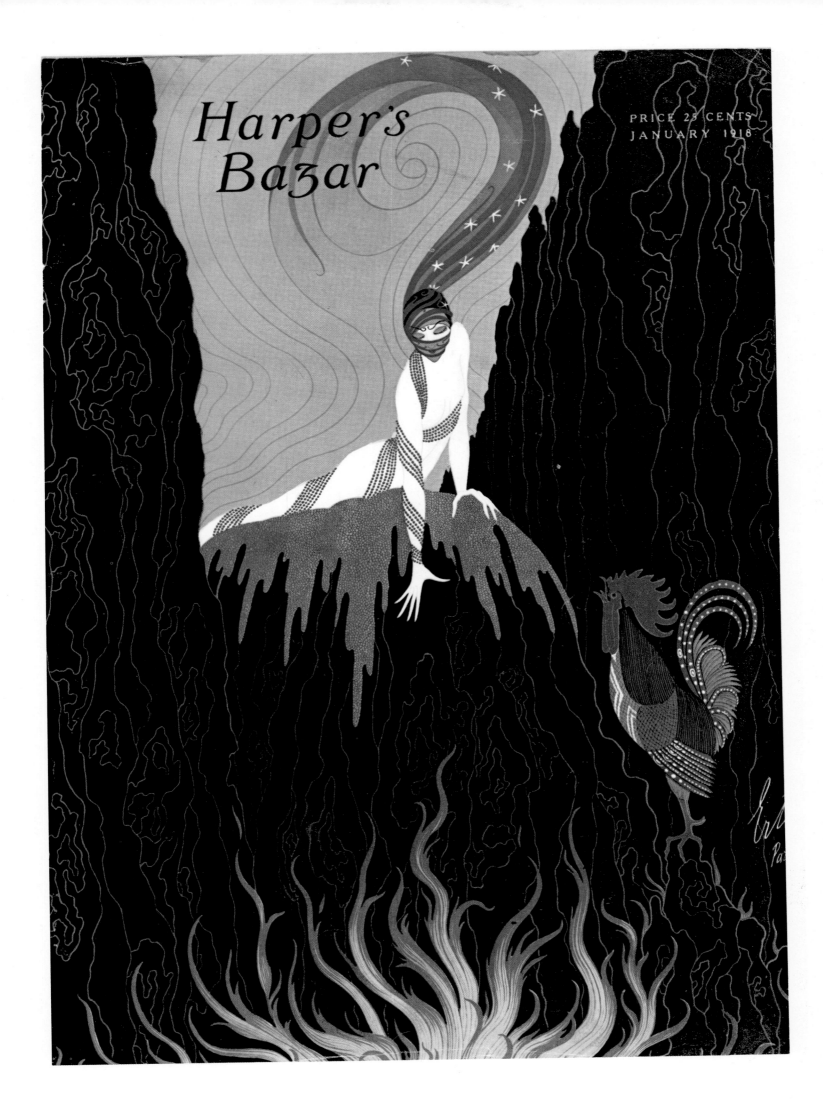

Harper's Bazar

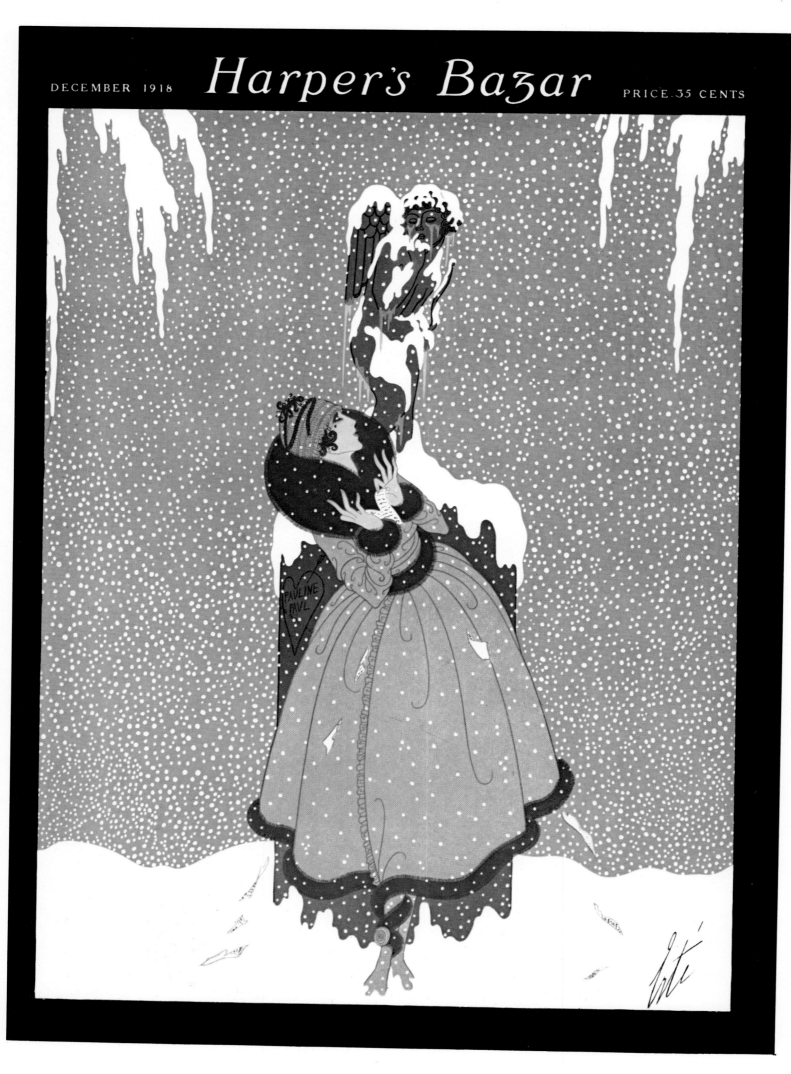

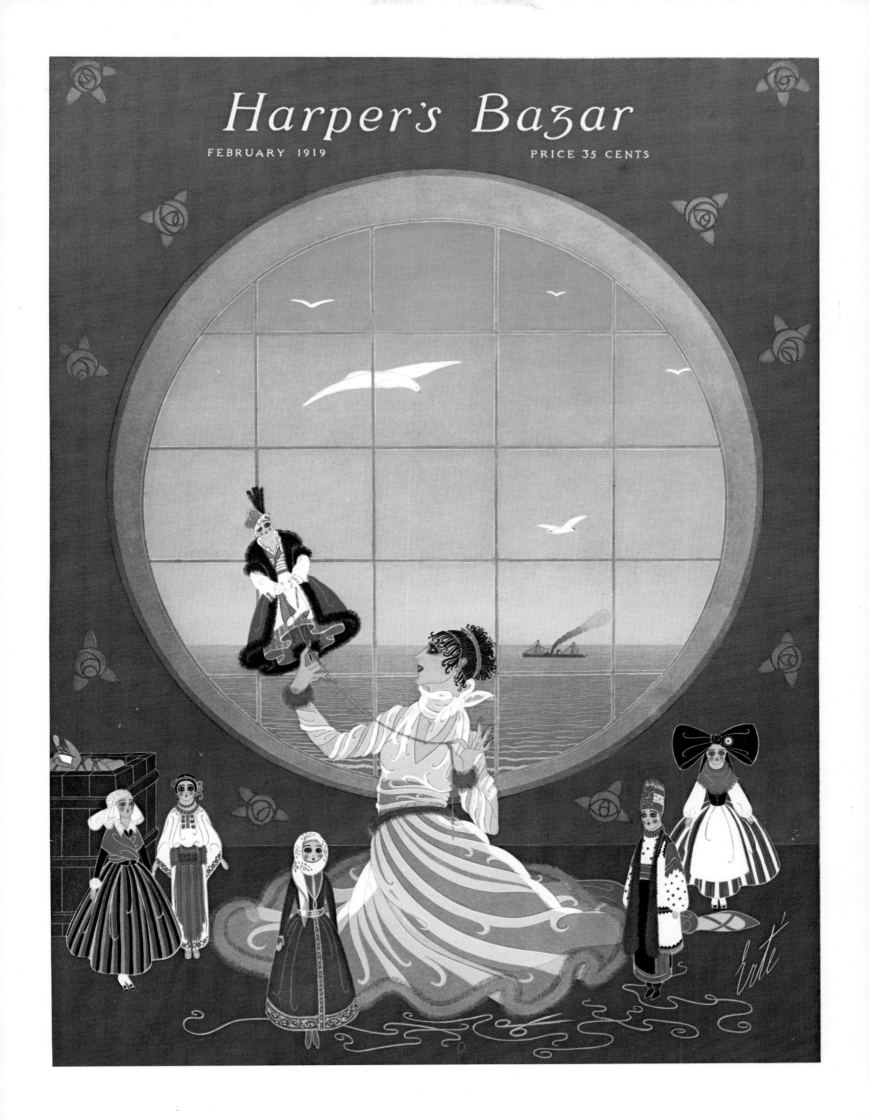

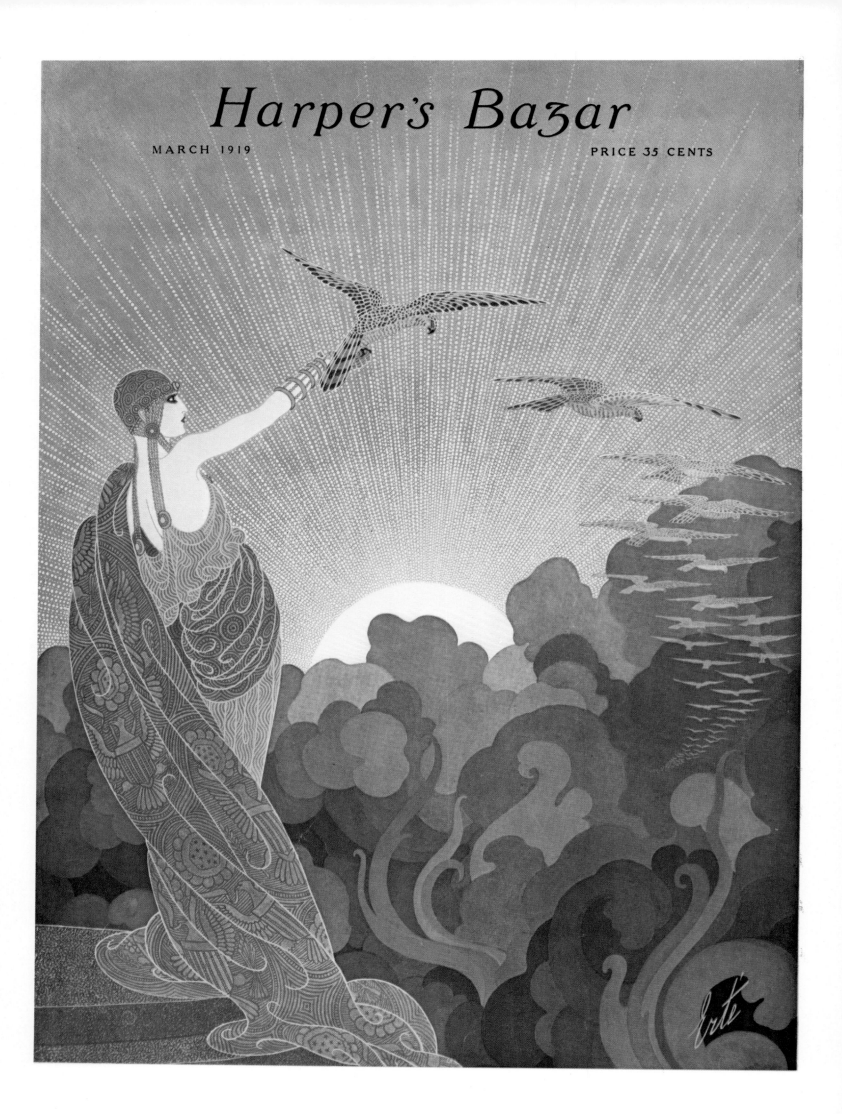

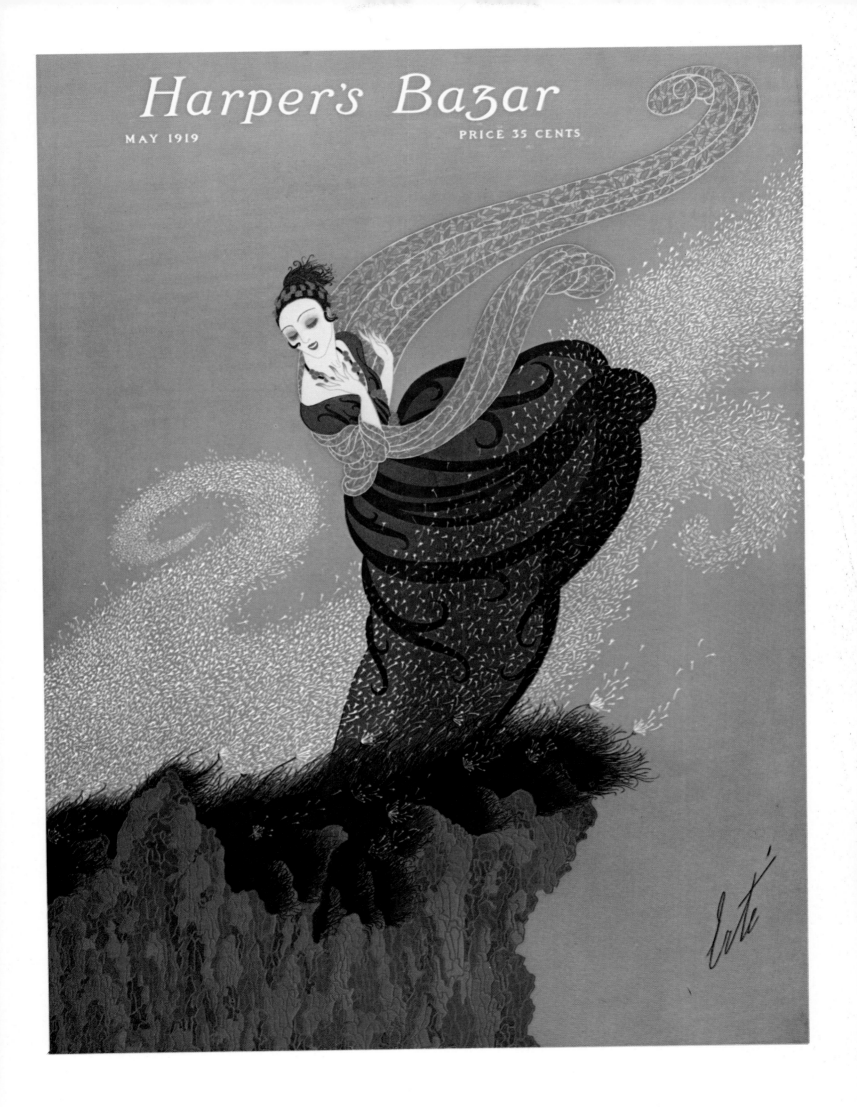

Harper's Bazar

NOVEMBER 1921 PRICE 50 CENTS

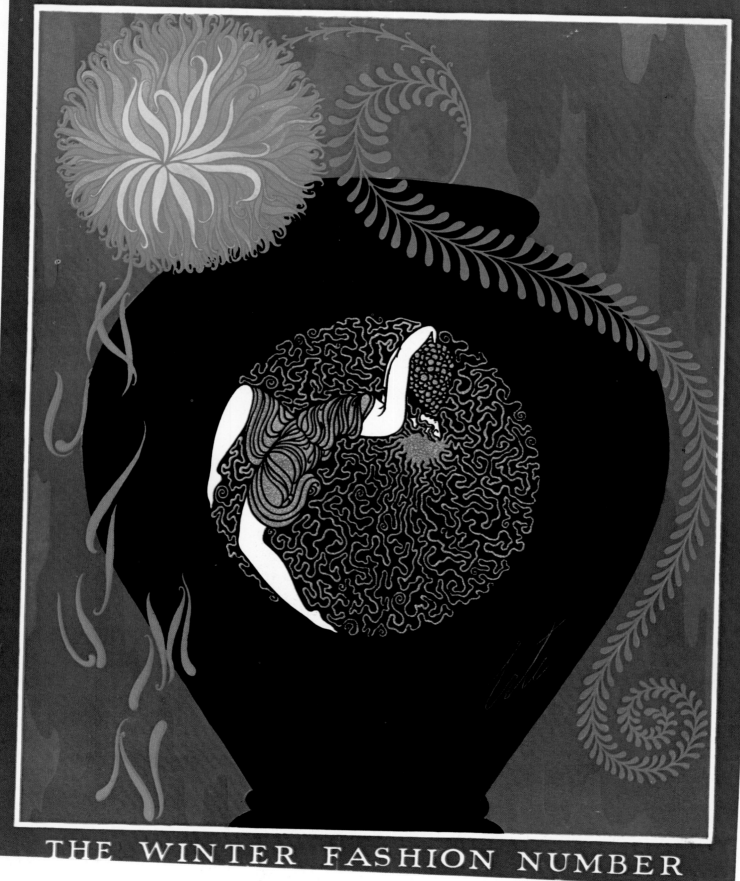

THE WINTER FASHION NUMBER

Harper's Bazar

AUGUST 1922 PRICE 50 CENTS

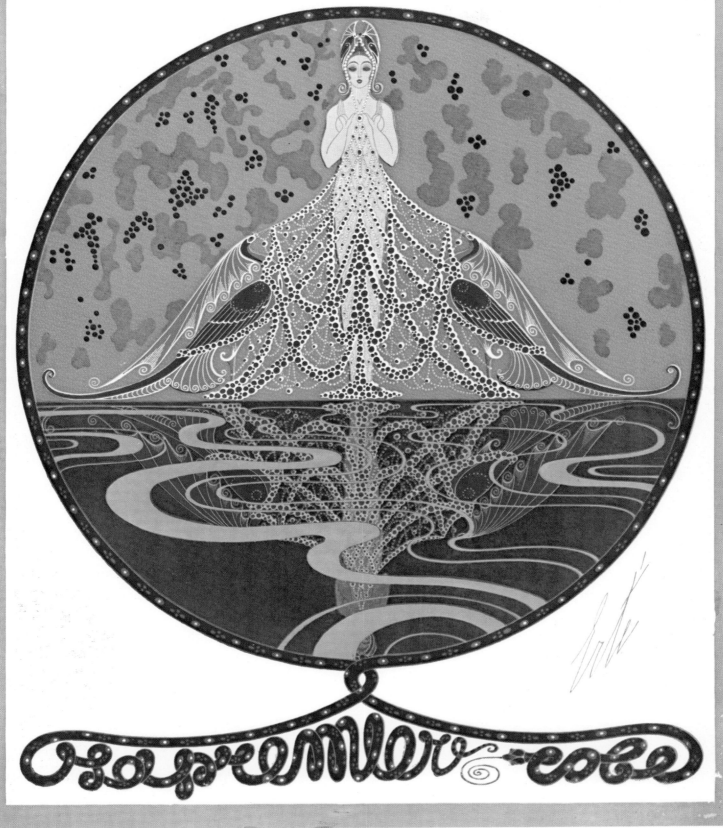

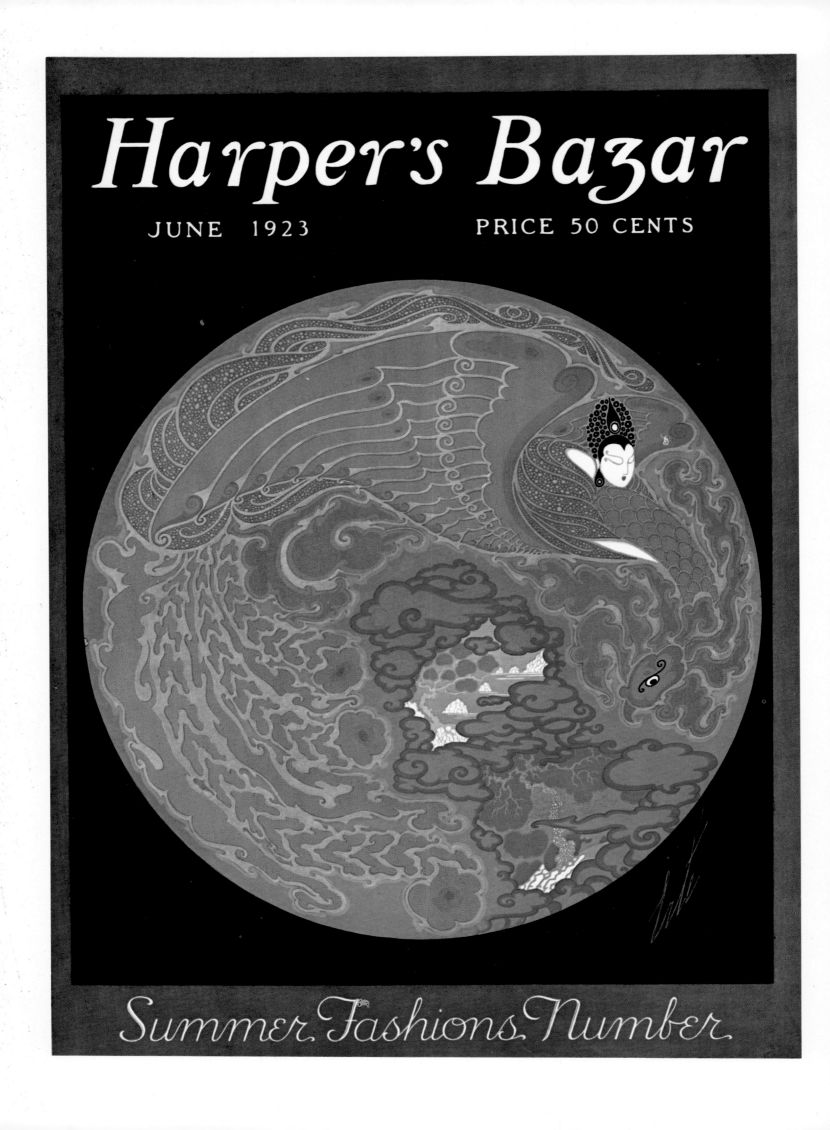

Harper's Bazar

JUNE 1923 PRICE 50 CENTS

Summer Fashions Number

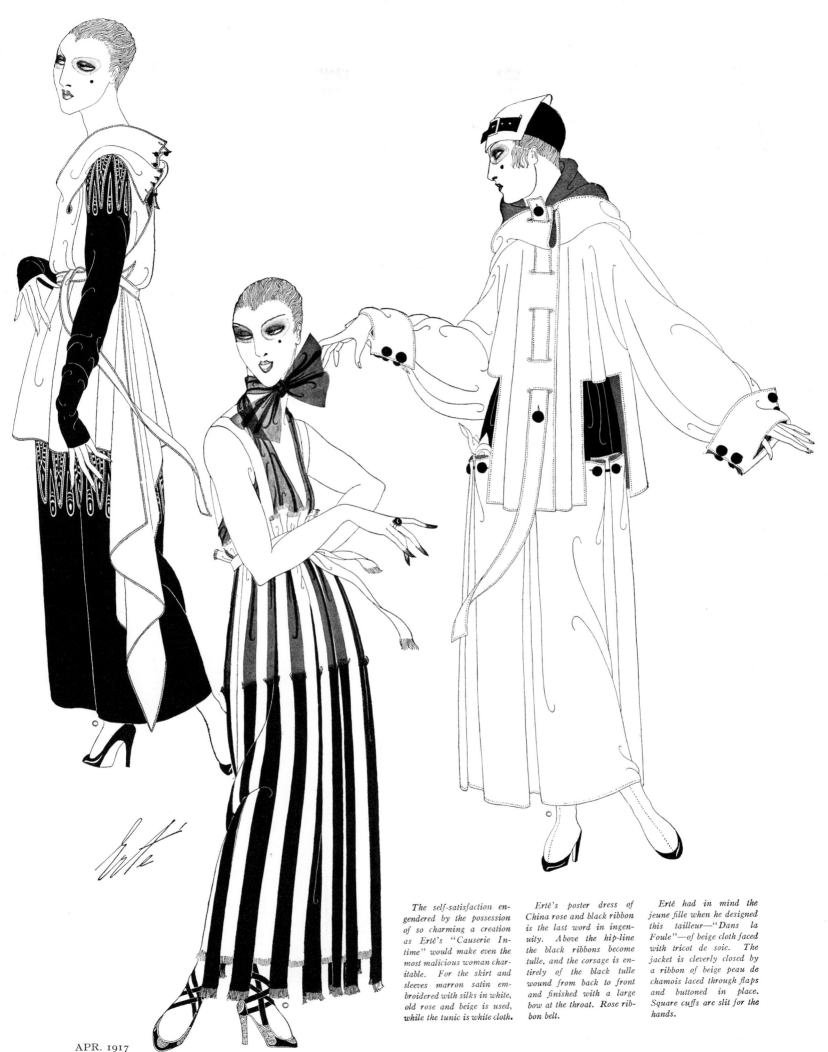

APR. 1917

The self-satisfaction engendered by the possession of so charming a creation as Erté's "Causerie Intime" would make even the most malicious woman charitable. For the skirt and sleeves marron satin embroidered with silks in white, old rose and beige is used, while the tunic is white cloth.

Erté's poster dress of China rose and black ribbon is the last word in ingenuity. Above the hip-line the black ribbons become tulle, and the corsage is entirely of the black tulle wound from back to front and finished with a large bow at the throat. Rose ribbon belt.

Erté had in mind the jeune fille when he designed this tailleur—"Dans la Foule"—of beige cloth faced with tricot de soie. The jacket is cleverly closed by a ribbon of beige peau de chamois laced through flaps and buttoned in place. Square cuffs are slit for the hands.

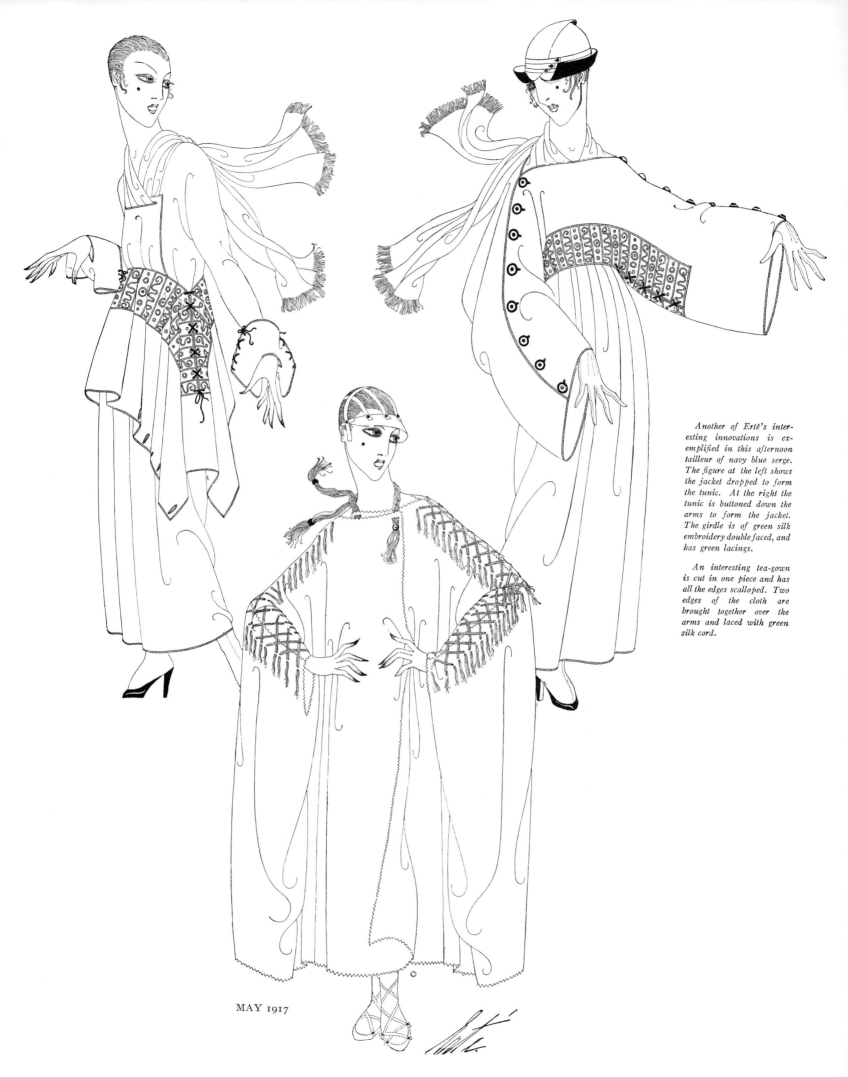

Another of Erté's interesting innovations is exemplified in this afternoon tailleur of navy blue serge. The figure at the left shows the jacket dropped to form the tunic. At the right the tunic is buttoned down the arms to form the jacket. The girdle is of green silk embroidery double faced, and has green lacings.

An interesting tea-gown is cut in one piece and has all the edges scalloped. Two edges of the cloth are brought together over the arms and laced with green silk cord.

MAY 1917

*Sketches made at
Monte Carlo especially
for Harper's Bazar
by ERTÉ*

An adorable combination on the promenade was a hat of purple straw, plaited white ribbon and flat rosebuds. The white silk parasol, laced with purple ribbon, had a handle of rosewood and carved Chinese ivory.

Erté was captivated by a striking black satin and lace gown recently worn at the Casino. The sash, which knotted in front ended in a tassel.

Erté thought this an ideal Riviera costume: white Jersey embroidered in blue and green silks; white Tagal hat with cocardes of ribbons in white and two shades of blue, and a parasol of white silk with frills in three shades of blue.

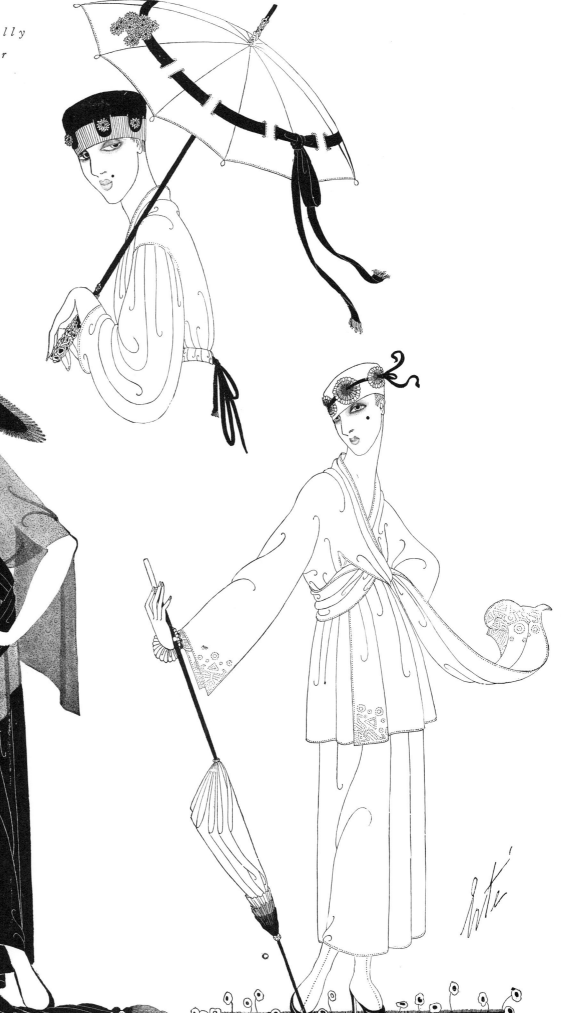

MAY 1917

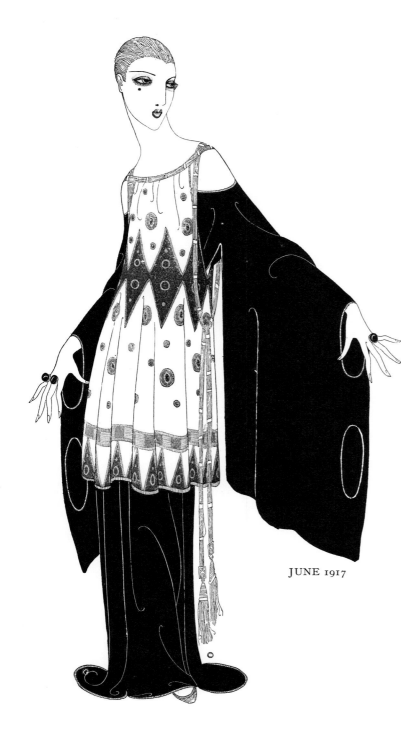

JUNE 1917

*Combine a chemise of black satin, a tunic of
green crêpe de Chine exquisite with Etruscan
embroideries, and cords run through gold rings,
and you have Erté's conception of an ideal tea-
gown*

*Very summery is "Naïveté", Erté's
frock of finely plaited white linen. A
square of linen, resembling an enormous
handkerchief, makes the bodice.*

JUNE 1917

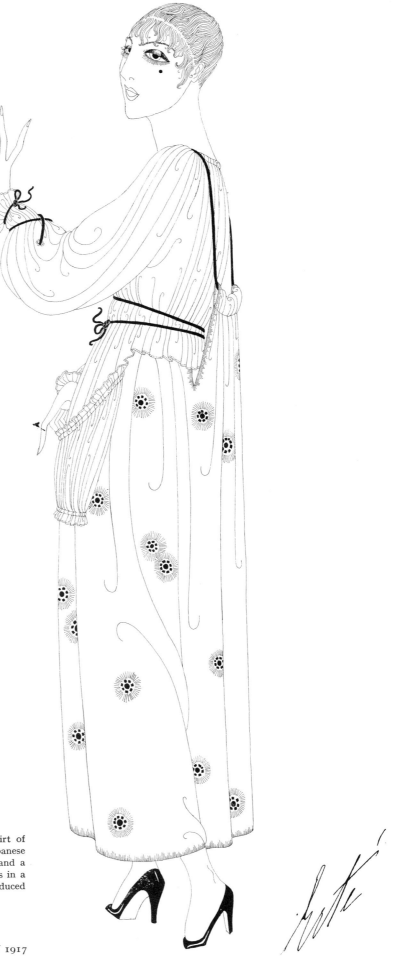

Erté's "A la Campagne" has a skirt of
white toile de soie, embroidered in Japanese
flowers of cerise, blue and purple, and a
bodice of white organdie which ends in a
large shirred pocket in front. (Reproduced
from the original drawing.)

JULY 1917

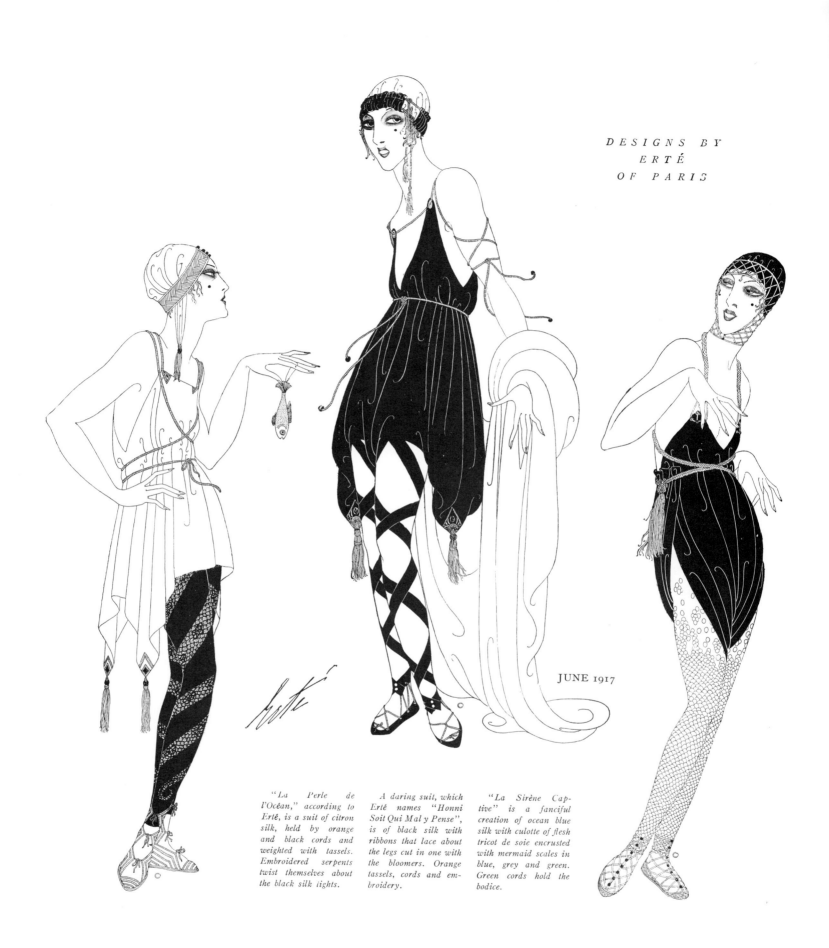

JUNE 1917

"La Perle de l'Océan," according to Erté, is a suit of citron silk, held by orange and black cords and weighted with tassels. Embroidered serpents twist themselves about the black silk tights.

A daring suit, which Erté names "Honni Soit Qui Mal y Pense", is of black silk with ribbons that lace about the legs cut in one with the bloomers. Orange tassels, cords and embroidery.

"La Sirène Captive" is a fanciful creation of ocean blue silk with culotte of flesh tricot de soie encrusted with mermaid scales in blue, grey and green. Green cords hold the bodice.

Daintiness is personified in the garden-party frock of sheer white lace and mauve taffeta at the left. There are adorable knotted pockets in the jacket, which contain clusters of roses in different shades. Roses also ornament the underbrim of the grey Tagal straw hat.

A most beautiful transparent evening wrap is Erté's creation of chiffon, silver embroidery and fox. The hood is cut in one with the cloak, as may be seen in the mirror, and is draped in the front to make a graceful oval frame for the face.

AUG. 1917

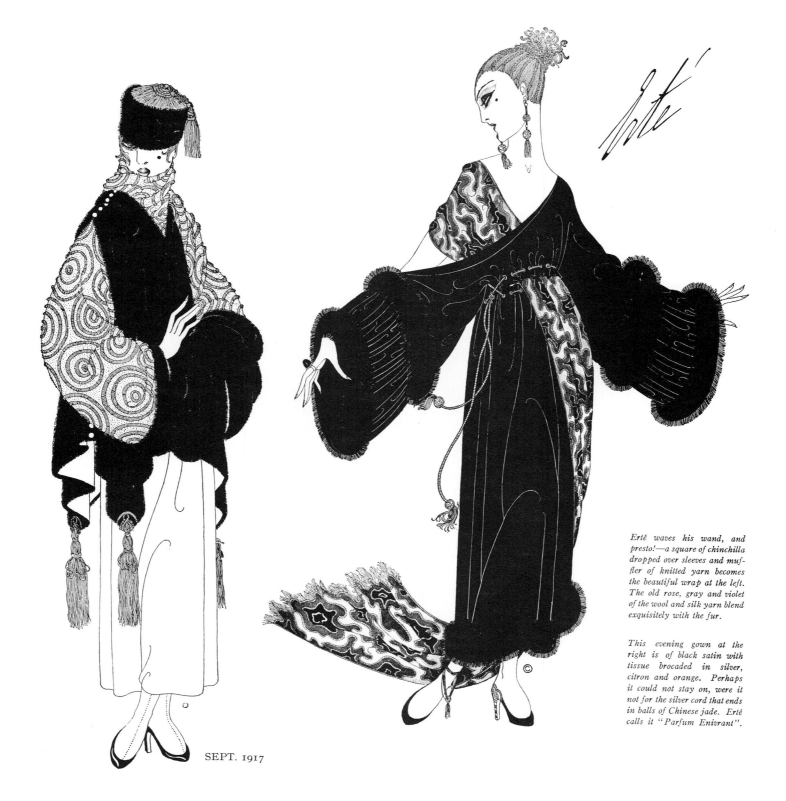

SEPT. 1917

*Erté waves his wand, and
presto!—a square of chinchilla
dropped over sleeves and muf-
fler of knitted yarn becomes
the beautiful wrap at the left.
The old rose, gray and violet
of the wool and silk yarn blend
exquisitely with the fur.*

*This evening gown at the
right is of black satin with
tissue brocaded in silver,
citron and orange. Perhaps
it could not stay on, were it
not for the silver cord that ends
in balls of Chinese jade. Erté
calls it "Parfum Enivrant".*

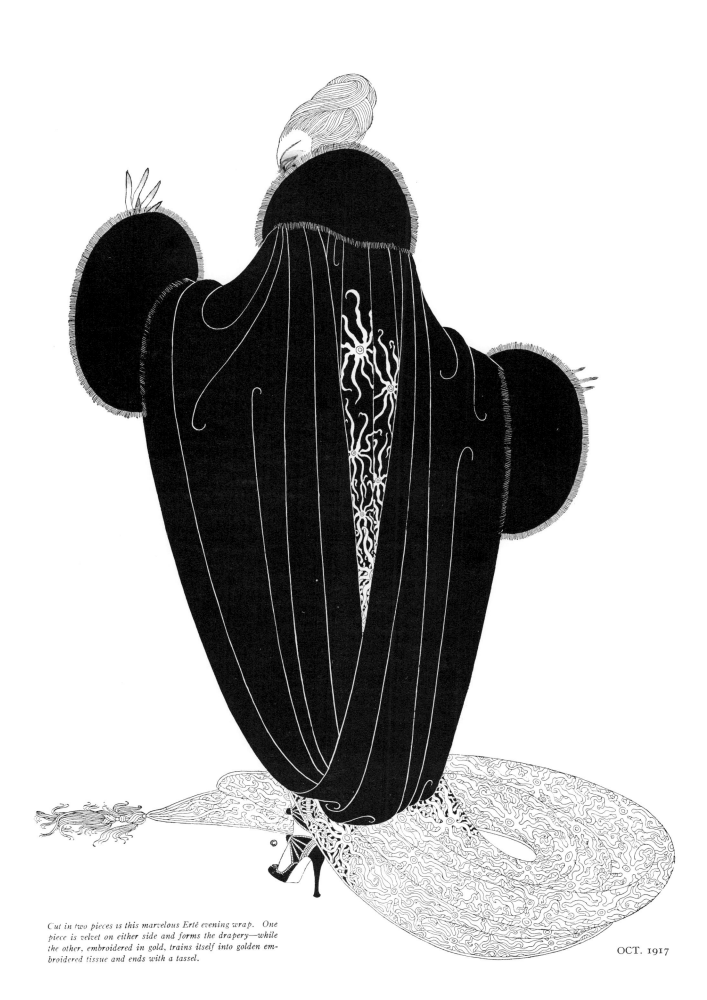

Cut in two pieces is this marvelous Erté evening wrap. One
piece is velvet on either side and forms the drapery—while
the other, embroidered in gold, trains itself into golden em-
broidered tissue and ends with a tassel.

OCT. 1917

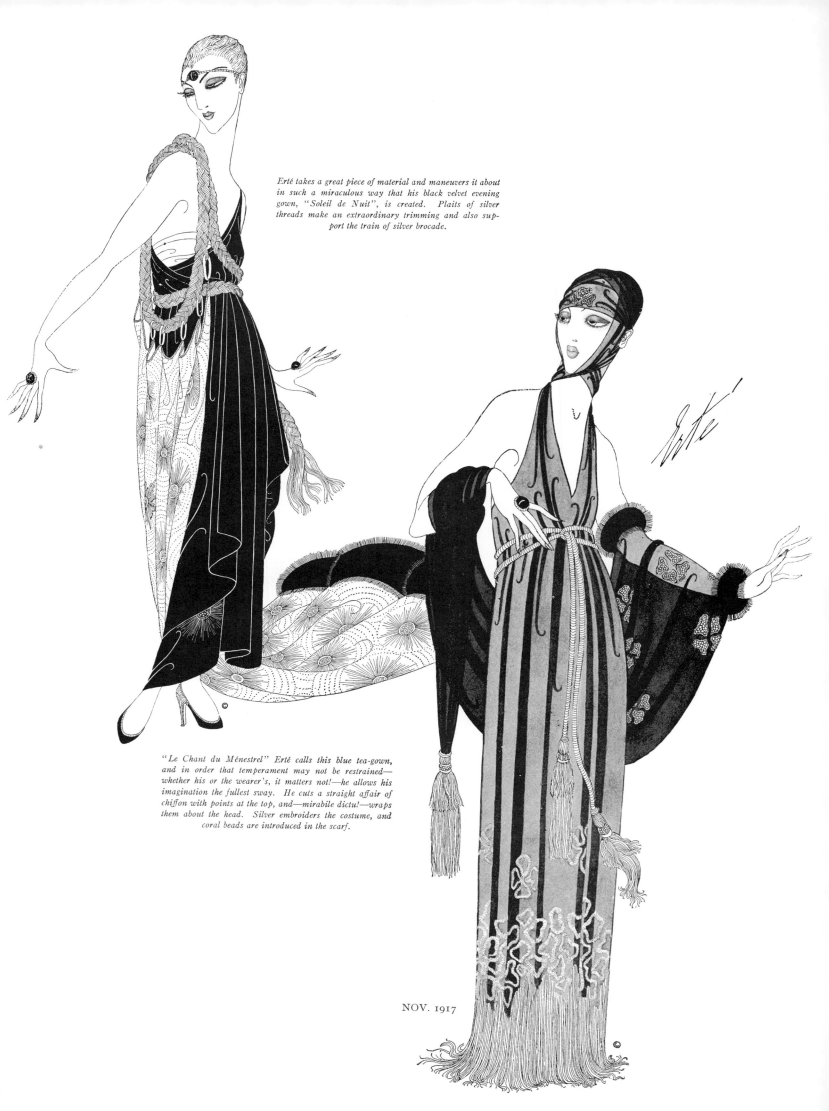

Erté takes a great piece of material and maneuvers it about in such a miraculous way that his black velvet evening gown, "Soleil de Nuit", is created. Plaits of silver threads make an extraordinary trimming and also support the train of silver brocade.

"Le Chant du Ménestrel" Erté calls this blue tea-gown, and in order that temperament may not be restrained—whether his or the wearer's, it matters not!—he allows his imagination the fullest sway. He cuts a straight affair of chiffon with points at the top, and—mirabile dictu!—wraps them about the head. Silver embroiders the costume, and coral beads are introduced in the scarf.

NOV. 1917

28

*Black gowns for evening are the demand, and Erté origi-
nates a dress of stately grace from mousseline. The
bodice shows exquisite workmanship in the handling of
jets—and as for the sleeves, they are very interesting, for
the fingers go through loops of jet.*

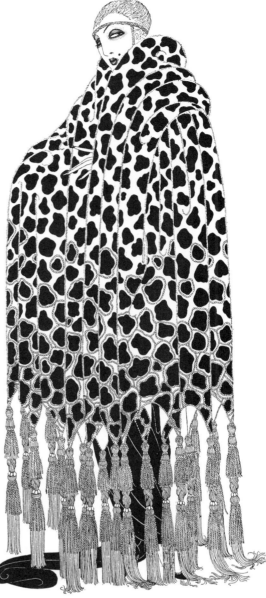

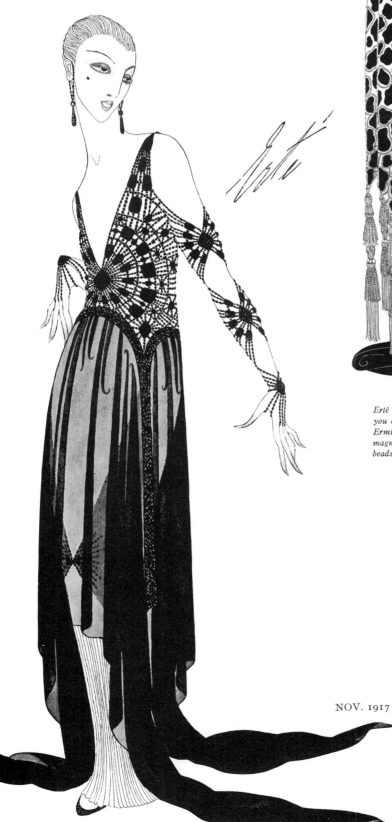

*Erté wraps about you the most gorgeous cape, and so when
you attend the opera you bring envy to all who behold you!
Ermine, encrusted with moleskin, would seem sufficient
magnificence, but the orientalism of Erté must have
beads, and we find them in an outline and combined with
silken tassels.*

NOV. 1917

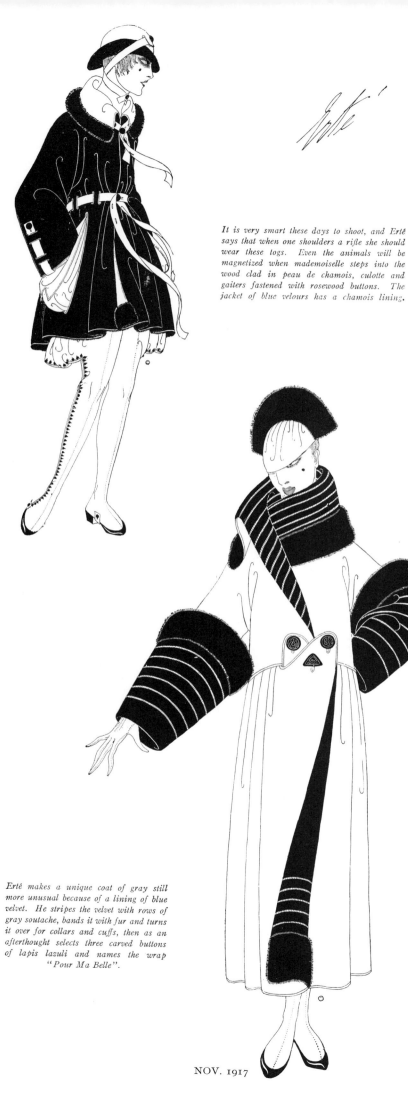

It is very smart these days to shoot, and Erté says that when one shoulders a rifle she should wear these togs. Even the animals will be magnetized when mademoiselle steps into the wood clad in peau de chamois, culotte and gaiters fastened with rosewood buttons. The jacket of blue velours has a chamois lining.

The imagination of Erté sought the practical when he designed a motor coat of green duvetyn and lined it with leopard fur. He made it so as to protect the frock from even a grain of dust. It is quite closed, except where the feet step through or the hands or fingers appear, therefore Erté names it "Vision Fugitive".

Erté makes a unique coat of gray still more unusual because of a lining of blue velvet. He stripes the velvet with rows of gray soutache, bands it with fur and turns it over for collars and cuffs, then as an afterthought selects three carved buttons of lapis lazuli and names the wrap "Pour Ma Belle".

NOV. 1917

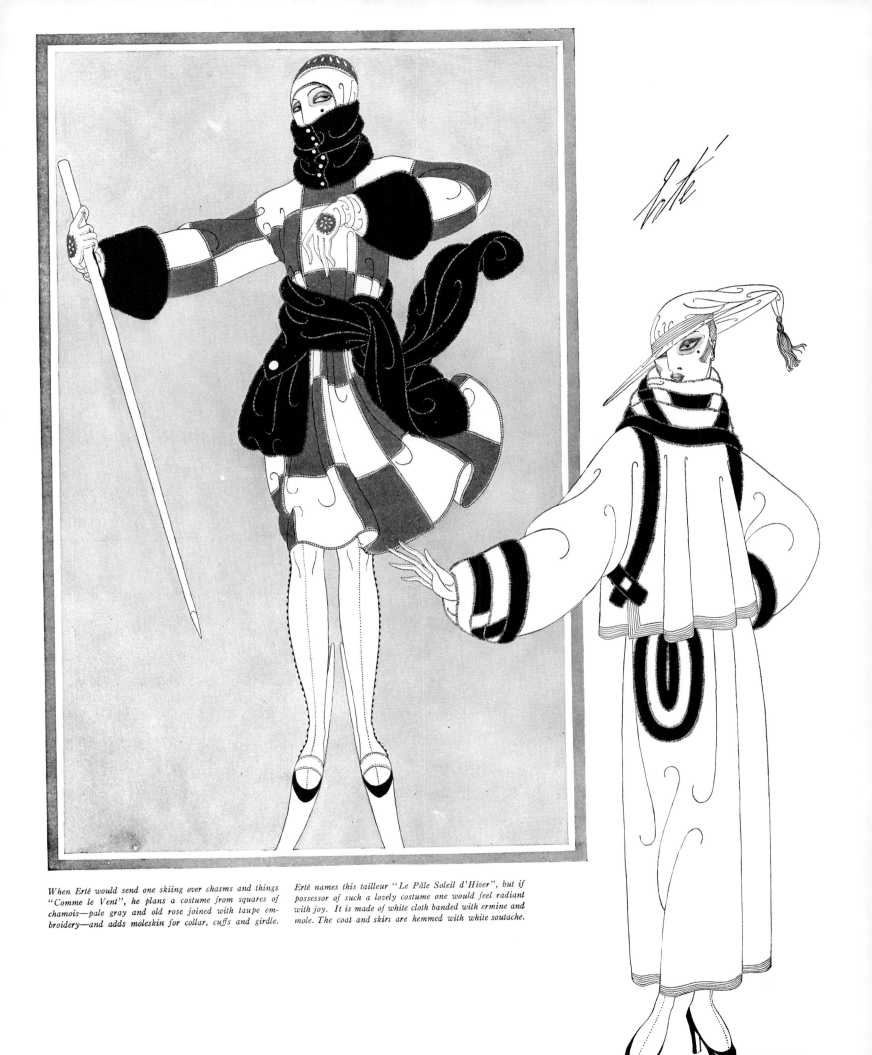

When Erté would send one skiing over chasms and things "Comme le Vent", he plans a costume from squares of chamois—pale gray and old rose joined with taupe embroidery—and adds moleskin for collar, cuffs and girdle.

Erté names this tailleur "Le Pâle Soleil d'Hiver", but if possessor of such a lovely costume one would feel radiant with joy. It is made of white cloth banded with ermine and mole. The coat and skirt are hemmed with white soutache.

DEC. 1917

31

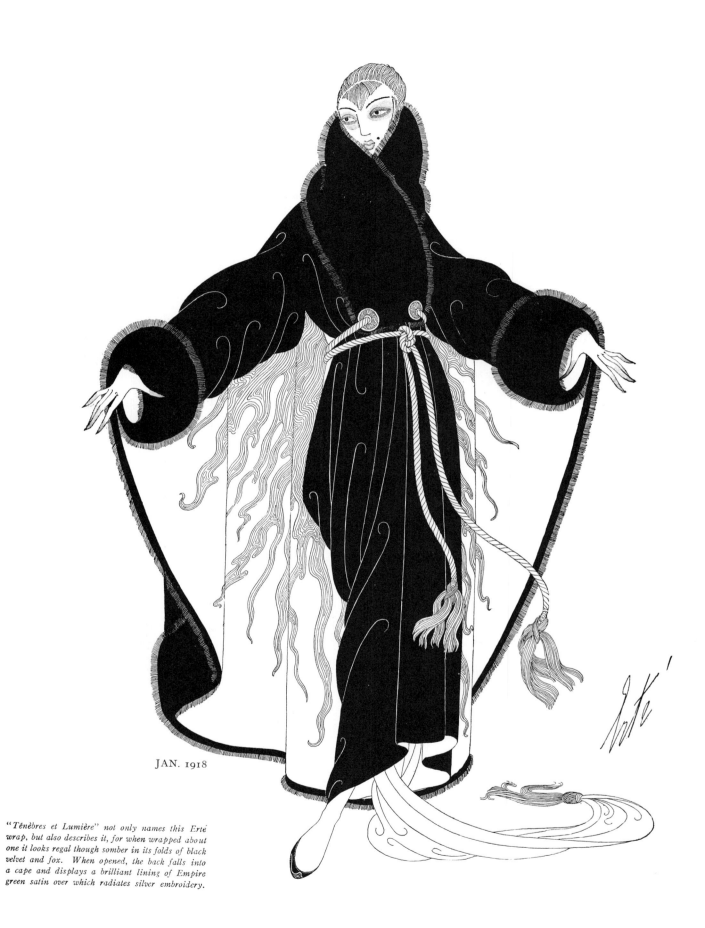

JAN. 1918

"Ténèbres et Lumière" not only names this Erté *wrap, but also describes it, for when wrapped about one it looks regal though somber in its folds of black velvet and fox. When opened, the back falls into a cape and displays a brilliant lining of Empire green satin over which radiates silver embroidery.*

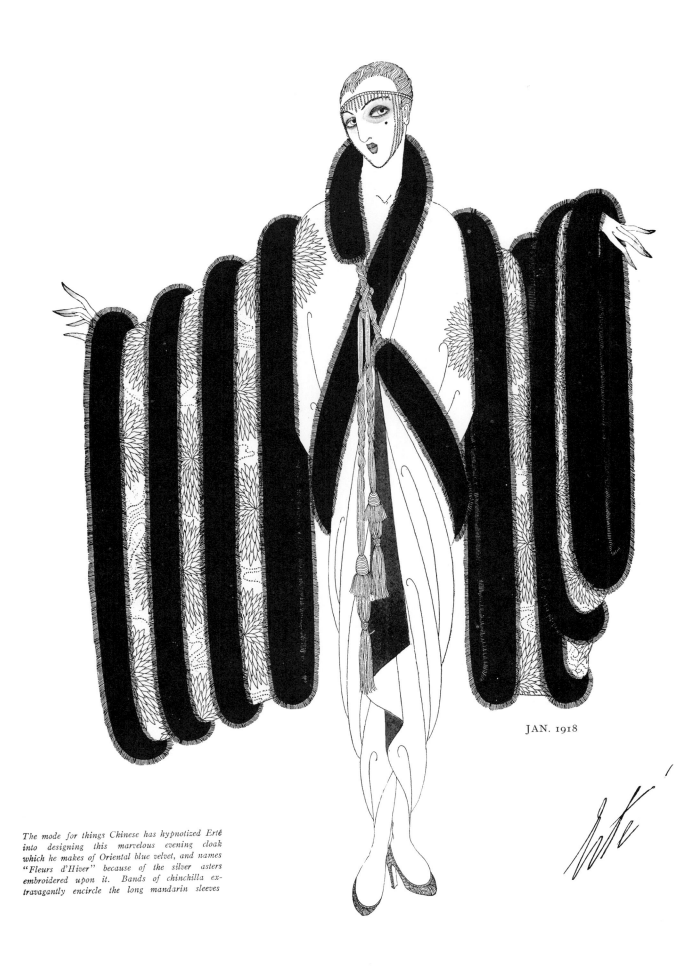

JAN. 1918

The mode for things Chinese has hypnotized Erté
into designing this marvelous evening cloak
which he makes of Oriental blue velvet, and names
"Fleurs d'Hiver" because of the silver asters
embroidered upon it. Bands of chinchilla ex-
travagantly encircle the long mandarin sleeves

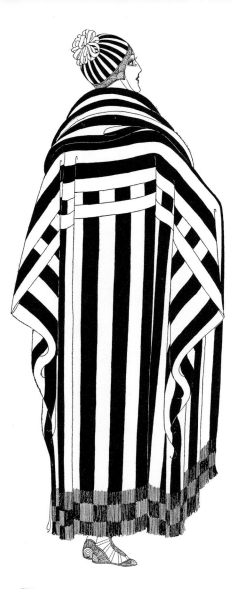

When she would recline upon Southern sands, Miss 1918 would do well to copy this bathing cape of black and white silk. The cap is made of ribbons with ends knotted into a pompon.

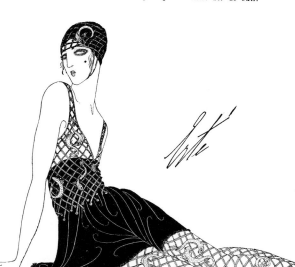

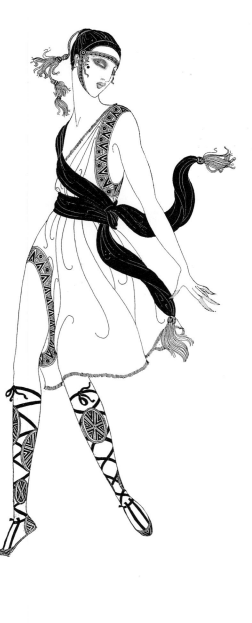

When "La Fille de Neptune" takes a dive at sunrise, she dons a swimming suit of white silk on which blue rings are appliqued. Her embroidered cap and shoes may be adapted to meet the whim of the most demure of earthly damsels.

The sea should fairly billow with enjoyment when "La Caresse des Flots" nestles within its foam. Erté designed this costume from citron taffeta embroidered at the edges, and finished it with an old blue sash of tricot de soie.

"La Pêche Miraculeuse" Erté calls this maiden, and verily he names her rightly, for it is no mean accomplishment to catch gold fish in the meshes of the black woven net of a bathing costume. Perhaps the orange cap and skirt act as bait.

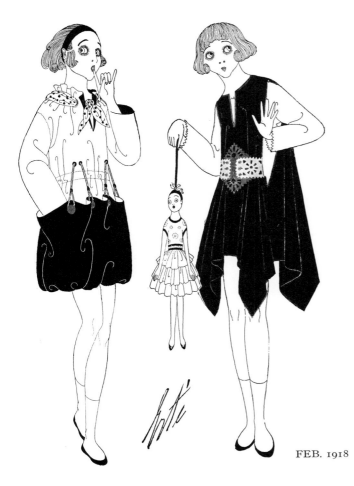

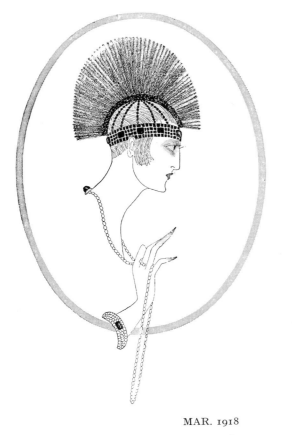

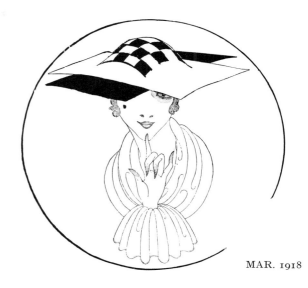

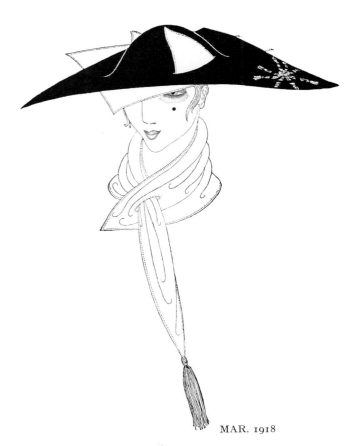

Hush!—Jeannette, did you hear what the lady said? That she adored my orange tie with its blue dots and the orange cords that fasten my gray skirt to my steel blue blouse. She said, too, that she liked silk gabardine for a child's dress.

Yes, but Hélène you didn't listen long enough, for she spoke of me and thought my frock much more unusual. She even noticed it was just a square of green velvet piped in myrtle cloth, and hung over a white cloth slip—so there!

FEB. 1918

MAR. 1918

Very clever is Erté's idea for a springtime hat that can be easily copied. Two rectangles of straw are placed one over the other and, after being cut, are interlaced to form a latticed crown.

MAR. 1918

Even Erté falls victim to the fascination of height in the evening coiffure and creates a head-dress of aigrettes that stand in stiff array upon a cap of jade beads. He rightly calls it L'Inspiration.

MAR. 1918

From two triangles of straw Erté evolves a becoming hat. One triangle is white and the other embroidered taupe. Two angles of the white triangle run through slits in the taupe one.

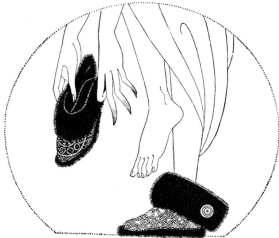

Erté was in a reckless mood when he selected chinchilla to band and line boudoir slippers. Yet one appreciates so helpful a suggestion as the "cuff" that buttons to fit the ankle.

APR. 1918

The genius of Erté shines forth in the golden bird that he embroiders upon dull gold net to make the train of a satin frock. To emphasize originality he hangs it from the arm caught onto bracelets.

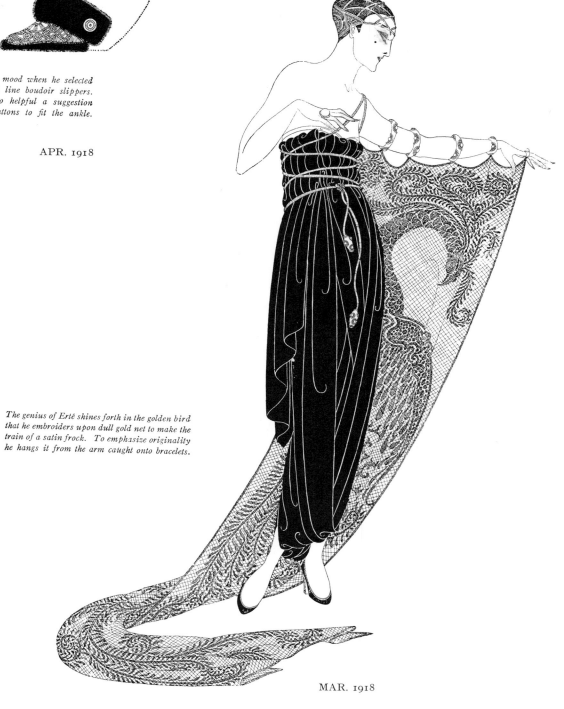

MAR. 1918

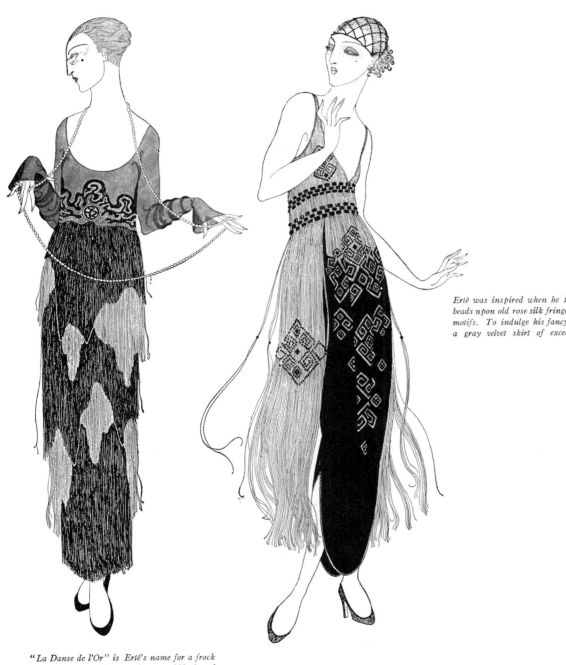

Not always will a woman find her hair, when coiffed, a crowning glory, but ever will she find her boudoir cap a glorifying crown, especially when Erté designs it of organdie.

APR. 1918

Erté was inspired when he threaded gray jade beads upon old rose silk fringe to form a belt and motifs. To indulge his fancy further, he made a gray velvet skirt of exceeding narrowness.

"La Danse de l'Or" is Erté's name for a frock that is sumptuous in every flounce of black and gold fringe, and also in the embroidery of black and gold that is worked on the long-sleeved bodice.

MAR. 1918

37

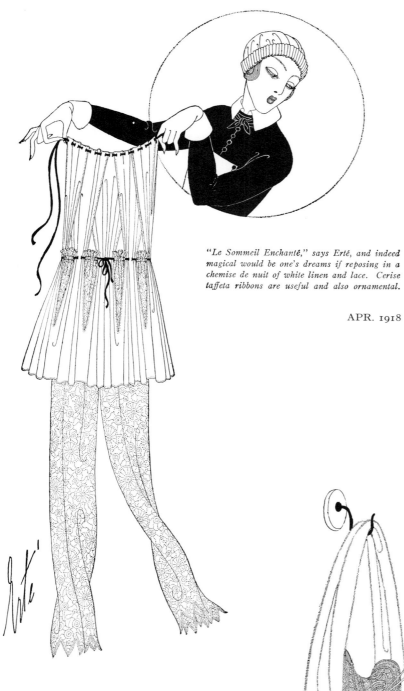

"*Le Sommeil Enchanté,*" says Erté, and indeed magical would be one's dreams if reposing in a chemise de nuit of white linen and lace. Cerise taffeta ribbons are useful and also ornamental.

APR. 1918

Even knitting bags incline to the fad of summer *fur*, and this one is ermine combined with woven *silks* of varied hues, while the needles are carved *ivory*.

MAY 1918

Erté brings happiness to her who would indulge in originality, when she dons his sports suit of light gray Jersey cloth that is embroidered in old rose yarn. Carved ivory dangles end each tassel.

APR. 1918

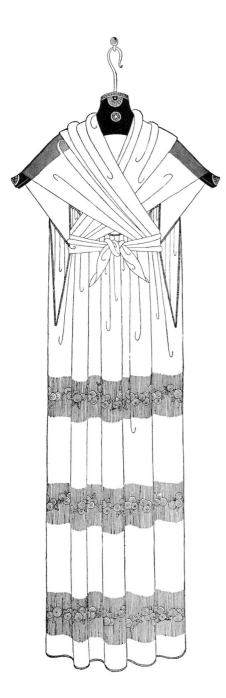

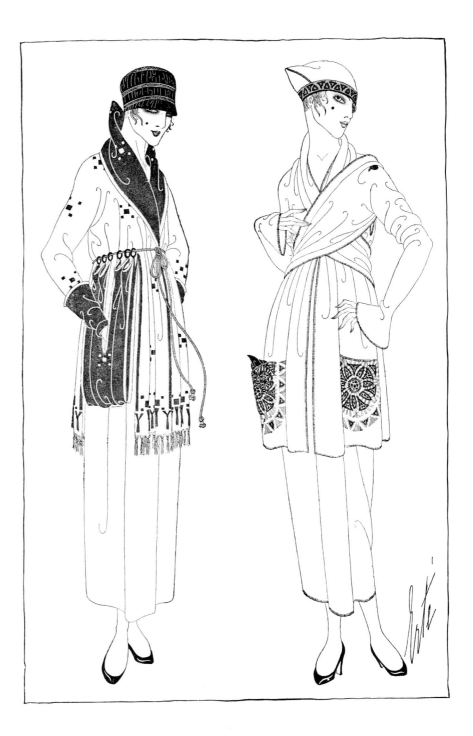

If you are of conservative inclination, this night-robe of white linen will surely meet your fancy. The fichu *is* quaintly feminine, and exquisite bands of embroidery portray daintiness in every rosebud.

APR. 1918

"La Gaieté" Erté calls this sweater, and who would not feel in a happy spirit if owning it, for orange tricot is faced with gray that shows when turned up to form pockets.

To achieve the slimness that is a decree of the mode, one should copy this Erté sweater of white silk that is artistic in its surplice drapery and in black and green embroidery.

MAY 1918

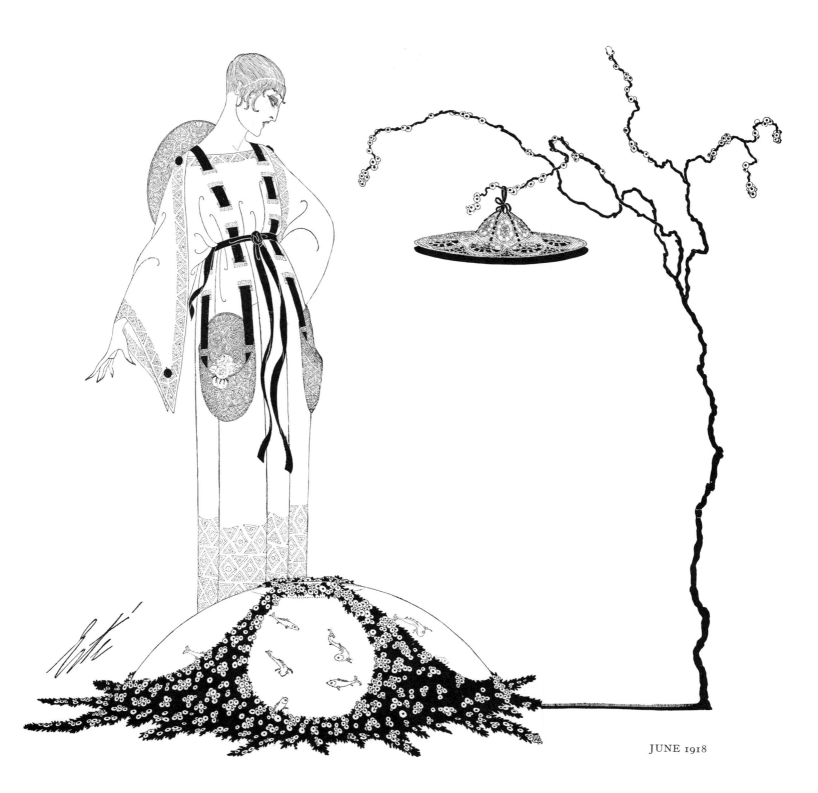

JUNE 1918

Erté christens this garden frock "Vive la
Nature!" and embroiders the natural pongee
with silks of many hues. When tired of the
hat one may casually drop it behind—it will
not fall, as the ribbons are not only laced through
the dress, but also through the straw pockets.
Upon the bough hangs a garden hat of white
straw, with an underbrim of cerise straw held
in place by ribbons laced through the crown.

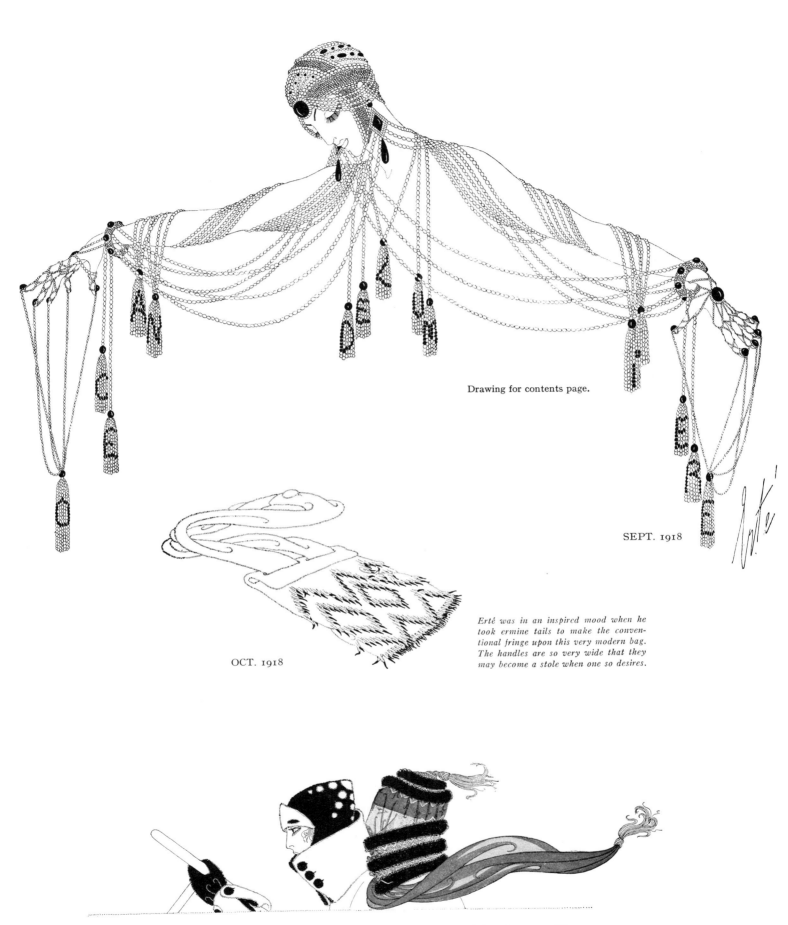

Drawing for contents page.

SEPT. 1918

OCT. 1918

Erté was in an inspired mood when he took ermine tails to make the conventional fringe upon this very modern bag. The handles are so very wide that they may become a stole when one so desires.

As the car goes whizzing by, one glimpses and admires the newest things in motor head-gear—a fur cap, inlaid with ermine, that turns back to form a warm collarette, and a fez of velvet banded with fur and Oriental embroidery that has a collar to match, into which the chiffon veil is gathered.

OCT. 1918

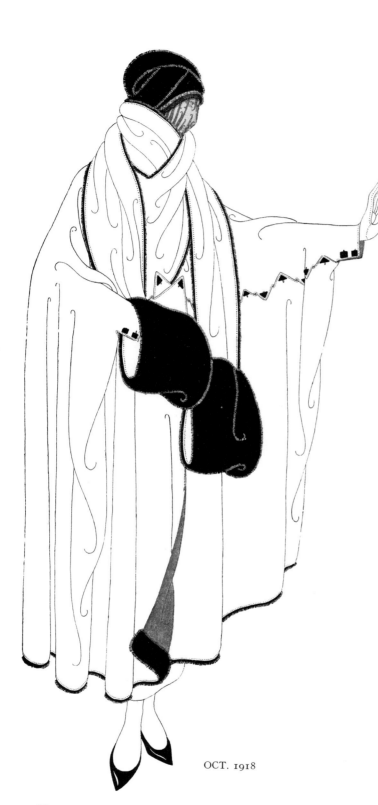

OCT. 1918

When you would a-motoring go, don an Erté coat
of russet duvetyn, lined with brown velvet and
edged with fur fringe. The stole, cut in one with
the coat, muffles snugly about the throat, while
the ends turn back to masquerade as a muff.

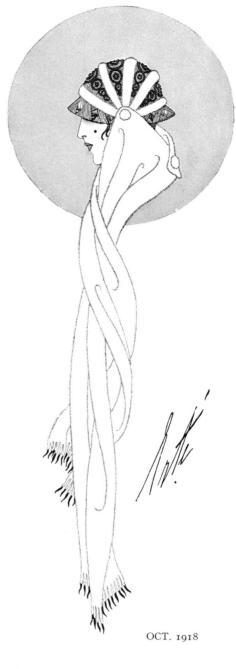

OCT. 1918

Upon white woven threads of silk, Erté applies
bands of ermine to make a hat that he embroiders
in black. Buttoned to either side is a straight
ermine scarf that is fastened at the back of the
neck with another button and so becomes a stole.

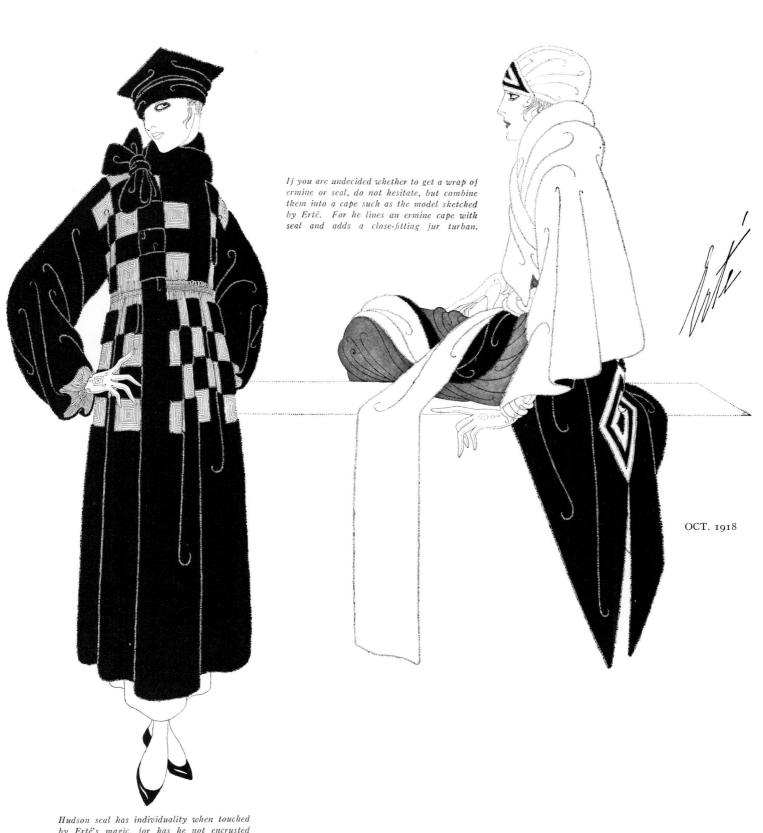

If you are undecided whether to get a wrap of ermine or seal, do not hesitate, but combine them into a cape such as the model sketched by Erté. For he lines an ermine cape with seal and adds a close-fitting fur turban.

OCT. 1918

Hudson seal has individuality when touched by Erté's magic, for has he not encrusted motifs of braid to make a design of novelty? A ribbon of the fur ties in a bow at the neck, with one end running through eyelets.

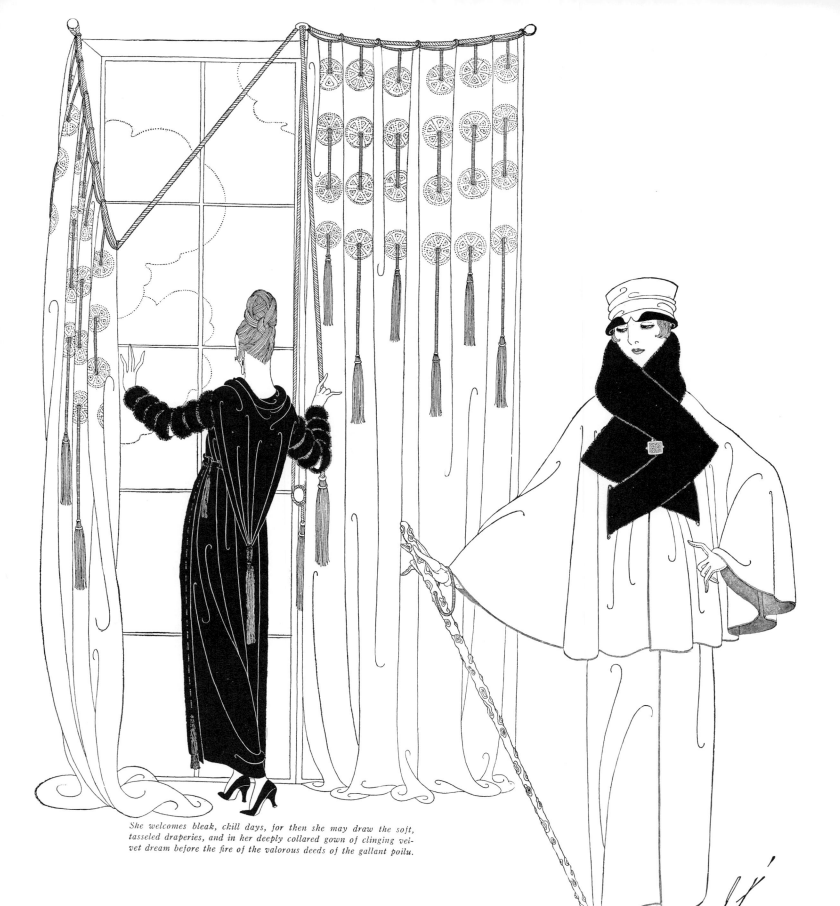

She welcomes bleak, chill days, for then she may draw the soft, tasseled draperies, and in her deeply collared gown of clinging velvet dream before the fire of the valorous deeds of the gallant poilu.

These are days when one is apt to hurry from one thing to another, and for just such busy times Erté has created this tailleur, which he calls "Une Promeneuse". It is of gray duvetyn, faced with chestnut brown, and the beaver collar crosses to form a girdle in the back. Of Chinese inspiration is the carved jade button.

NOV. 1918

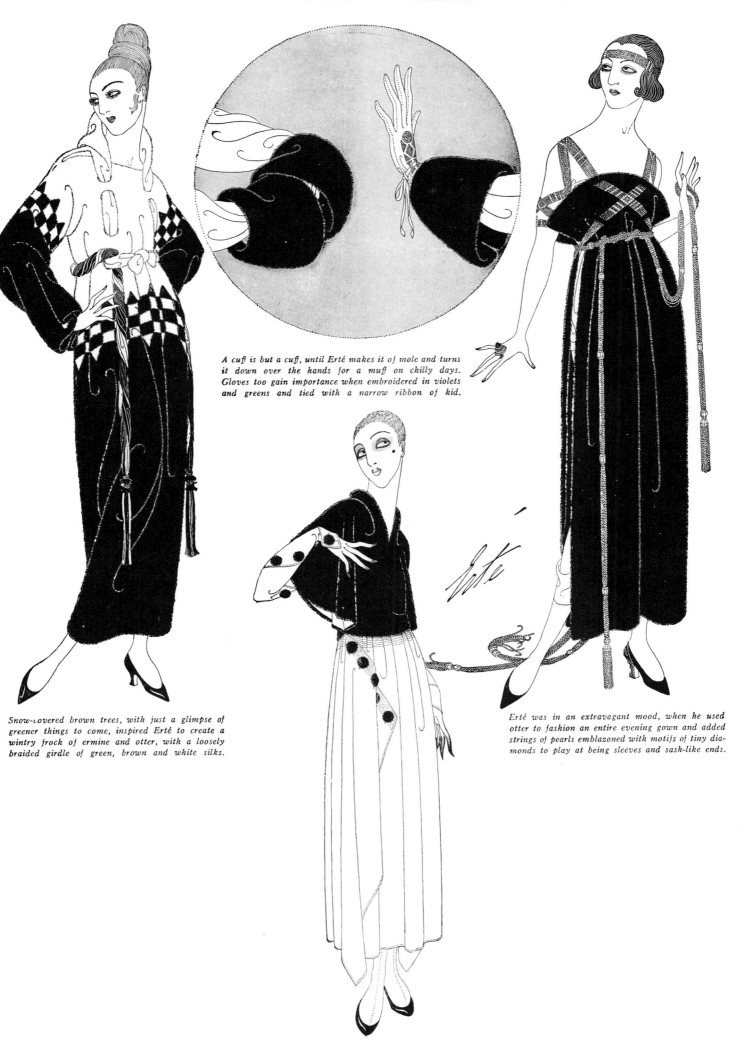

A cuff is but a cuff, until Erté makes it of mole and turns it down over the hands for a muff on chilly days. Gloves too gain importance when embroidered in violets and greens and tied with a narrow ribbon of kid.

Snow-covered brown trees, with just a glimpse of greener things to come, inspired Erté to create a wintry frock of ermine and otter, with a loosely braided girdle of green, brown and white silks.

Erté was in an extravagant mood, when he used otter to fashion an entire evening gown and added strings of pearls emblazoned with motifs of tiny diamonds to play at being sleeves and sash-like ends.

Very youthful is this frock of duvetyn with its buttons and gaily swinging cape of moleskin that slips on over the head and fastens at the waist.

DEC. 1918

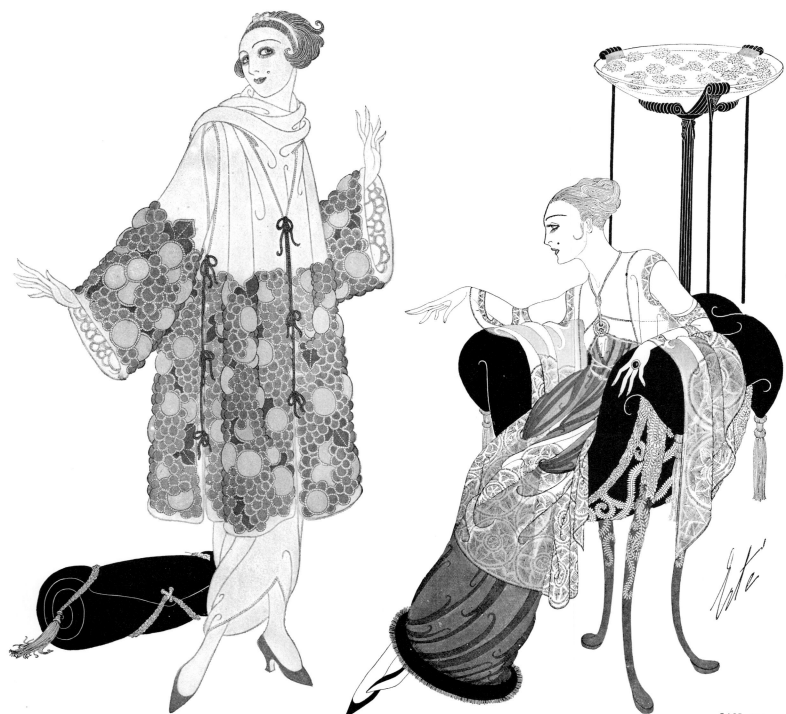

JAN. 1919

An excuse par excellence for idleness even in
these crowded days is a lounging robe of pearl-
gray satin with deep sleeves and swathing collar,
and satin fruits padded in colorful array upon
its surface. Then Erté has made a queer rolled
cushion of soft black velours and tied it with gold
tasseled cords to tempt further milady to dream.

That so many clever things can all happen to one
gown is one of the delightful mysteries of Erté's
creations, and unique indeed is his dinner gown
of black and white mousseline with its banding
of black fox. The tea-table is glass, upon a
sculptured iron stand, while in the water under
its transparent surface float fragile water-lilies.

With tiny ivory buttons to fasten it at the sleeves and waist and soft white crêpe de Chine to make it, a blouse could not help but be dainty. But when Erté creates it, it is bound also to be "different".

ERTÉ GIVES TO EVERY WOMAN AN INDIVIDUALITY

"Celle que j'aime"—most appropriately named by the way—is of four pieces of chamois-colored duvetyn faced with raven-blue satin. And Erté, lover of the unusual, tucks the side panels under the girdle of braided green and silver silks to form the deep, monk-like sleeves.

If your modiste is clever, she will slash the bodice and sleeves of your pale gray cloth frock and interlace the strips. Of course all the edges must be embroidered with old rose and blue silks to match the silken girdle, while the all-important buttons are lapis lazuli.

FEB. 1919

To accord with his hat of rose and black and white crêpe de Chine, Erté laces three lengths of the soft picot-edged material together with embroidered ribbon to make a graceful scarf.

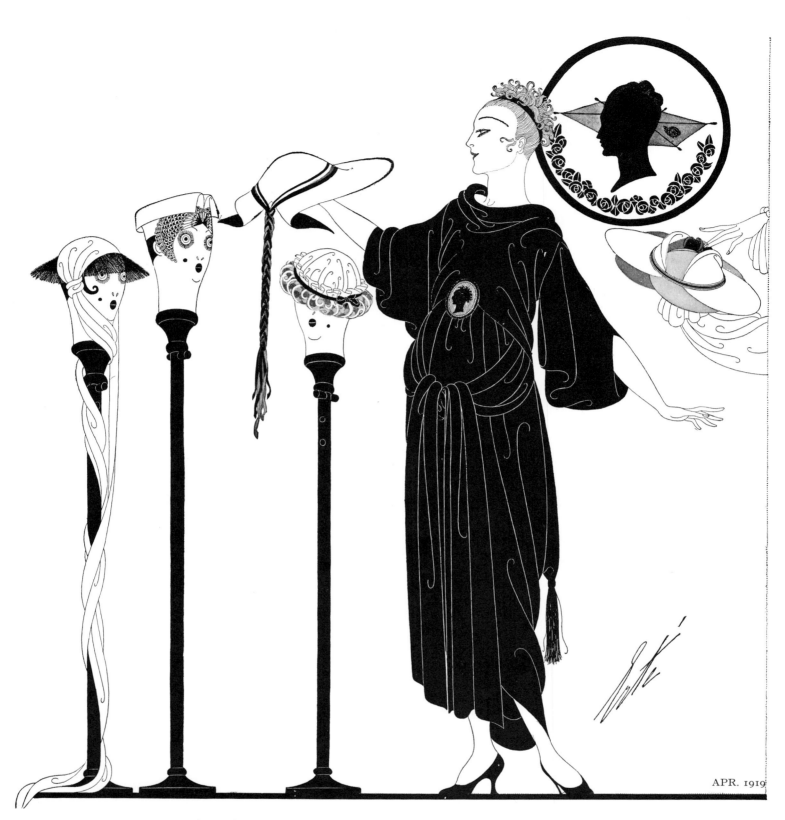

APR. 1919

An amusing conceit indeed to embroider the silhouette of one's head and wear it proudly on the bodice of an afternoon frock! Erté makes the gown of black satin, drapes it with much art and adds a long silken tassel. Quite diverting is the hat madame holds, for it is of white Tagal faced with black velours, and it braids its green, black and white ribbons in a neat queue down the back. At the extreme left, there is a long swathing green scarf that is knotted over the ears and edged with feathery black aigrettes to make a hat. The one next to it is but a rectangle of black Tagal, trimmed Egyptian fashion with a motif of tiny feathers.

Inspired perhaps by the beautifully draped turbans of the East is the one on the standard above at the right. Erté has created it from a circle of white tulle, turned back over a wreath of tiny roses in lovely pastel shades and tied firmly with a narrow black velvet ribbon. A hat that is lovely enough to have its portrait painted is the one above in the circle. Erté makes it of transparent black mousseline over a frame of delicate, carved ivory and ornaments it with a Chinese motif upon the brim. One would always credit Erté with the greatest originality, but he surpasses even himself when he creates the hat at the extreme right of the page of four circles of rose Tagal and bands it at the crown with rose ribbons.

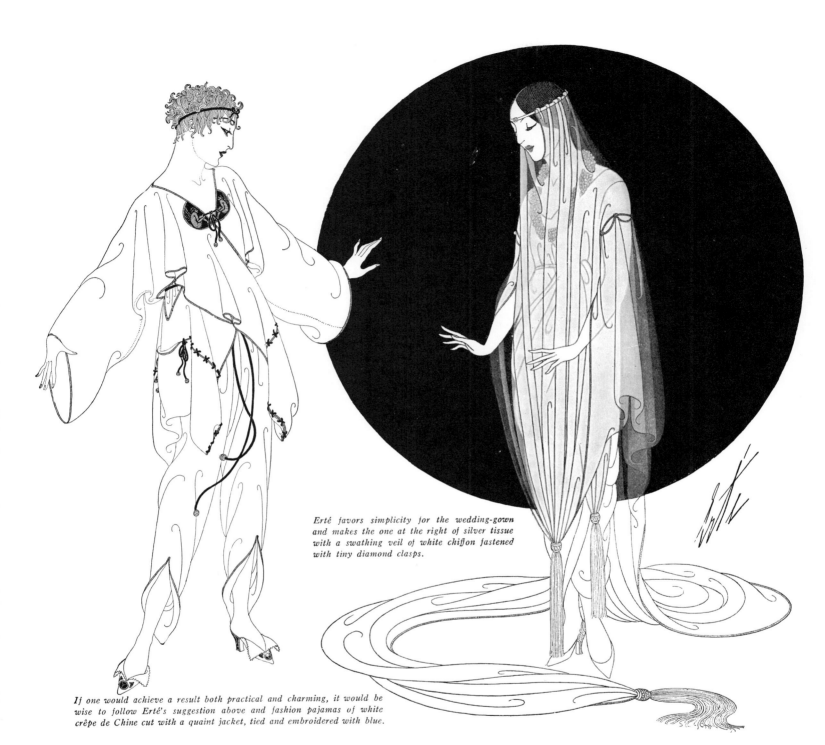

Erté favors simplicity for the wedding-gown and makes the one at the right of silver tissue with a swathing veil of white chiffon fastened with tiny diamond clasps.

If one would achieve a result both practical and charming, it would be wise to follow Erté's suggestion above and fashion pajamas of white crêpe de Chine cut with a quaint jacket, tied and embroidered with blue.

MAY 1919

49

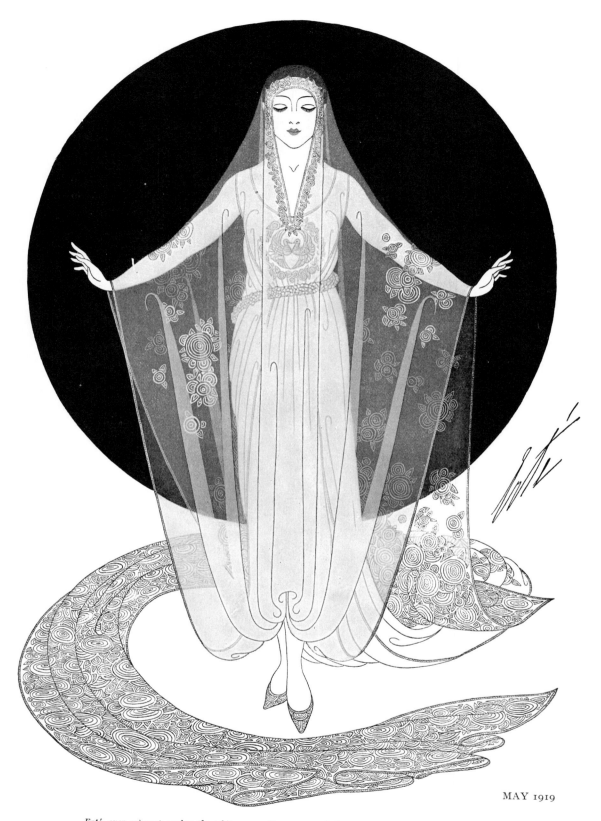

MAY 1919

Erté, ever original, makes the white mousseline gown and the veil above all in one by simply turning the front of the gown back over the head and allowing it to trail gracefully in the back, weighted by its silver embroidery.

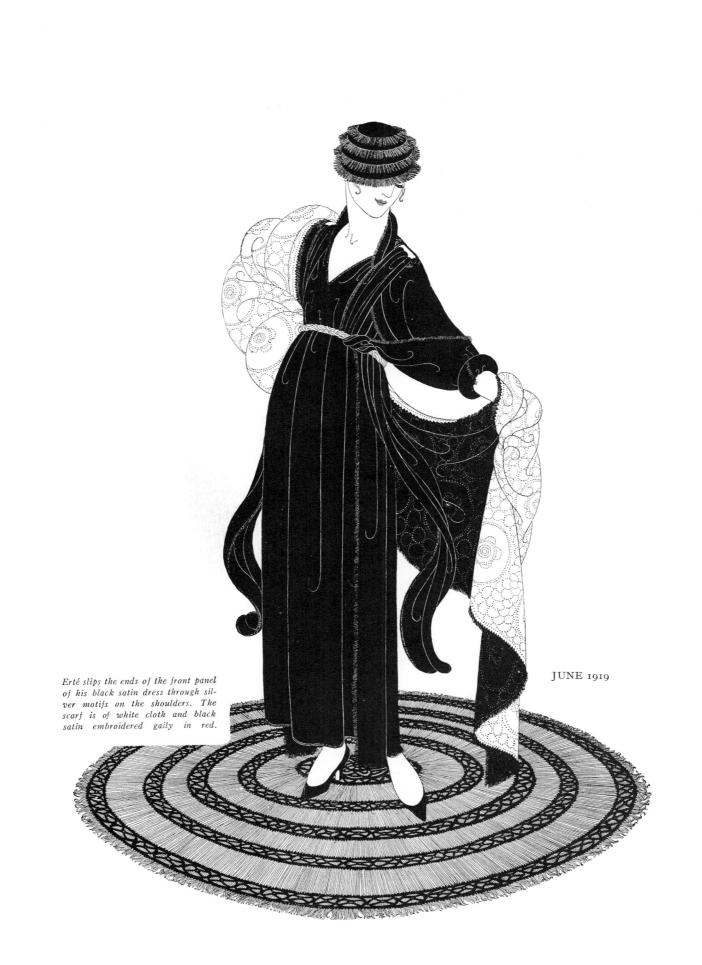

Erté slips the ends of the front panel of his black satin dress through silver motifs on the shoulders. The scarf is of white cloth and black satin embroidered gaily in red.

JUNE 1919

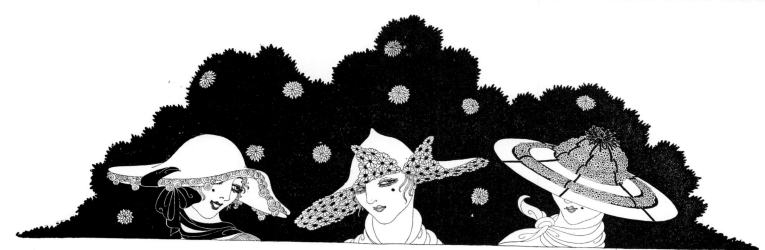

It was left for Erté to take a large leghorn hat, with a double brim, and fill it in with tiny roses, held together at one side by a broad black velvet ribbon.

It is quite the simplest thing in the world to turn at odd angles a huge cream-colored straw hat, face it with daisies, and give it no other trimming at all.

Four woven wreaths of yellow forget-me-nots, two circles of white straw and narrow green ribbons are all that is necessary for Erté to make a lovely hat.

JULY 1919

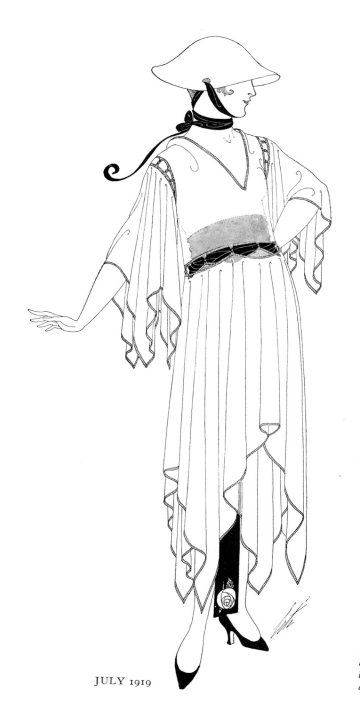

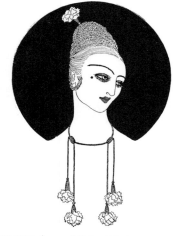

If your gown is exquisitely pink, be sure to slip a fresh carnation into the tiny platinum holders that Erté makes in the shape of a calyx, and fasten your tight braids with a platinum pin to match.

JULY 1919

JULY 1919

Two of the nicest things about the frock of white lawn at the left is its long rose-trimmed girdle of blue and the novel method of attaching the sleeves and skirt which is bound with blue embroidery.

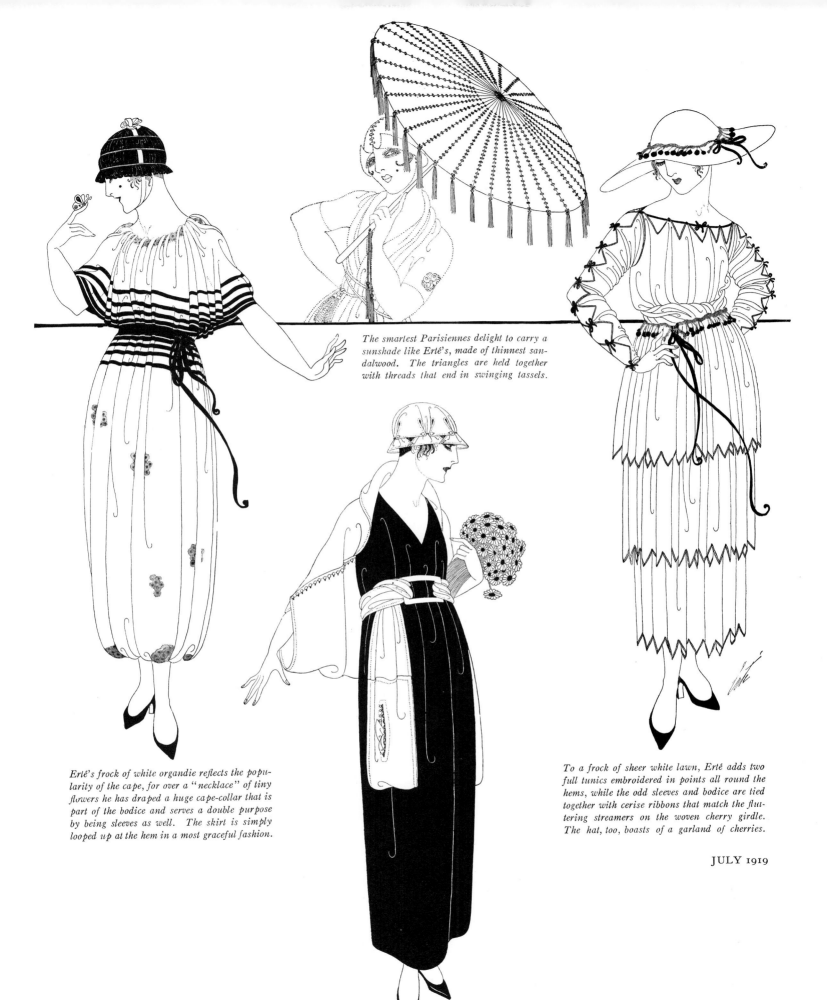

The smartest Parisiennes delight to carry a sunshade like Erté's, made of thinnest sandalwood. The triangles are held together with threads that end in swinging tassels.

Erté's frock of white organdie reflects the popularity of the cape, for over a "necklace" of tiny flowers he has draped a huge cape-collar that is part of the bodice and serves a double purpose by being sleeves as well. The skirt is simply looped up at the hem in a most graceful fashion.

To a frock of sheer white lawn, Erté adds two full tunics embroidered in points all round the hems, while the odd sleeves and bodice are tied together with cerise ribbons that match the fluttering streamers on the woven cherry girdle. The hat, too, boasts of a garland of cherries.

JULY 1919

Over a straight sleeveless slip of black satin, one wears a cape of sheer organdie that has a girdle to slip through an ivory buckle and end in a deep pocket. The tiny round buttons are made of ivory.

53

Erté believes in lighting the porch artistically and places gaily-hued, round lan-
terns of paper, which hold tiny electric bulbs, on a disk of carved iron. The
whole is suspended from heavy silk cords, tasseled on the ends. Of black straw
is the demure little bonnet above at the left, with its soft black aigrettes. Under
the silk cord net of the turban at the right, there are many pink satin roses,
securely held in place perhaps by the black velvet ribbon that binds the forehead.

AUG. 1919

The dullest of lessons would become fascinating if
one might study it in Erté's gray and green tricot.

Erté has made her frock of marron duvetyn, interwoven
with cream chamois to form the pockets and sleeves.

54

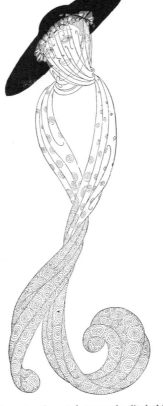

Even the largest and most dangerously tilted of becoming hats would remain secure when held in place by the scarf above. Erté makes it of chiffon and plaits it where it joins the hat.

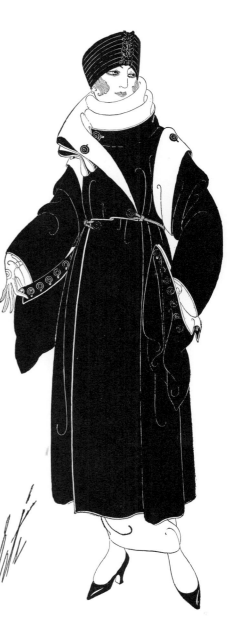

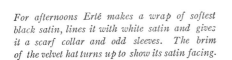

For afternoons Erté makes a wrap of softest black satin, lines it with white satin and gives it a scarf collar and odd sleeves. The brim of the velvet hat turns up to show its satin facing.

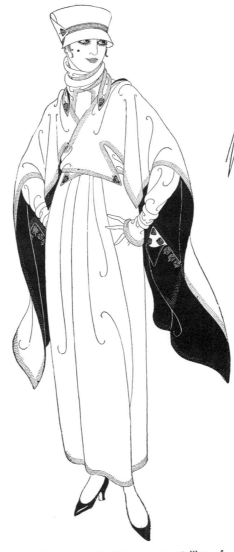

Taupe satin is always lovely, and especially so when it fashions a long wrap lined with banana-colored cloth. The huge pockets are held to the coat with the aid of a single large button.

AUG. 1919

For the first days of fall Erté suggests a tailleur of chamois cloth, faced with marron satin, and buttons the jacket surplice fashion across the front.

55

ERTÉ DEPLORES THE FOLLIES OF FASHION AND PRAISES THE ART EXHIBITIONS IN PARIS SALONS

Erté needs but two lengths of coral crêpe de Chine to make the peignoir at the left—one piece making the corsage and sleeves, the other the skirt. All the edges are embroidered in gray, while silver tassels complete the metallic motifs at the ends of the sleeves.

Could there be anything more dainty than Erté's pajama-like night-robe at the left? It is fashioned of the softest yellow chiffon and bound in silver. The girdle is of silver and yellow threads, tasseled at the ends. To accompany it there is a bewitching little cap of chiffon bordered with a band of embroidered flowers in mauve, blue and pale green.

A blouse that is entirely fashioned of white soutache braid is a pleasing and practical novelty indeed. Erté gives the one at the left the quaintest sort of cuffs and cuts the collar off quite abruptly. Instead of buttons, there is a soutache ribbon that is laced down the front of the blouse to hold it.

Erté calls his tea gown at the left "A Cinq Heures," which is indeed appropriate. He makes it of taupe satin with a long train that prefers to wind itself about the wearer's waist for a girdle and to end in a long silken tassel. The filmy scarf is of chiffon, held at the wrists by a bracelet of fur and weighted at each end by an intricate design worked in soft brown moleskin.

One would be wise indeed to follow Erté's suggestion at the right for one's fall suit. He makes it of dark blue velours and gives the jacket a most attractive cape in the back that hangs gracefully long and rippling, like the small sketch at the lower left of the opposite page. The trimming and lining of the little jacket are white soutache, to match the snug little turban.

One of the most ravishing evening wraps that Erté has ever created is the one below of black velvet, lined with gleaming silver tissue. The huge enveloping collar and the band that trims the back and makes shawl-like sleeves are of soft chinchilla, with silver motifs.

SEPT. 1919

To accompany the suit at the top of the page, there is an interesting handbag below that will find room in its spaciousness for all the delightful accessories to beauty its possessor will need. It is of the dark blue velours and made upon an ivory frame.

Erté extravagantly uses blue aigrettes to make the exquisite fan below, and mounts them on a hand-chiseled silver frame. Of course one may have the sprays of aigrettes to match one's gown, and repeat the color in a jewel in the bottom of the frame.

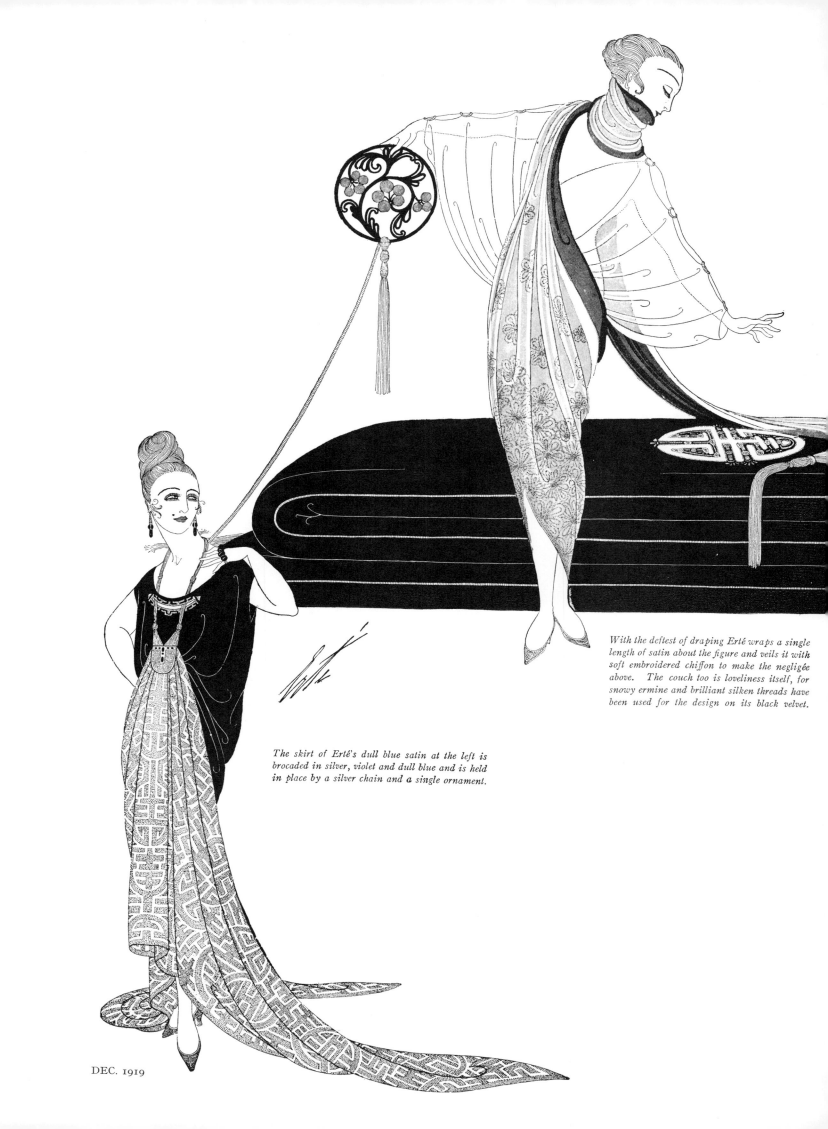

With the deftest of draping Erté wraps a single length of satin about the figure and veils it with soft embroidered chiffon to make the negligée above. The couch too is loveliness itself, for snowy ermine and brilliant silken threads have been used for the design on its black velvet.

The skirt of Erté's dull blue satin at the left is brocaded in silver, violet and dull blue and is held in place by a silver chain and a single ornament.

DEC. 1919

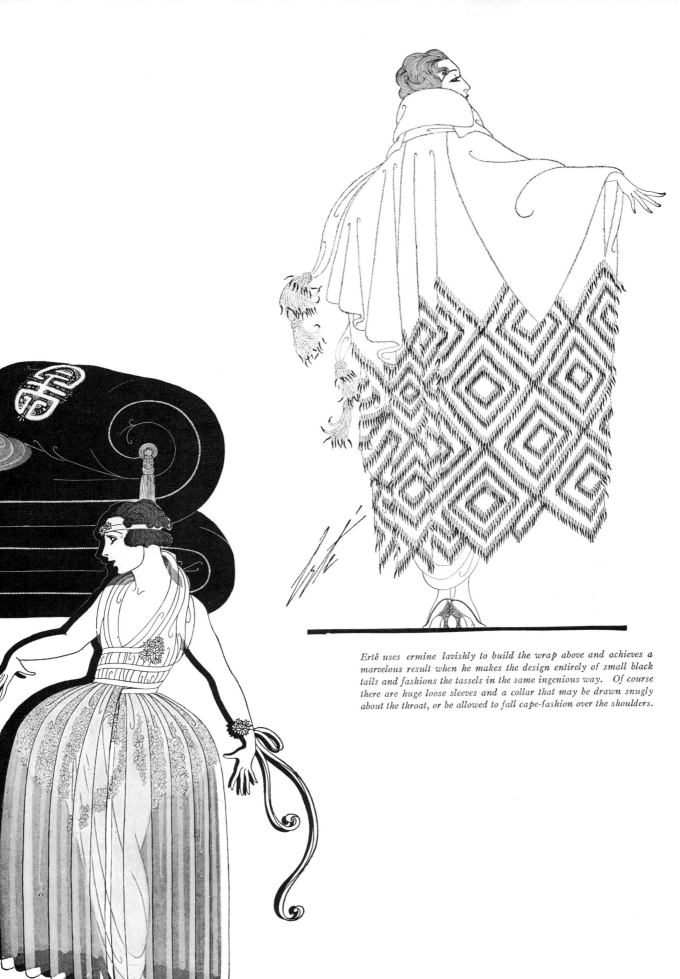

Erté uses ermine lavishly to build the wrap above and achieves a
marvelous result when he makes the design entirely of small black
tails and fashions the tassels in the same ingenious way. Of course
there are huge loose sleeves and a collar that may be drawn snugly
about the throat, or be allowed to fall cape-fashion over the shoulders.

One could not help but dance, and, dancing, could not help
but enjoy it, if one were to wear Erté's youthful gown above
of sheer white tulle. Beneath the filmy tulle there are large
paniers of exquisite mauve flowers upon a slip of palest yel-
low satin, and narrow yellow ribbons flutter about adorably.

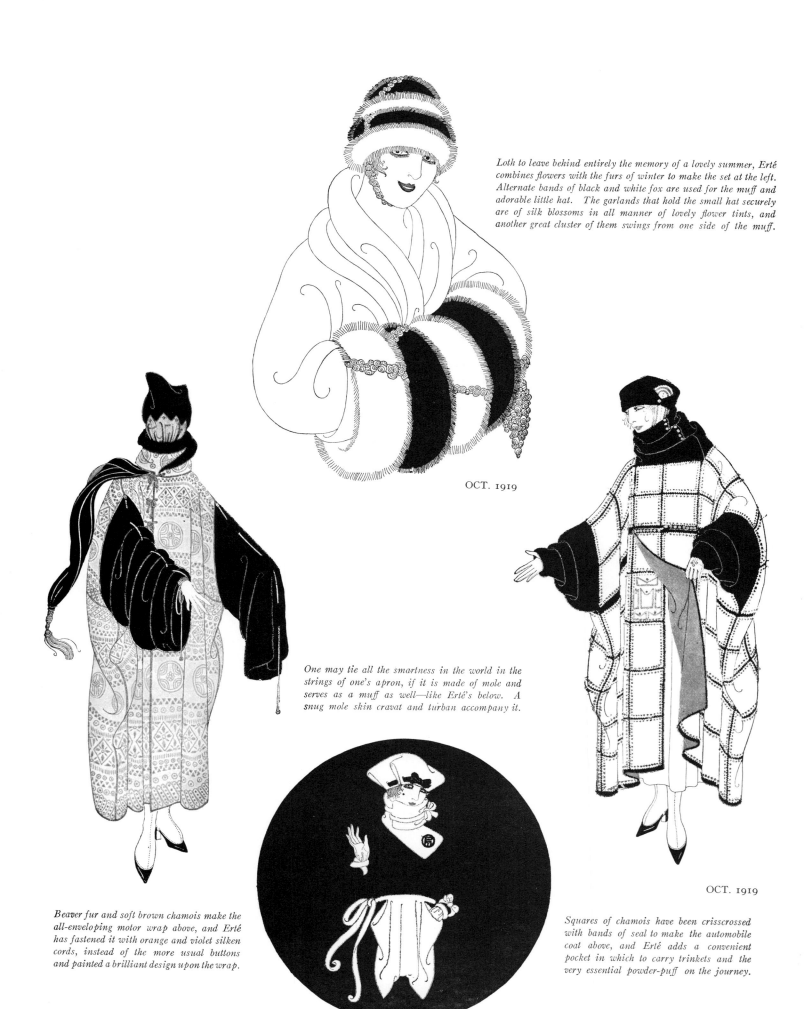

Loth to leave behind entirely the memory of a lovely summer, Erté combines flowers with the furs of winter to make the set at the left. Alternate bands of black and white fox are used for the muff and adorable little hat. The garlands that hold the small hat securely are of silk blossoms in all manner of lovely flower tints, and another great cluster of them swings from one side of the muff.

OCT. 1919

One may tie all the smartness in the world in the strings of one's apron, if it is made of mole and serves as a muff as well—like Erté's below. A snug mole skin cravat and turban accompany it.

OCT. 1919

Beaver fur and soft brown chamois make the all-enveloping motor wrap above, and Erté has fastened it with orange and violet silken cords, instead of the more usual buttons and painted a brilliant design upon the wrap.

Squares of chamois have been crisscrossed with bands of seal to make the automobile coat above, and Erté adds a convenient pocket in which to carry trinkets and the very essential powder-puff on the journey.

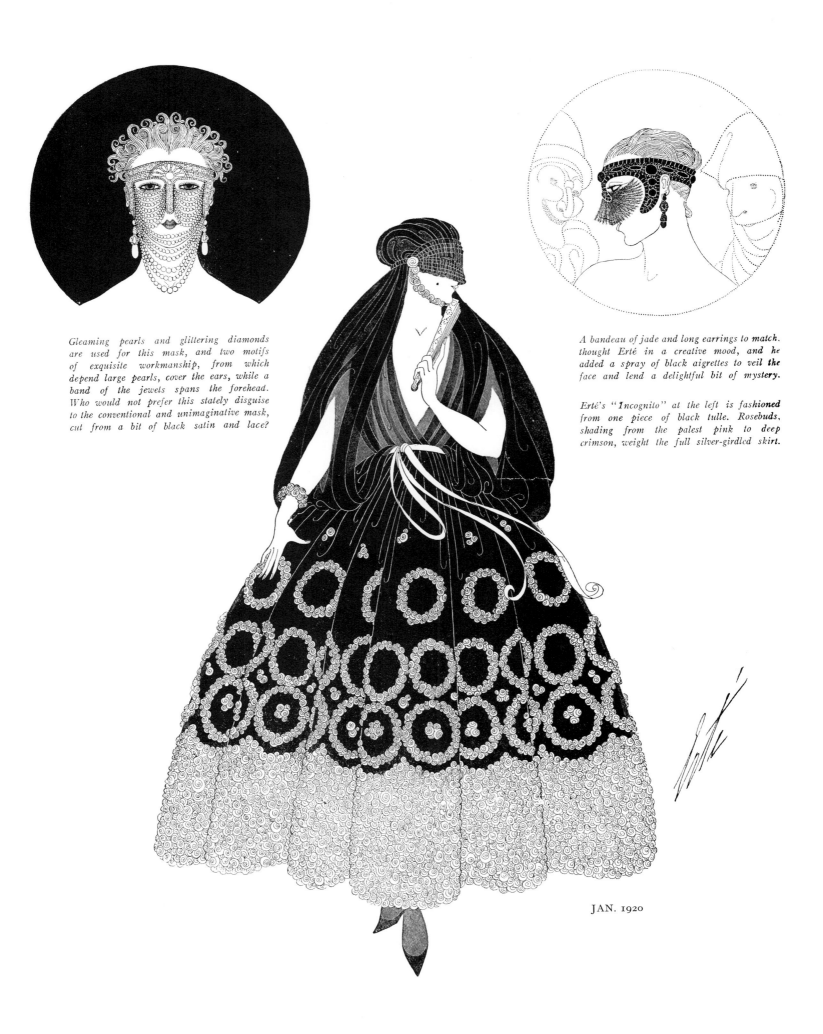

Gleaming pearls and glittering diamonds are used for this mask, and two motifs of exquisite workmanship, from which depend large pearls, cover the ears, while a band of the jewels spans the forehead. Who would not prefer this stately disguise to the conventional and unimaginative mask, cut from a bit of black satin and lace?

A bandeau of jade and long earrings to match, thought Erté in a creative mood, and he added a spray of black aigrettes to veil the face and lend a delightful bit of mystery.

Erté's "Incognito" at the left is fashioned from one piece of black tulle. Rosebuds, shading from the palest pink to deep crimson, weight the full silver-girdled skirt.

JAN. 1920

61

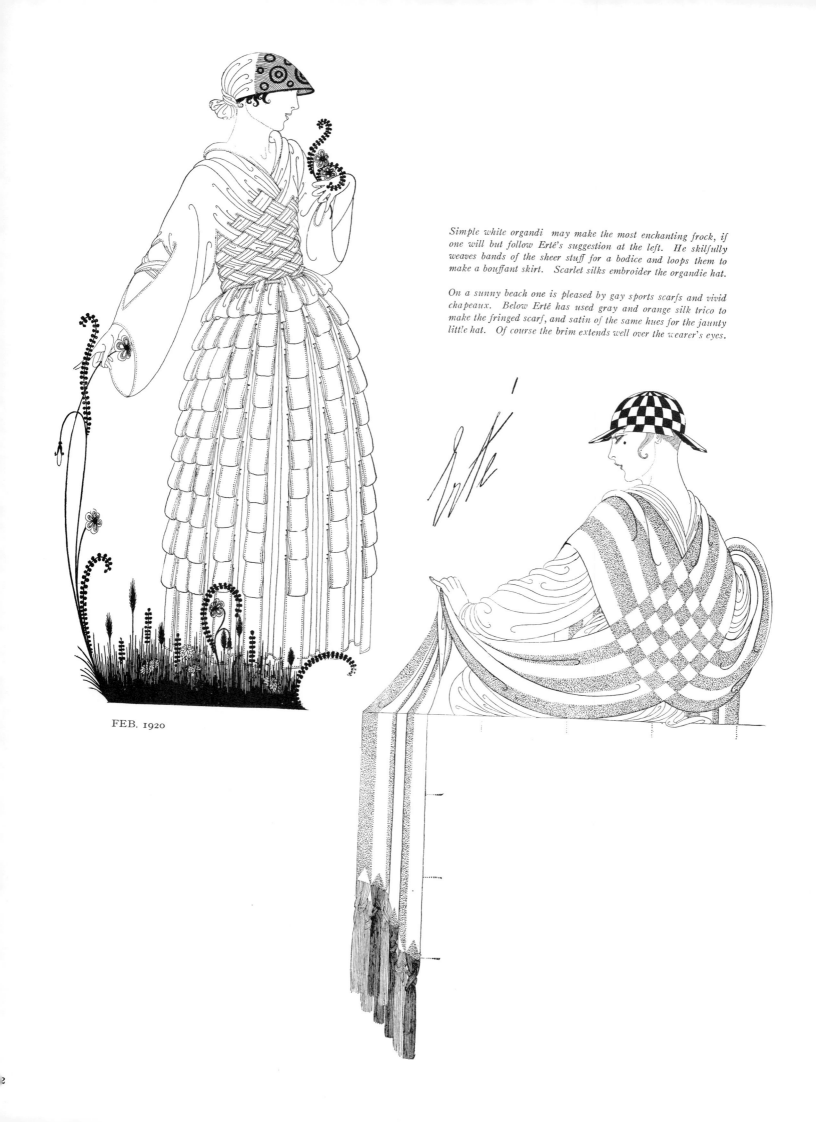

Simple white organdi may make the most enchanting frock, if one will but follow Erté's suggestion at the left. He skilfully weaves bands of the sheer stuff for a bodice and loops them to make a bouffant skirt. Scarlet silks embroider the organdie hat.

On a sunny beach one is pleased by gay sports scarfs and vivid chapeaux. Below Erté has used gray and orange silk trico to make the fringed scarf, and satin of the same hues for the jaunty little hat. Of course the brim extends well over the wearer's eyes.

FEB. 1920

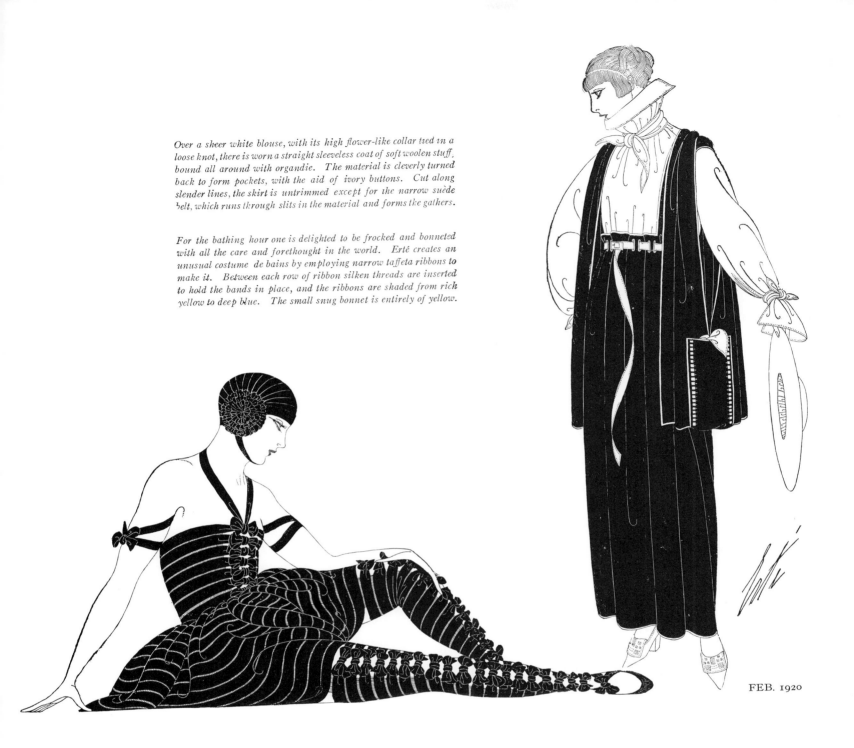

Over a sheer white blouse, with its high flower-like collar tied in a loose knot, there is worn a straight sleeveless coat of soft woolen stuff, bound all around with organdie. The material is cleverly turned back to form pockets, with the aid of ivory buttons. Cut along slender lines, the skirt is untrimmed except for the narrow suède belt, which runs through slits in the material and forms the gathers.

For the bathing hour one is delighted to be frocked and bonneted with all the care and forethought in the world. Erté creates an unusual costume de bains by employing narrow taffeta ribbons to make it. Between each row of ribbon silken threads are inserted to hold the bands in place, and the ribbons are shaded from rich yellow to deep blue. The small snug bonnet is entirely of yellow.

FEB. 1920

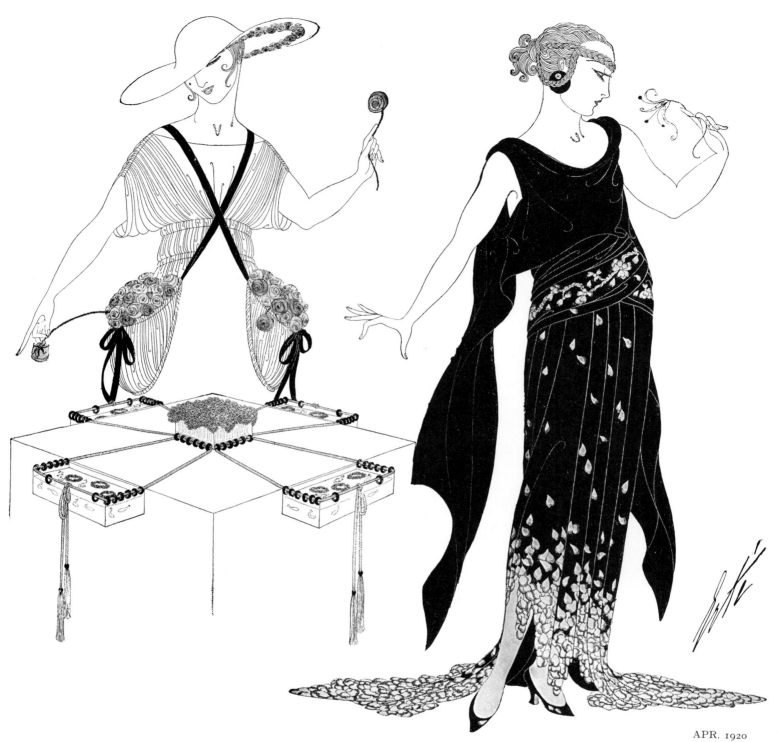

APR. 1920

Erté's garden apron is made of crêpe de Chine
with black velvet ribbons to hold it over the
shoulders and huge plaited pockets for flowers.
To wear with it, there is a broad flower-
faced straw chapeau of graceful shape.

Over a pedestal of white marble, Erté crosses
silken cords from which hang small glass aqua-
riums. In the water goldfish swim about, and
floating upon the surface are forget-me-nots.
Altogether this is a most novel garden feature.

Truly a flower gown is the one above, for it
has been made entirely of rose satin and its
irregular hem and sweeping train are appliqued
with rose petals, fashioned of velvet in all the
exquisite shades of rose that the garden knows.

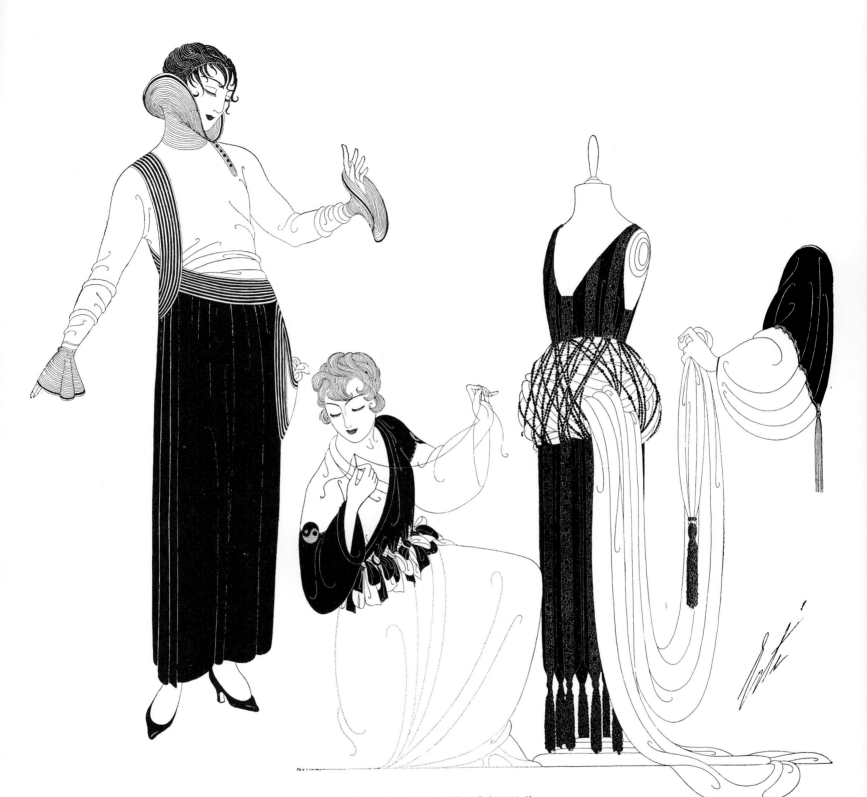

Madame, who watches with such interest the work of her couturiere, is clad in one of Erté's creations for spring. Her skirt is of tricotine and her bodice of soft white cloth, braided lavishly to form a high collar, cuffs and girdle.

Over a simple skirt the couturière wears a charming blouse, fashioned by Erté of gray and blue mousseline. Above in the center a marvelous evening gown is being constructed of jet and embroidered satin, with draperies of soft white material to encircle the hips beneath innumerable strings of the glittering jet.

APR. 1920

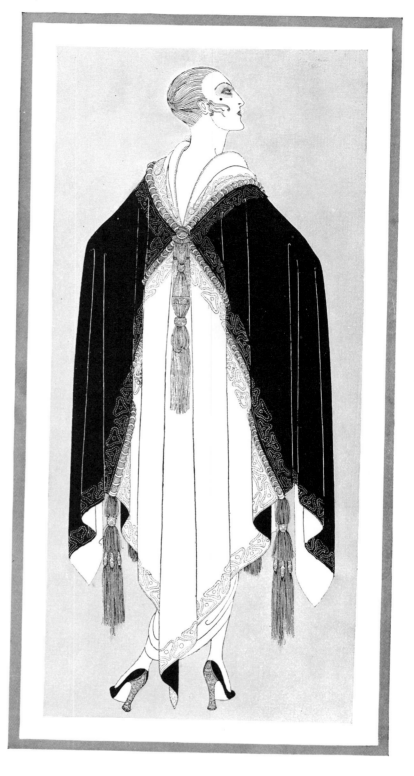

The evening wrap at the right is a fascinating arrangement of three squares, the strongly contrasting outer and inner colors being reversed in the central square. With unerring instinct for the piquant, Erté indicates here the delicately patterned heels that delight Paris.

JULY 1920

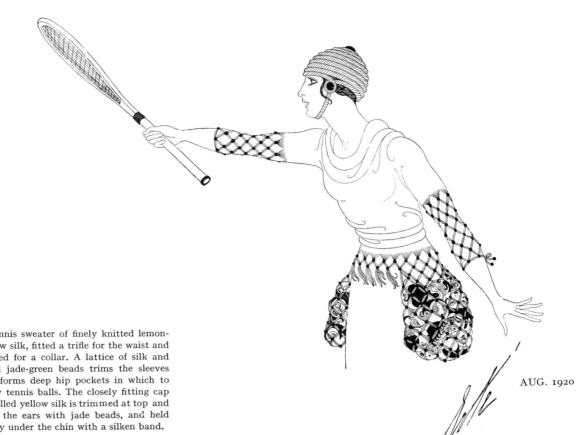

A tennis sweater of finely knitted lemon-yellow silk, fitted a trifle for the waist and draped for a collar. A lattice of silk and vivid jade-green beads trims the sleeves and forms deep hip pockets in which to carry tennis balls. The closely fitting cap of rolled yellow silk is trimmed at top and over the ears with jade beads, and held firmly under the chin with a silken band.

AUG. 1920

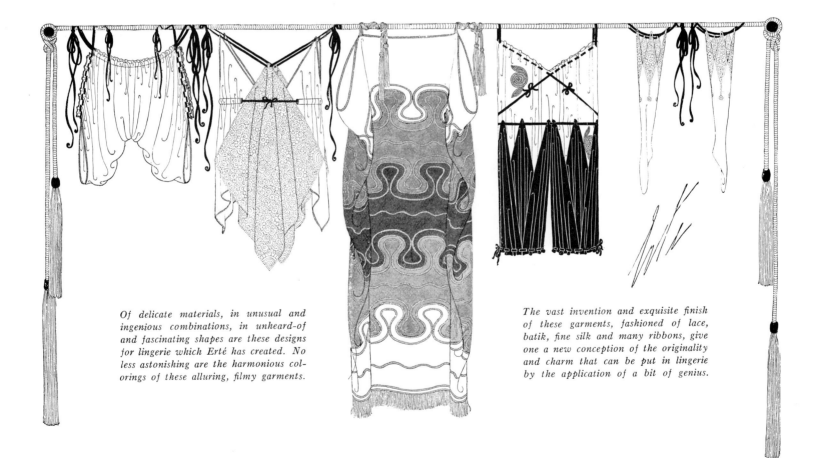

Of delicate materials, in unusual and ingenious combinations, in unheard-of and fascinating shapes are these designs for lingerie which Erté has created. No less astonishing are the harmonious colorings of these alluring, filmy garments.

The vast invention and exquisite finish of these garments, fashioned of lace, batik, fine silk and many ribbons, give one a new conception of the originality and charm that can be put in lingerie by the application of a bit of genius.

JULY 1920

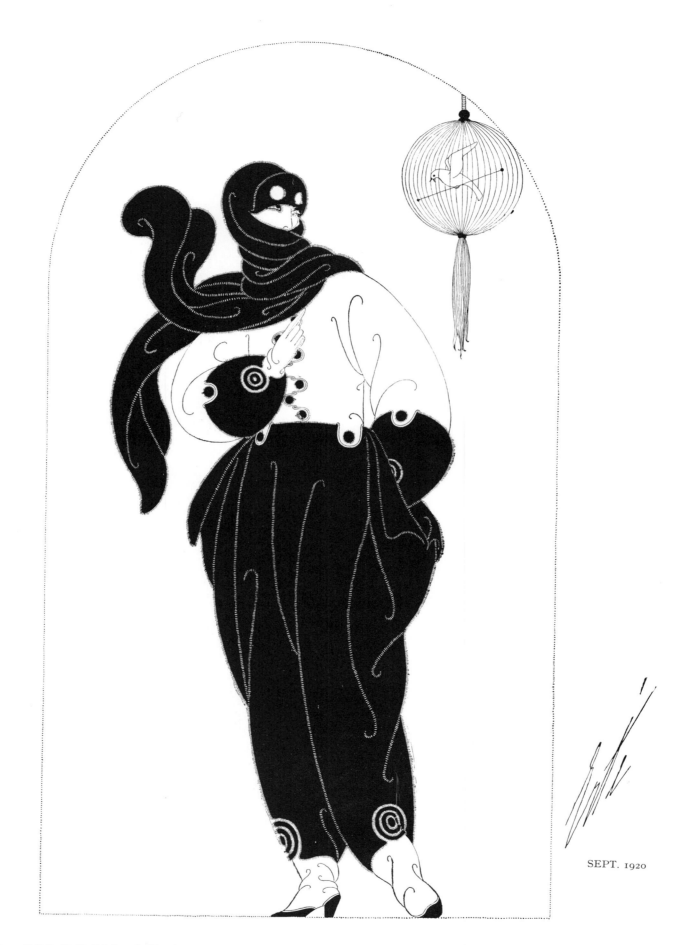

SEPT. 1920

A PILGRIM OF THE SKY IS ERTÉ'S FAIR MONDAINE

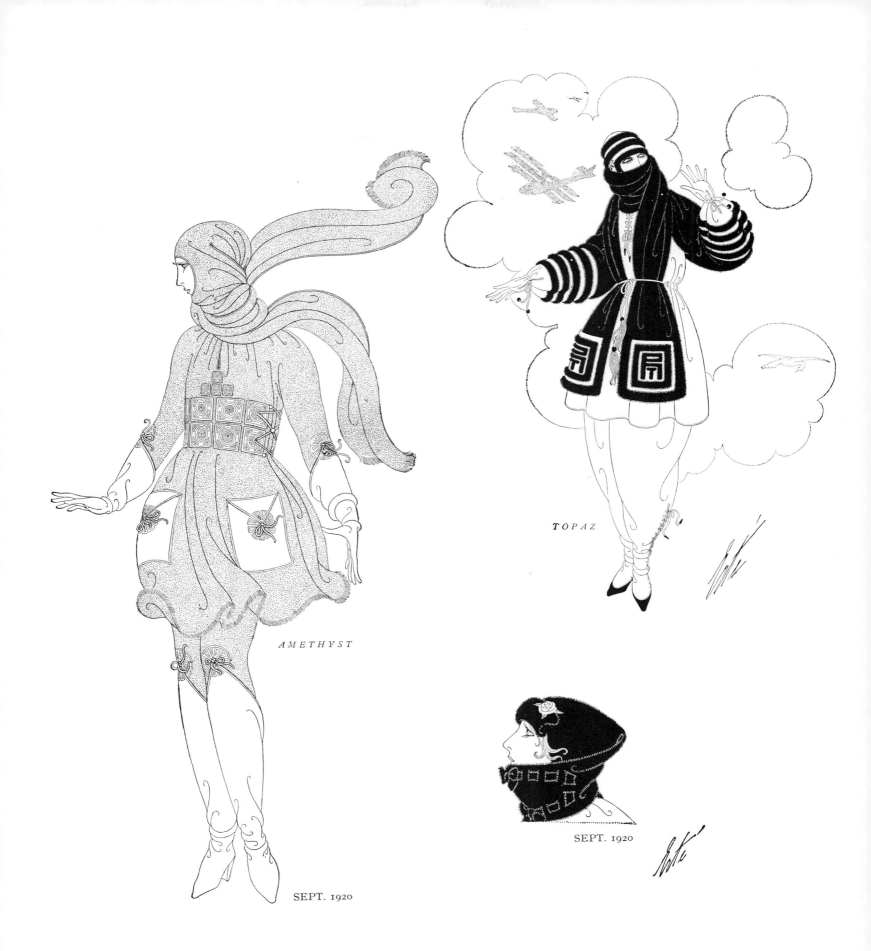

TOPAZ

AMETHYST

SEPT. 1920

SEPT. 1920

Descriptions of the costumes on these two pages will be found in the
September 1920 letter from Erté reprinted on page xi.

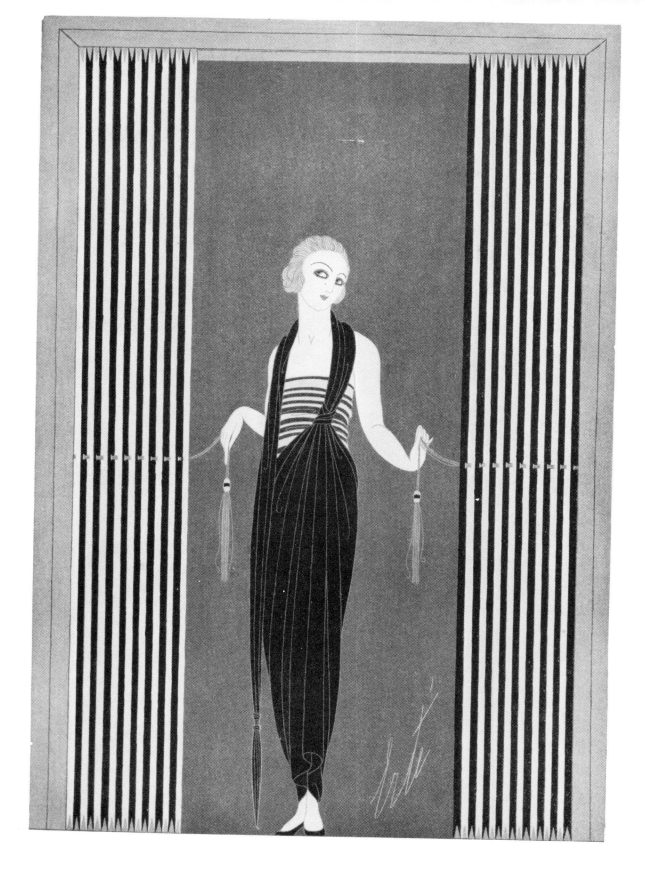

*Erté's favorite willowy outline characterizes
an interesting dinner gown of orchid velvet.
The skirt, drawn up slightly in the front,
extends in scarf-like fashion over a bodice
of gleaming green velvet striped with silver.*

NOV. 1920

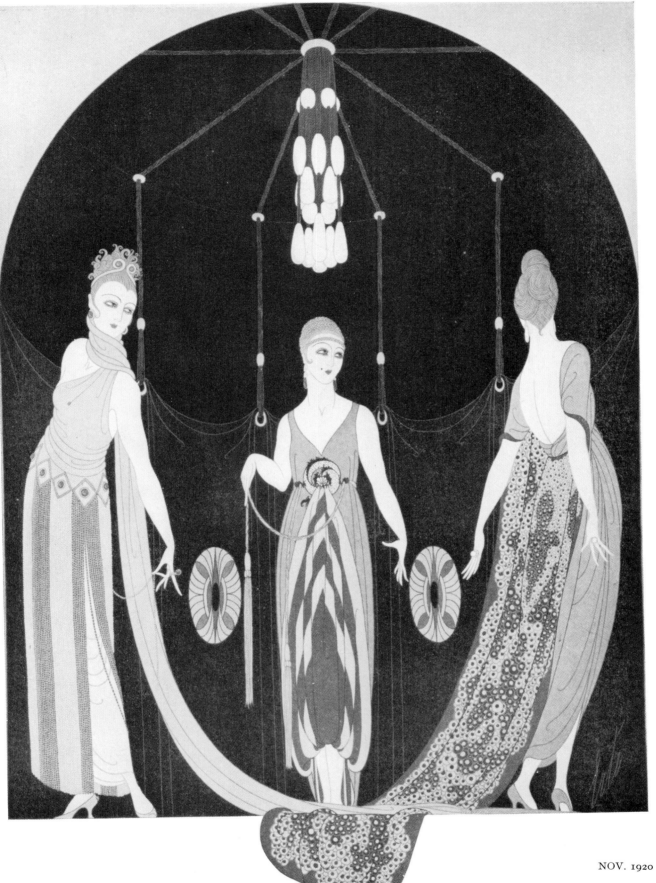

NOV. 1920

The scarfed costume drips with crystals over a slip of mousseline. A refreshing note appears in the costume of turquoise with a drapery of silver striped green satin, while the gown of violet satin has its embroidered train lined with black velvet.

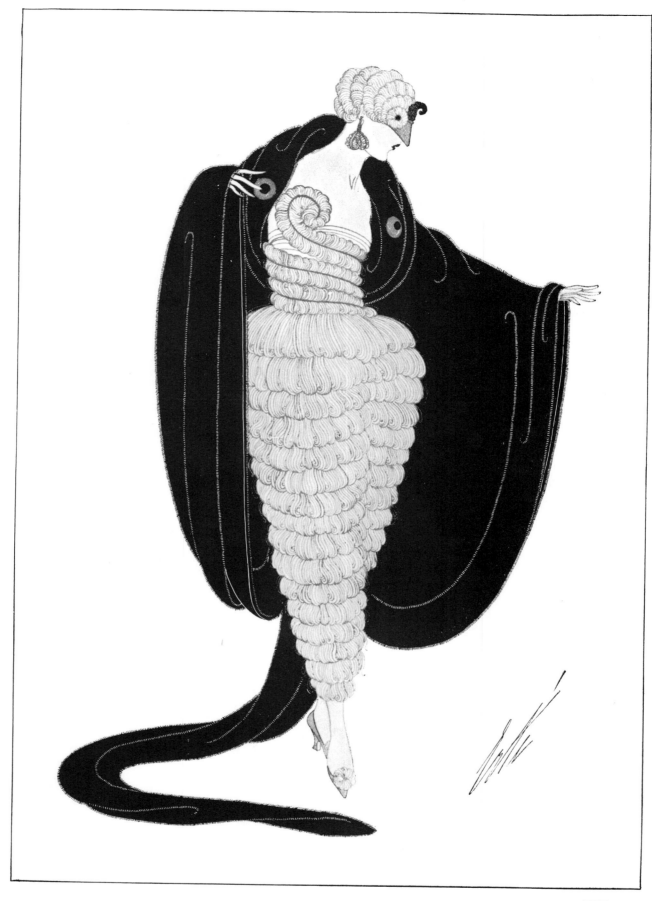

DEC. 1920

Erté's cat and bird will enrapture her who is in quest of a costume for "bal masque" which shall be at once bizarre and beautiful. The trousers are composed of many flounces of yellow ostrich flues and the corsage is no less than a silver ribbed plume wound round and round the form. Yellow plumes crown the head and a silver mask tufted with orange feathers conceals the features, so far the wearer represents a bird. She has but to fold her arms, however, within a voluminous coat of sleek black fur, to be transformed into a cat with gleaming black and green enamel eyes—the cat that cruelly catches the bird.

Of violet satin is this entrancing negligée
with trailing sleeves. It is richly en-
crusted with silver embroidery and bor-
dered with gray fox and—oh, very
Ertéesque!—its right sleeve is gracefully
caught up and entwined around the
wearer's waist and then becomes a scarf.

A broad strip of brown satin lined with
pale blue velvet forms the negligée that
may be seen on the lower right. The
end of its long train is drawn over the
right shoulder and is attached to the
lining by means of an embroidered motif
in gold and silver, violet and brown.

As quaintly exotic as an oriental throne
is this three-legged chair of black lac-
quer. Its round seat is covered with a
flat cushion of otter and ermine and
the back is a cylindrical cushion of otter
finished at each end with circular strips
of ermine and pendant white silk tassels.

DEC. 1920

73

Drawings for contents page.

FEB. 1921

*Juliet's chaplet of pearls wears
a different guise when Erté
festoons it through a plati-
num bandeau and attaches it
to fringed earrings of dia-
monds and pearls. The ban-
deau forms a broad comb.*

APR. 1921

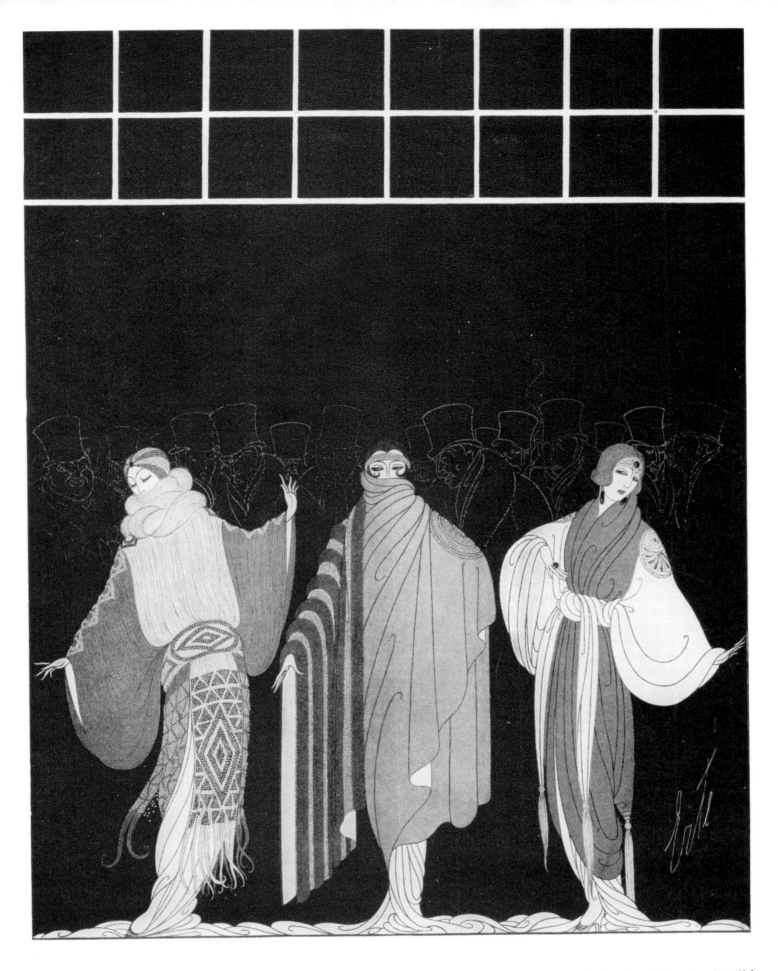

To carry out the artist's color scheme, the gown is of black satin bearing a medallion embroidered in black, white and gold. This design represents a bird from whose beak extend black and white silk cords dotted with tiny gold balls. These cords form the double girdle with long ends.

We can not help being impressed with Erté's delightful fancy when he creates wraps for eve-

ning. They are so marvelous in line and color. Fragile in effect but really most wearable is a draped wrap of silver tissue overlaid with black and silver silk threads held in place down the arms and at the waist-line with ivory and ebony beads. These beads also appear on the skirt. The collar is of the silver threads laced to form an Elizabethan ruff.

More practical, perhaps, but no less beautiful is a cape of gray cloth, banded with chinchilla and lined throughout with coral velvet. The medallion on the shoulder, of tiny coral beads, gives an alluring note of color.

The third wrap in this collection is of black satin, sleeved with saffron yellow satin and embroidered with motifs in violet and silver threads.

MAR. 1921

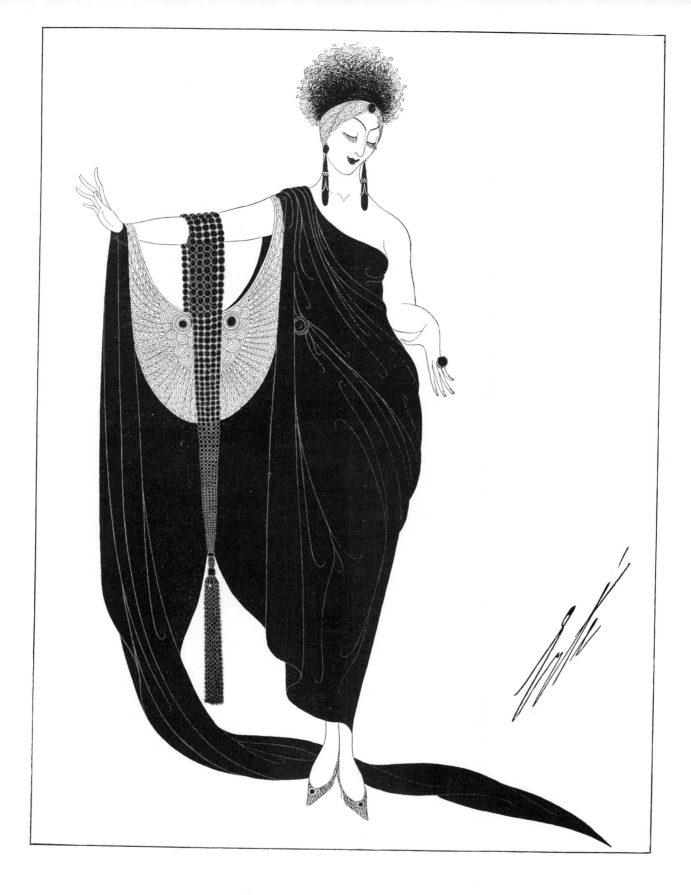

Black satin, marvelously wrapped about the figure, makes a striking evening gown when Erté attaches one end of the voluminous drapery to the lady's wrist and embroiders the inner section with a solid design in silver.

MAY 1921

Erté is using much silver this spring. With green satin embroidered with silver as a background he twines silver tissue about the figure and the result is an astonishing girdle that sweeps the floor.

Full of practical suggestions is a gown of lavender satin cut in barrel shape. The middle section is braided with soutache in shades of brown. Orange satin lines the novel and amusing open sleeves.

Combining white duvetyn with black satin is one of Erté's fads. For an afternoon frock he decrees that the satin forming the skirt shall be drawn up to encircle the top of the duvetyn bodice.

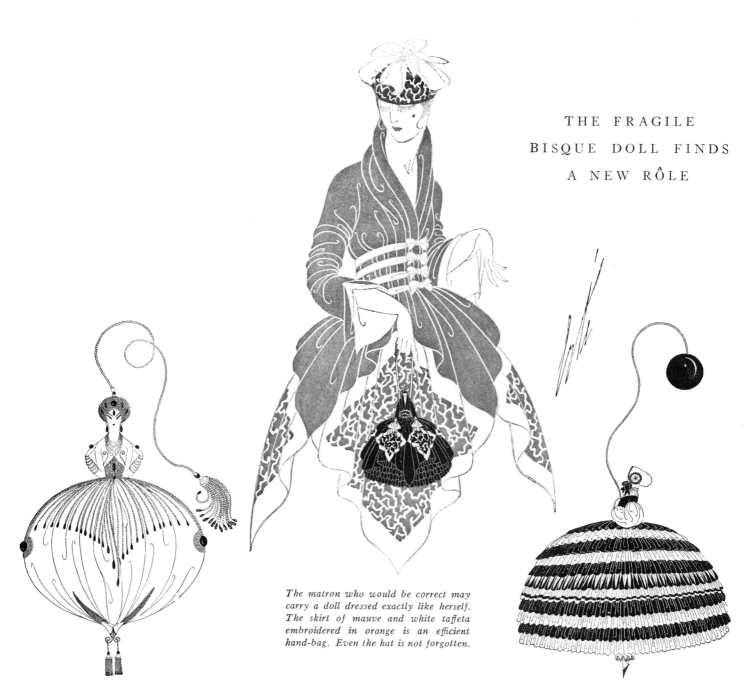

THE FRAGILE
BISQUE DOLL FINDS
A NEW RÔLE

The matron who would be correct may carry a doll dressed exactly like herself. The skirt of mauve and white taffeta embroidered in orange is an efficient hand-bag. Even the hat is not forgotten.

To carry with her evening costume and so provide a carry-all for her little nothings, Erté makes Madame a bag of silver tissue and semi-precious stones. The bouffant bloomers of tissue form the bag.

Frills of black and white taffeta form the doll's petticoat and in turn a bag for the débutante. The doll's face is hidden by her bonnet. The balloon is really a jade ball attached to a thin chain.

JUNE 1921

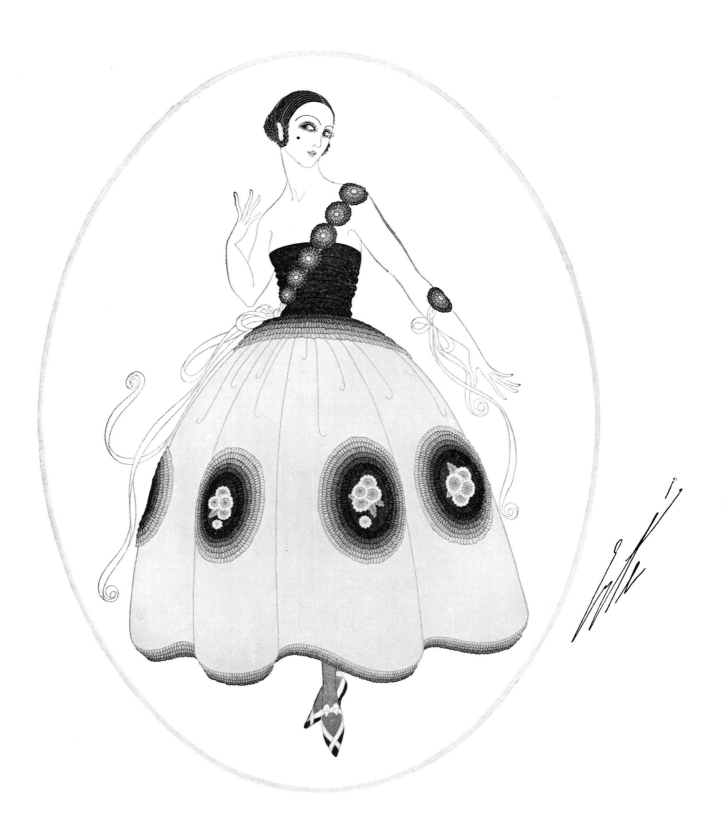

The quizzical look in Camilla's eye reflects, no doubt, her amusement over the couturiers' acceptance of the bouffant skirt—a mode sponsored by Erté these many moons.

AUG. 1921

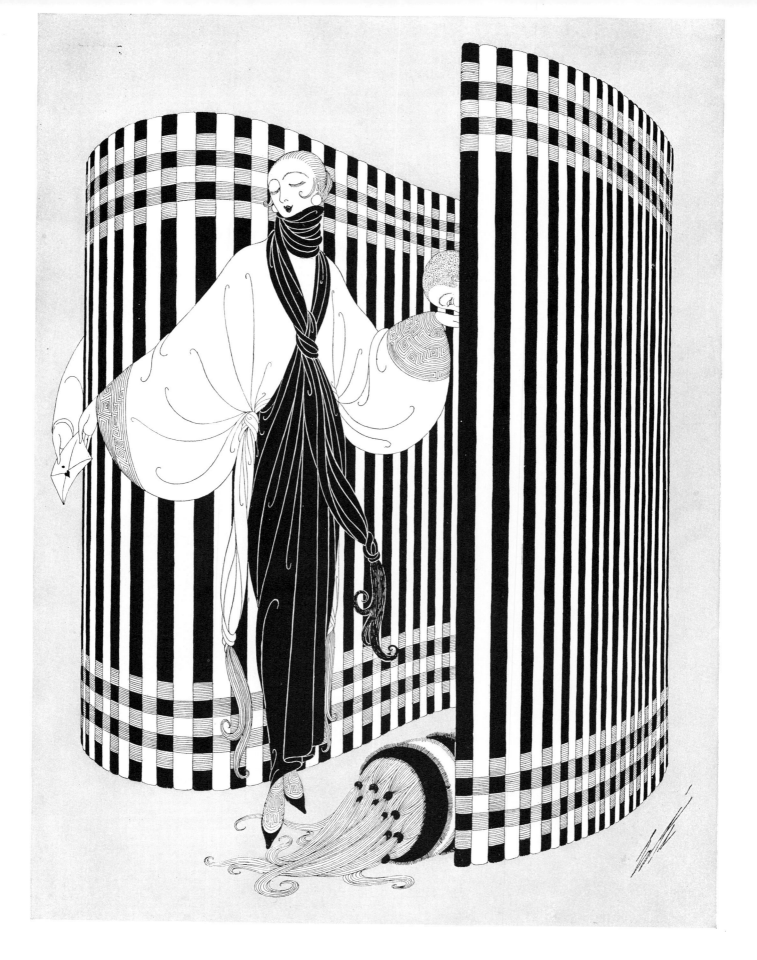

This is the sort of thing that makes us murmur, "Ah, they undoubtedly do manage those things so much better in France." Erté has given this flexible screen of panels of black and white lacquered wood, held together with yellow silk threads, all the versatility of an intrigante, and her same ease in being adequate to all situations. The bolster-shaped cushion on the floor is made of bands of black and white fox, and appears to be filled with yellow silk tassels that flow from either end.

SEPT. 1921

ERTÉ DESIGNS WRAPS
THAT PLAY UPON
THE MAGPIE THEME

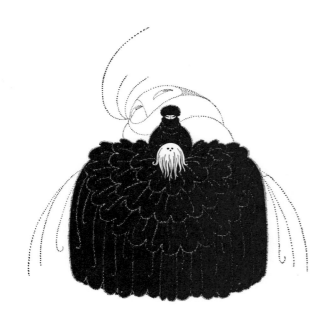

A foolish little doll made of soft mole is really an enchant-ing muff. The doll holds a diminutive dog (named Bo-bo, of course) that is made of monkey fur, with intelligent eyes of onyx. This is the sort of thing the Parisienne does and makes one actually apolo-getic for being an earnest per-son with a purpose in life.

OCT. 1921

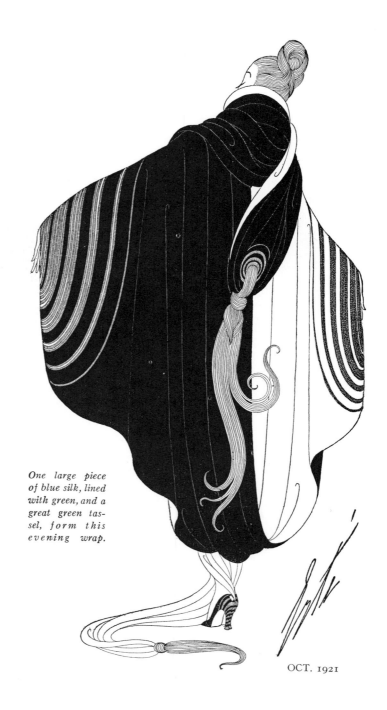

One large piece of blue silk, lined with green, and a great green tas-sel, form this evening wrap.

OCT. 1921

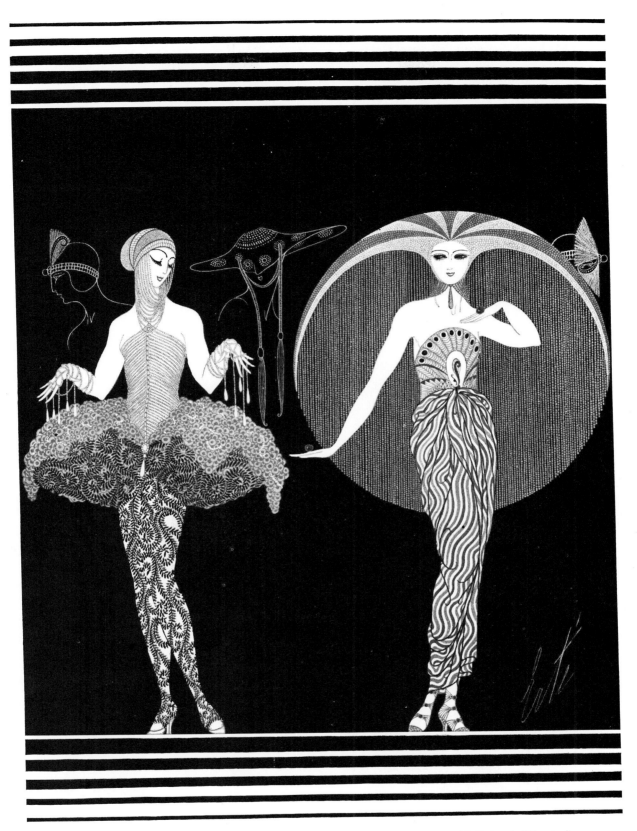

(*Left, in small sketches*) *A cabochon on a jet band is pressed, and this aigrette becomes a circular fan that covers the face, shown at the extreme right.* (*Middle*) *It is a purple straw pierced and embroidered green.* (*Left, large*) *"Morning" comes, vine clad and carrying panniers of yellow flowers.* (*Right*) *"Day" wears the sun on her head and is embroidered in orange and flame.*

DEC. 1921

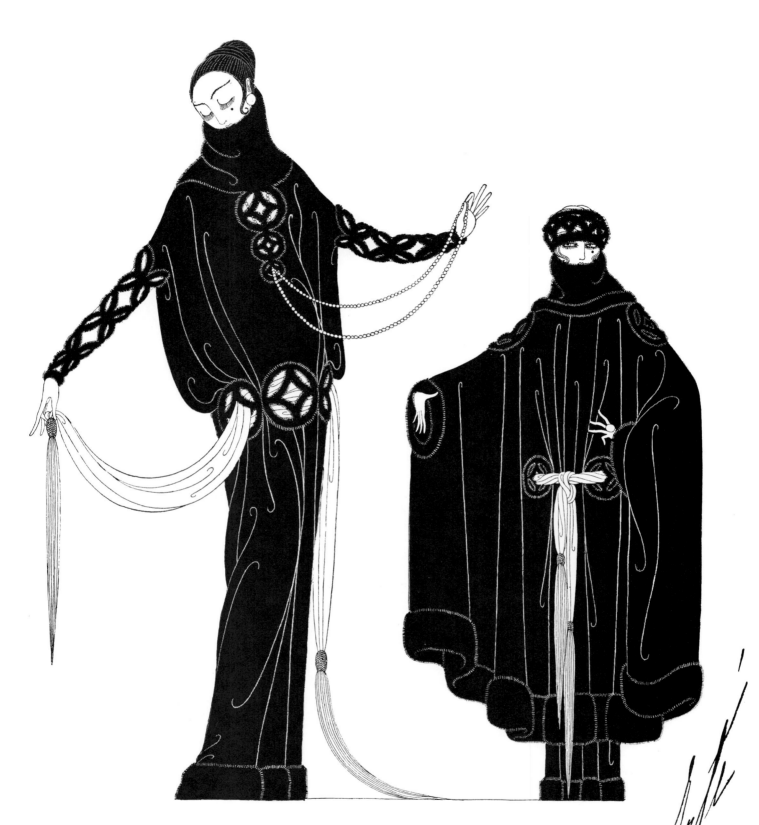

An afternoon gown made entirely of mole does diverting things with openwork. Under the cut-out part on the girdle is cloth of gold; drawn through that on the bodice is a "sautoir" of turquoise; under that on the sleeves is the lady's own ivory skin.

And then, here's the wrap she wears with it. It is circular and collarless, since it uses the collar of the gown underneath. That's not all, either—it closes itself by pulling through and tying the long, shimmering cloth of gold sash ends of the gown.

JAN. 1922

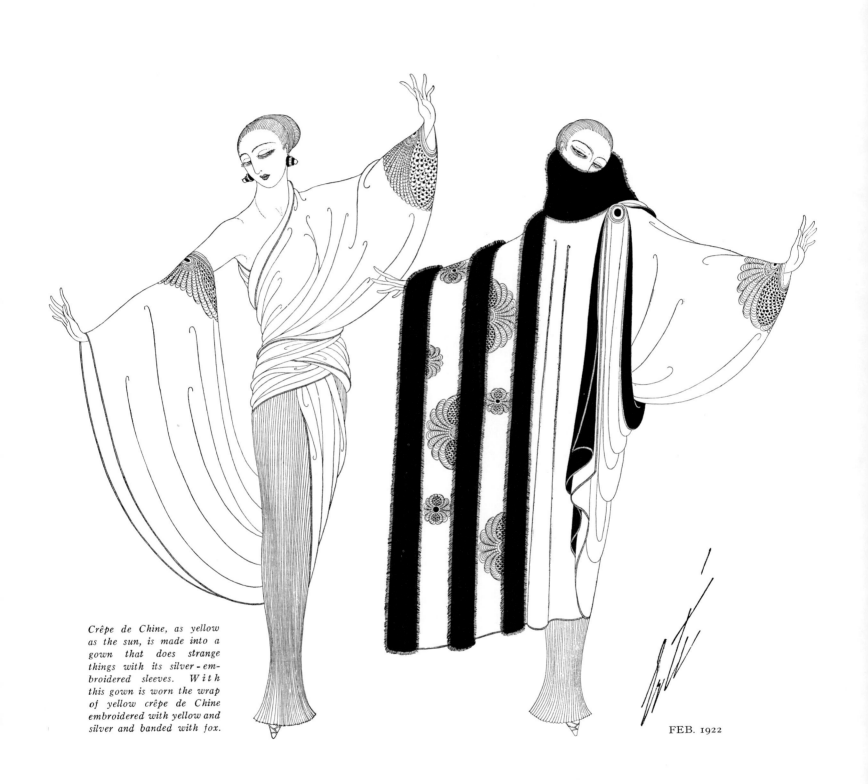

Crêpe de Chine, as yellow as the sun, is made into a gown that does strange things with its silver-embroidered sleeves. With this gown is worn the wrap of yellow crêpe de Chine embroidered with yellow and silver and banded with fox.

FEB. 1922

85

White marocain crêpe, edged with jade green, is interwoven at the shoulders of a blouse, and is used in a long piece that crosses over scarfwise in the front and is drawn through the material in the back. The mirror shows just how the blouse crosses in the back. In the front the interwoven strips of the crêpe end in long jade green tassels forming a most unusual ornament that shows below the tailleur.

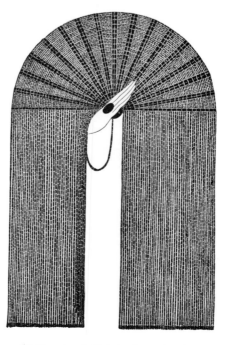

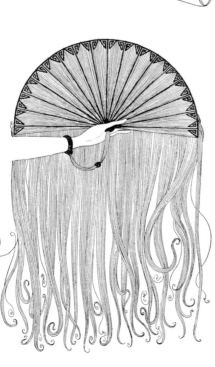

Four white pieces of gabardine, joined by means of jet buttons on a jet necklace, form a remarkable little blouse to wear under a tailleur or with a white skirt. Jet fastens it at the waist.

The edges of a simple crêpe de Chine blouse are all frayed; and the blouse is oddly knotted together. There is open-work of amber beads.

FEB. 1922

A long tassel that becomes a fan when one opens it is strangely made of lacquered wood and gaily colored silk strands.

Another tassel that is also a fan is of strands of jet beads, held together by jet sticks with strands of jet between.

The beaks of embroidered gold parrots hold the long mauve satin drapery of this remarkably—and really very simply—draped evening wrap. The wrap is designed to be worn with the gown below it, forming an exquisite complete costume.

The gown below—of dull gold tissue and mauve satin—has its skirt held to the bodice by the beaks of gold embroidered parrots.

Glove-purses of embroidered white suède. Undoubtedly a French way of not letting your right hand in on whom your left hand is doing.

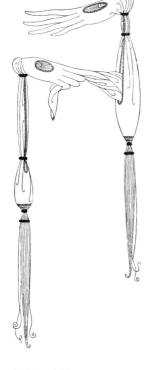

A WRAP AND GOWN
MADE TO SPEND THEIR
EVENINGS TOGETHER

MAR. 1922

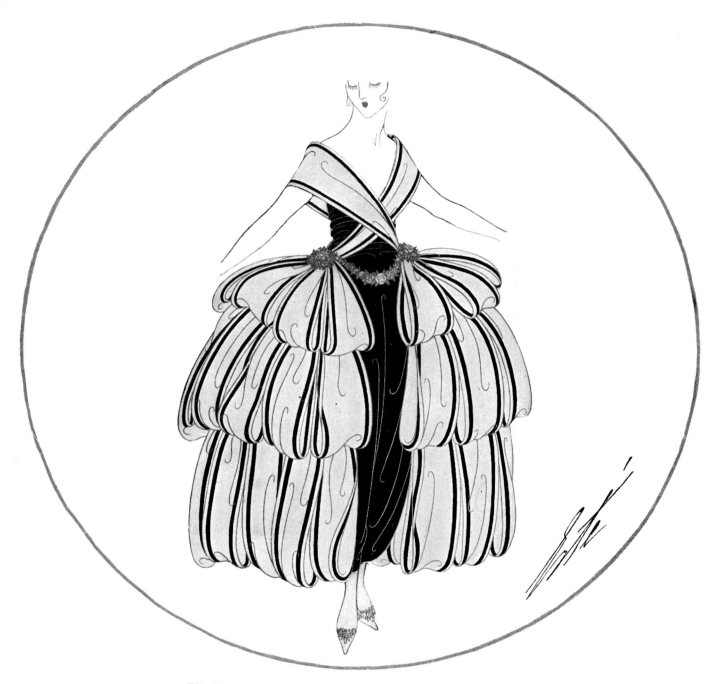

This black taffeta and black and white ribbon gown with its piquant
garland of flowers one can imagine being made deftly and in a great
hurry for a tall slender girl to dance in, like an animated shepherdess.

MAR. 1922

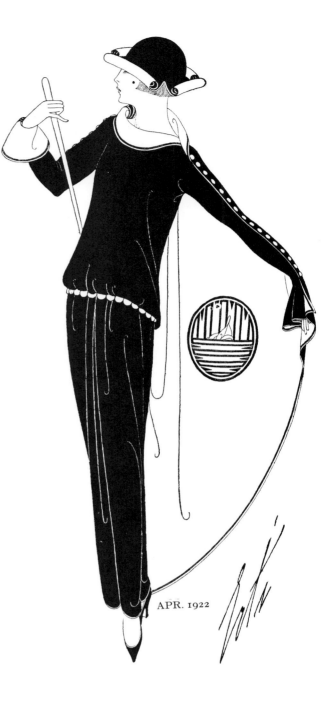

Again Erté persuades one large piece of material to become a gown. It is of brown satin lined with black cloth, and caught together with ivory buttons. A cape is attached all the length of the left sleeve by buttons.

APR. 1922

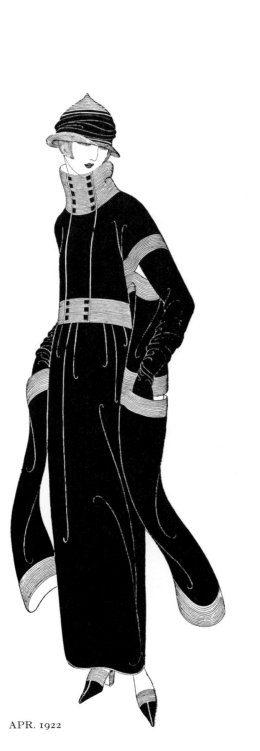

APR. 1922

Two openings, one for the arm and another for a pocket, appear on the long sleeves of this beige duvetyn tailleur, trimmed with wide bands of orange soutache braid. The tailleur with its short coat looks like a frock.

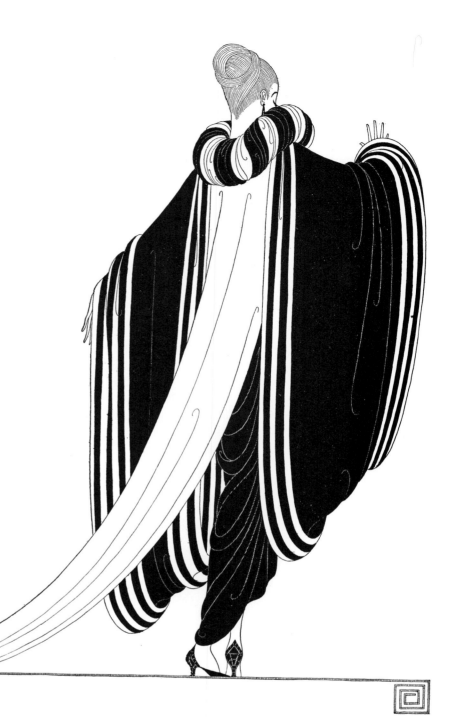

When Erté is left alone with one large piece of black satin he can evolve almost any ingenious and lovely thing. This time it is a gorgeous wrap to wear with the gown on the page opposite. It's an odd wrap that has no back-bone of its own, but depends upon the long train of the gown to give it a spinal column. You see, the wrap consists really of only a great pair of black satin sleeves, striped with gold and fastened to a great rolled collar of gold and black. This fastens in front with a design of gold embroidery, and is, for all intents and purposes, a wrap that covers the case by showing only a bit of the gown.

MAY 1922

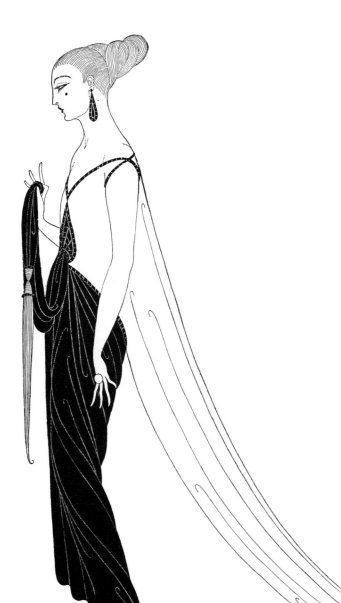

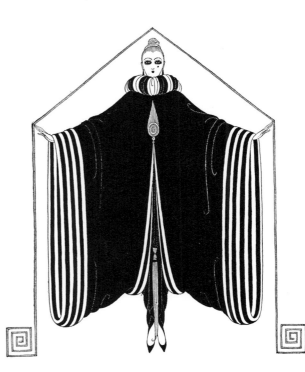

This is the front view of the wrap on the opposite page. In spite of its being no more than a pair of great black satin sleeves attached to a roll of black satin and gold, it is entirely adequate as a wrap and has a shimmering molten look.

A slim bodice of dull gold cloth, and then a long tasseled gold train falling from the shoulders. Then a black satin skirt draped up to the bodice and pulled through a motif of jet and gold. It is a gown with a flair for the Egyptian.

MAY 1922

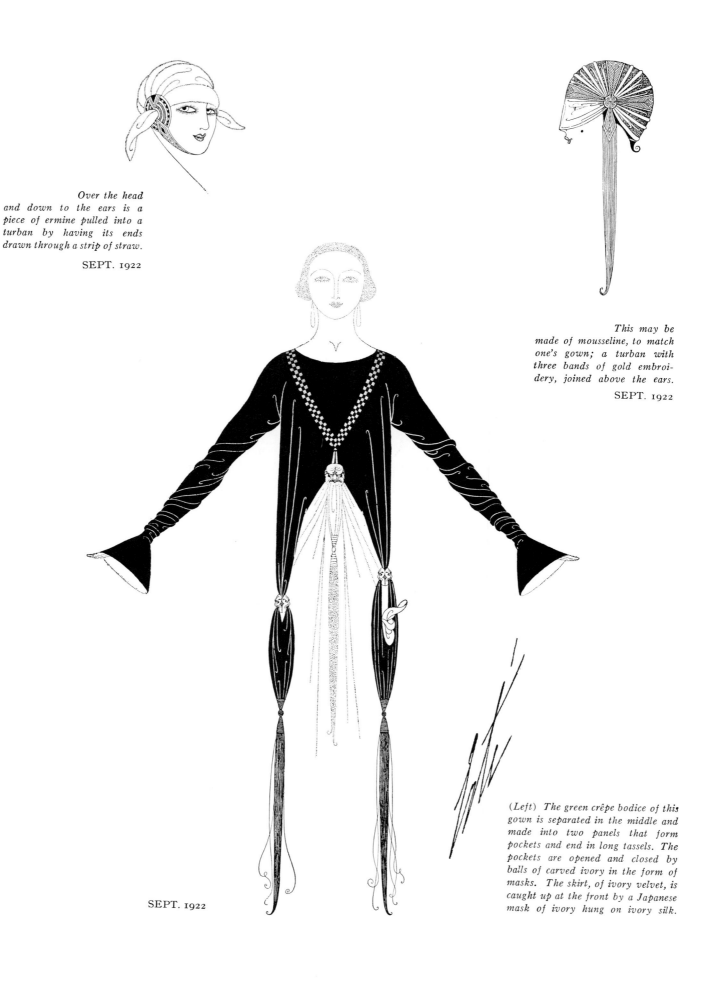

Over the head and down to the ears is a piece of ermine pulled into a turban by having its ends drawn through a strip of straw.

SEPT. 1922

This may be made of mousseline, to match one's gown; a turban with three bands of gold embroidery, joined above the ears.

SEPT. 1922

(Left) The green crêpe bodice of this gown is separated in the middle and made into two panels that form pockets and end in long tassels. The pockets are opened and closed by balls of carved ivory in the form of masks. The skirt, of ivory velvet, is caught up at the front by a Japanese mask of ivory hung on ivory silk.

SEPT. 1922

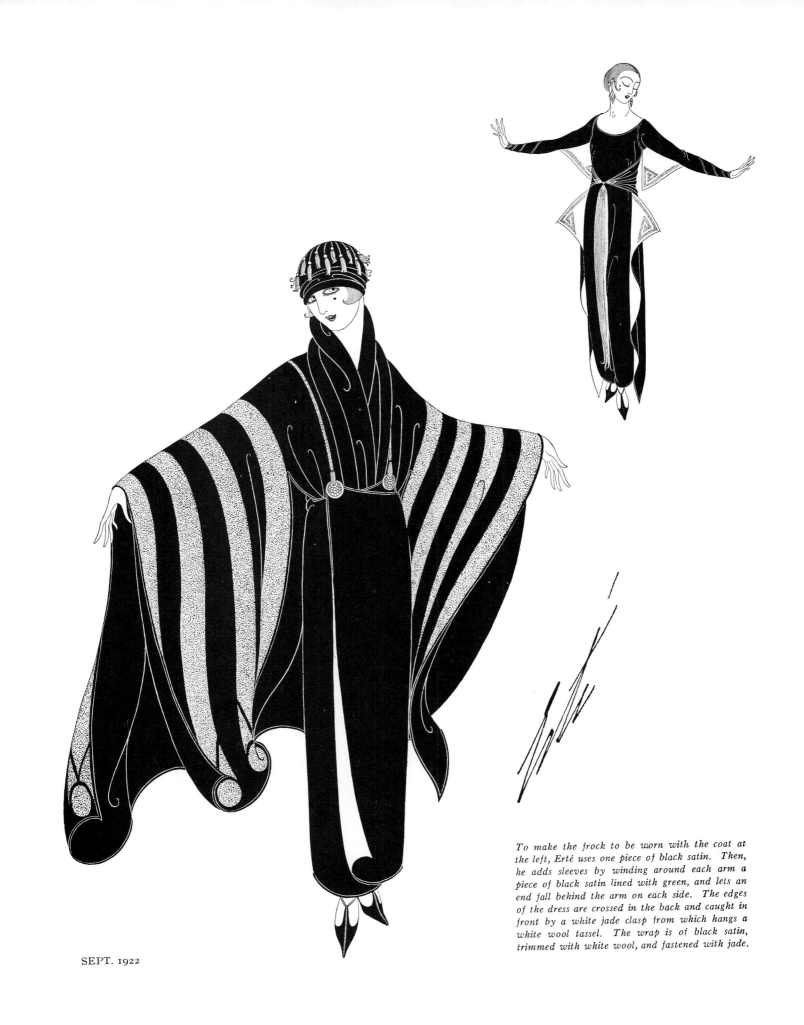

SEPT. 1922

To make the frock to be worn with the coat at
the left, Erté uses one piece of black satin. Then,
he adds sleeves by winding around each arm a
piece of black satin lined with green, and lets an
end fall behind the arm on each side. The edges
of the dress are crossed in the back and caught in
front by a white jade clasp from which hangs a
white wool tassel. The wrap is of black satin,
trimmed with white wool, and fastened with jade.

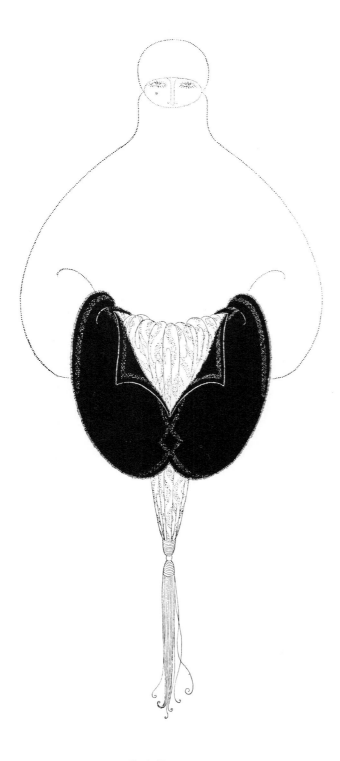

Probably no one in the world has as many fanciful ideas for muffs as Erté. The muff, its feminine charm and its decorative possibilities, seems to fascinate him. Of otter, banded with a narrow edge of mole, he has evolved a muff that is lovely enough to be the center of interest of a costume. The otter is made over mole-gray fabric, weighted by a long gold tassel.

OCT. 1922

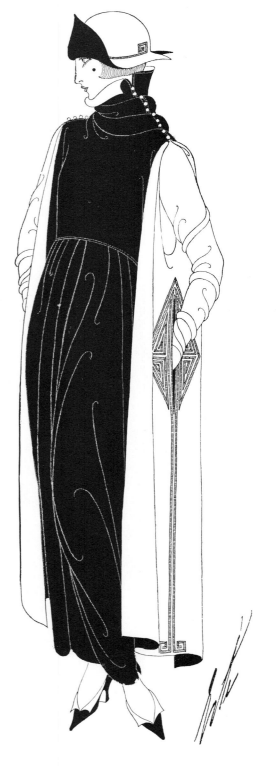

The waist-line of this costume is just as high as Erté chose to make it. The wrap is of embroidered gray duvetyn, faced with henna, and the frock worn with it is henna-colored.

OCT. 1922

There is a strong Greek feeling about this very high-waisted gown made of a single piece of gold fabric, faced with very thin and supple mauve velvet. The over-part of the gown, that clasps on the shoulders with amethyst and gold buttons, has the gold fabric on the outside and is slit and drawn back to form a train ending in a long orange tassel. Another orange tassel swings from the girdle and splashes its glowing color against the long mauve velvet under-frock.

NOV. 1922

NOV. 1922

In a long sweep from the shoulder, to a yard or more on the floor, is the dense black of velvet bordered with the deeper black of fox fur. The fox bands mark an opening in the back of the wrap to show a draped panel made of the black velvet, embroidered with two tones of gold and set with cabochons of jet.

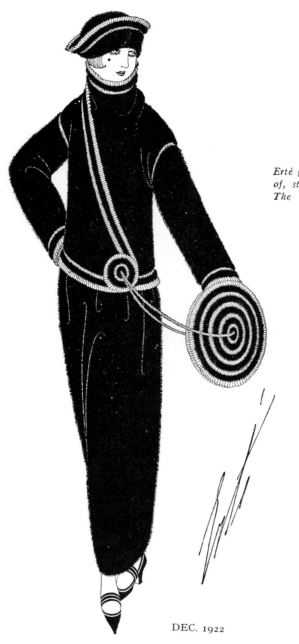

Erté gives a tailleur of mole tiny frills of, strangely enough, white organdie. The muff duplicates the cocarde.

DEC. 1922

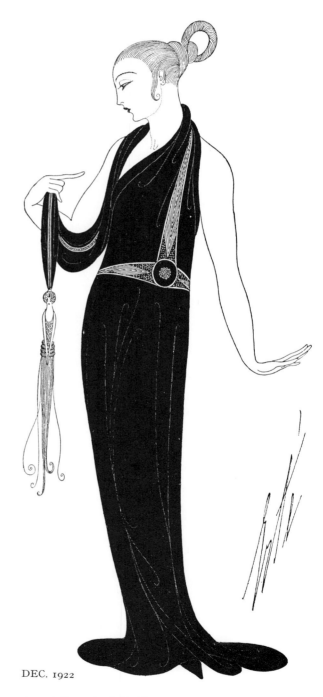

DEC. 1922

Around the neck of this blue satin evening gown is thrown the embroidered panel that forms the bodice and ends in a doll tassel made of cream and orange threads.

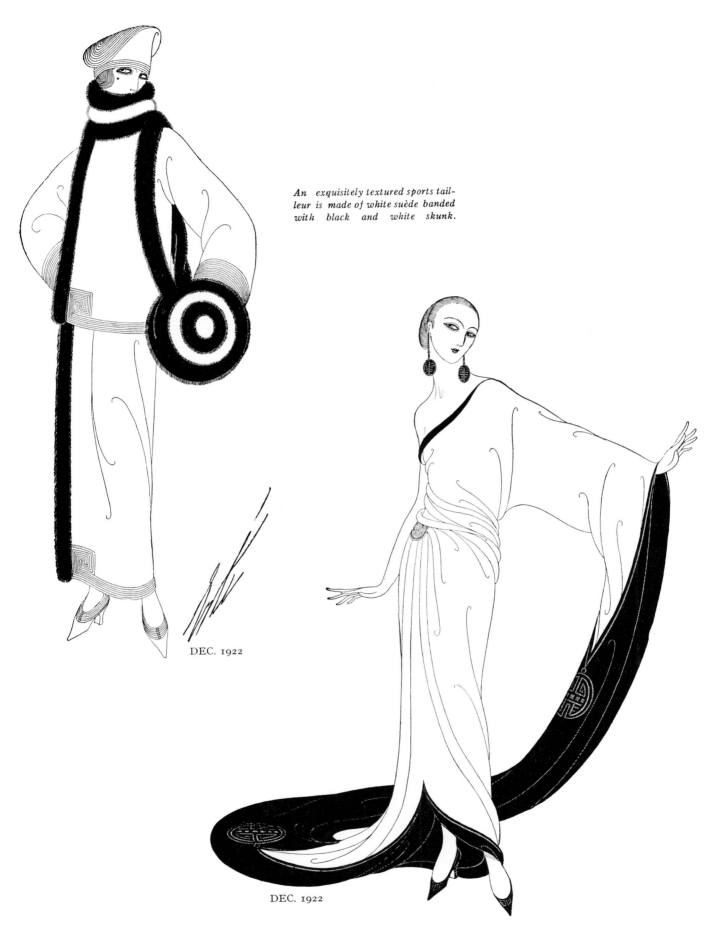

An exquisitely textured sports tail-leur is made of white suède banded with black and white skunk.

DEC. 1922

DEC. 1922

The skirt and train and left sleeve of this dull gold tissue evening gown are all one long continuous piece. The dark lining is Chinese red velvet, embroidered with gold.

Over the thick black roll of hair is spread a gold net, finished with two long tassels that sway over each shoulder like fantastic hair.

(*Upper middle*) For the blonde, Erté has designed a coiffure skewered with jet pins over the ears, pins fastened to a jet girdle by long jet strands.

For the brunette is a coiffure entwined in a network of tiny coral beads. Two braids are fastened together in front by a coral tassel.

COIFFURES FOR THE BLONDE,

THE DARK, AND

THE DARING

A mauve silk afternoon frock, banded with sabie and embroidered with old gold, has an unusual skirt, formed by splitting a plain skirt and letting the ends fall over a gold girdle. The bodice has a strange cut-out motif at the neck-line.

JAN. 1923

This is a variation of the coiffure at the upper left. The roll of hair is enclosed in a gold net of different design. The tassels fall just in front of the ears. It is an idea for short hair; the roll is not necessarily one's own.

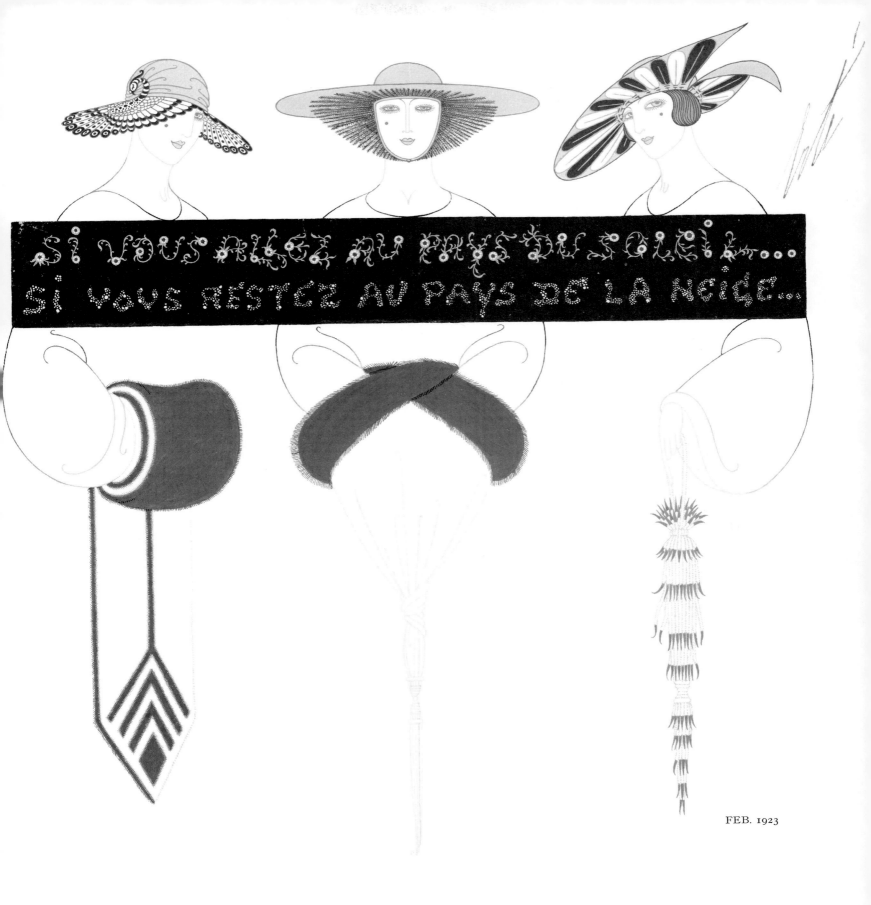

SI VOUS ALLEZ AU PAYS DU SOLEIL...
SI VOUS RESTEZ AU PAYS DE LA NEIGE...

FEB. 1923

A hat for "the land of the sun," with its brim made of the fanlike feathers of two exotic conventionalized birds.

Marron-colored aigrettes are mounted on a blue straw hat to form a strange elliptical little halo for one's face.

A green straw hat, with its brim split, for the South, is trimmed, under the brim, with flat black and white quills.

(Reproduced from the original drawing.)

99

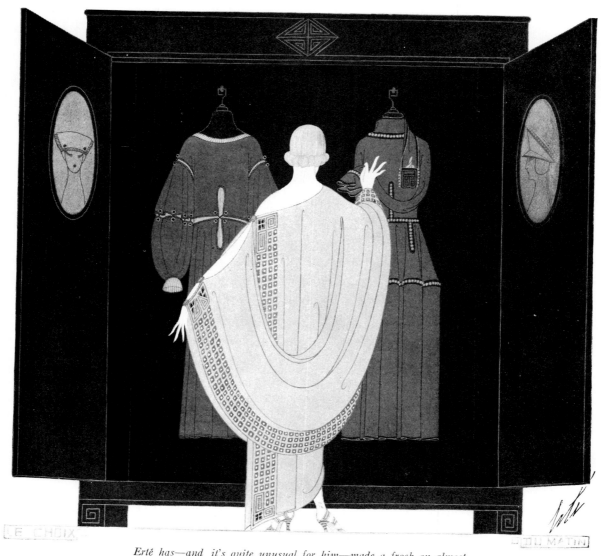

Erté has—and it's quite unusual for him—made a frock on almost peasant lines. It is of yellow cloth, embroidered with black and silver. The other frock is navy blue serge, banded with black and white.

The heads on he doors show the hats to be worn with the frocks in the closet.

MAR. 1923

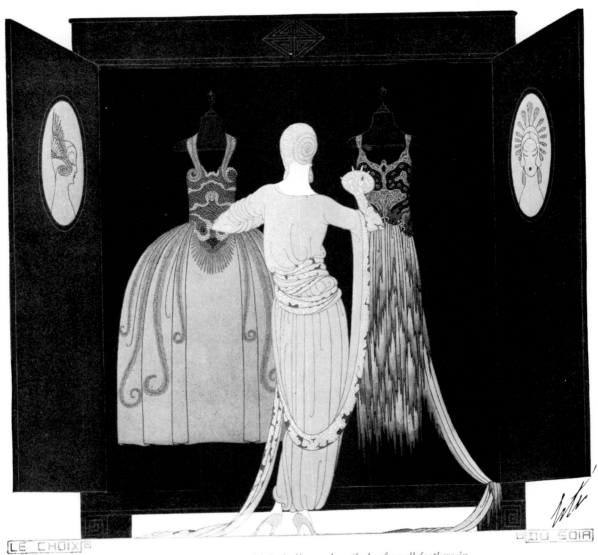

LE CHOIX

DU SOIR

*For evening is a gown with its bodice made entirely of small feathers in
shades of yellow, green and blue. The gown at the right has its bodice
embroidered in dragons of gray and gold; the skirt is flame-colored.*

*The gown on
the figure is of henna
crêpe. Its long right
sleeve forms a girdle*

MAR. 1923

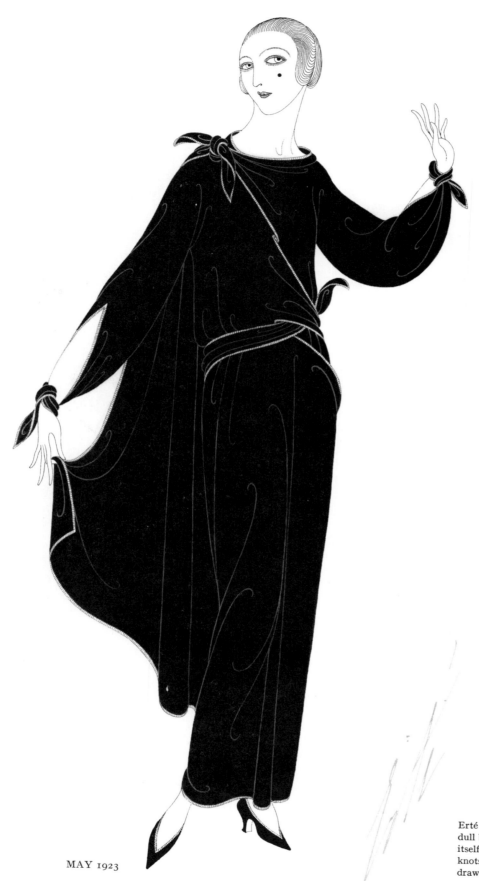

MAY 1923

Erté has adroitly made a single piece of dull blue crêpe, embroidered in orange, tie itself into a frock by a series of clever knots. (Reproduced from the original drawing.)

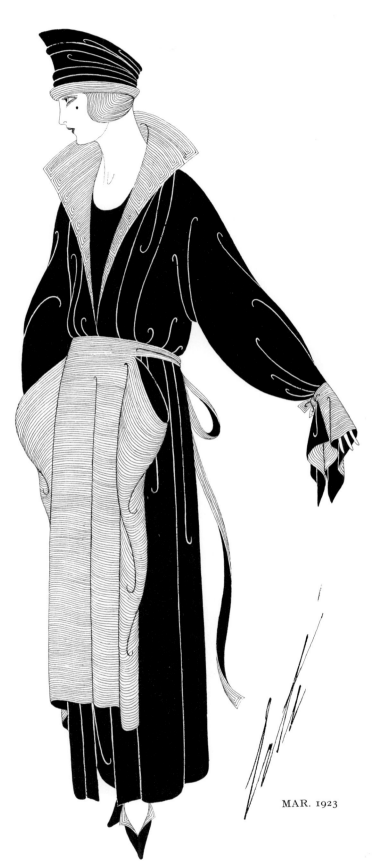

Over a frock of gray charmeuse is an apron with yellow braid. (Reproduced from the original drawing.)

MAR. 1923

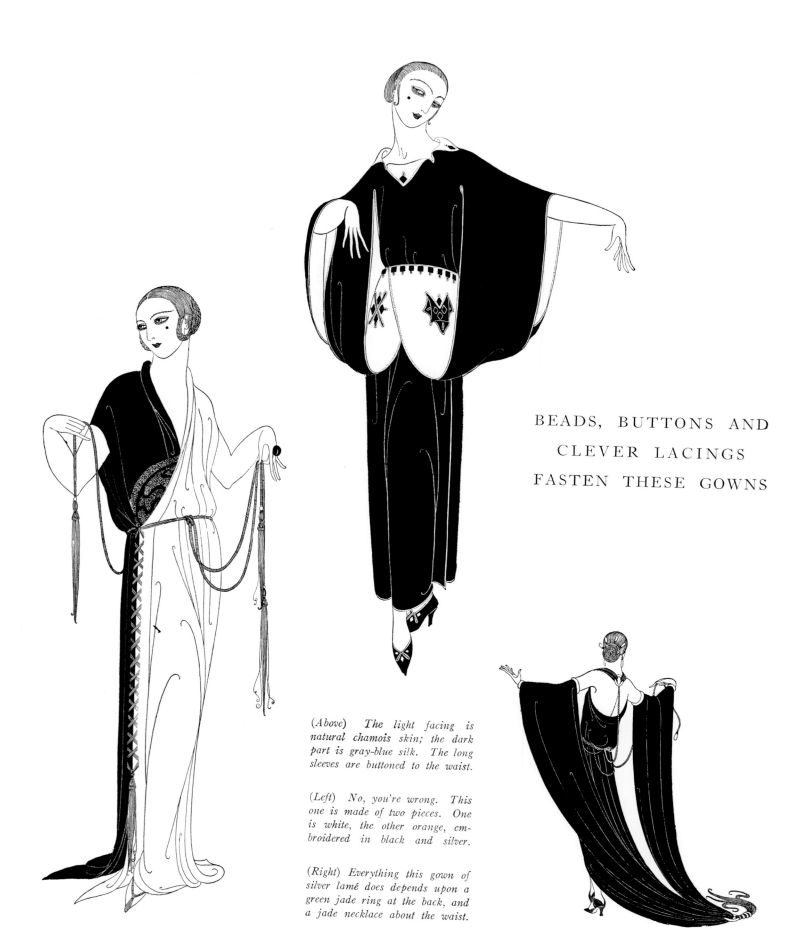

BEADS, BUTTONS AND
CLEVER LACINGS
FASTEN THESE GOWNS

*(Above) The light facing is
natural chamois skin; the dark
part is gray-blue silk. The long
sleeves are buttoned to the waist.*

*(Left) No, you're wrong. This
one is made of two pieces. One
is white, the other orange, em-
broidered in black and silver.*

*(Right) Everything this gown of
silver lamé does depends upon a
green jade ring at the back, and
a jade necklace about the waist.*

MAY 1923

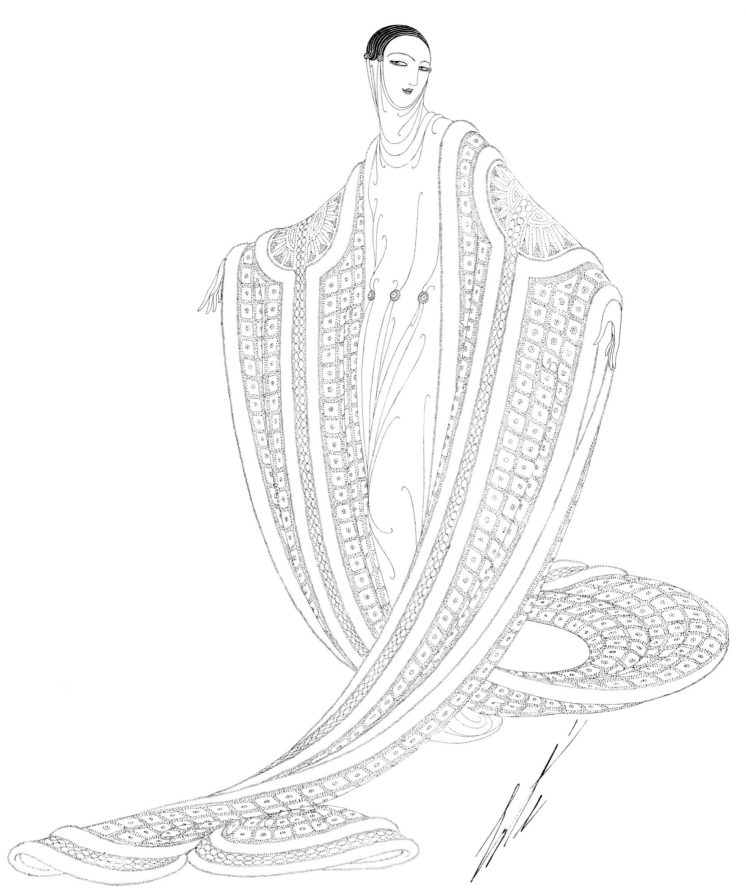

JUNE 1923

*For the last issue of Harper's Bazar, Erté designed a series of exquisite wedding
gowns; and then, when he had all those done, he thought of another—really
too lovely to leave out of this issue. It is of white crêpe, made in one piece, cut
curiously so that the high neck is attached to the coiffure with carved silver pins.
The long trailing sleeves are embroidered with silver and banded with ermine.*

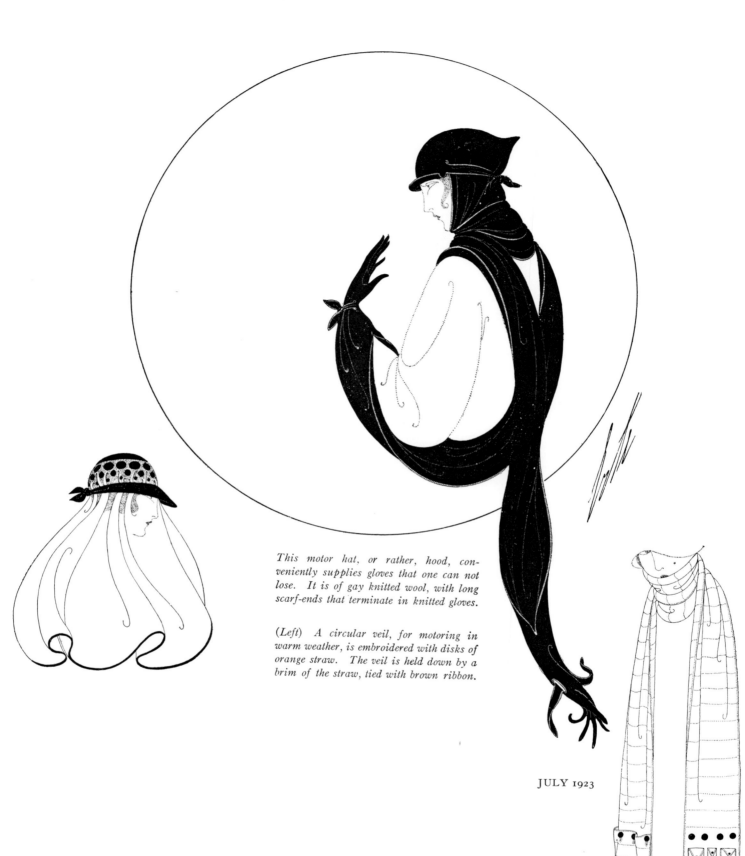

This motor hat, or rather, hood, conveniently supplies gloves that one can not lose. It is of gay knitted wool, with long scarf-ends that terminate in knitted gloves.

(Left) A circular veil, for motoring in warm weather, is embroidered with disks of orange straw. The veil is held down by a brim of the straw, tied with brown ribbon.

JULY 1923

A remarkable scarf, of beige suède, has places for powder and rouge.

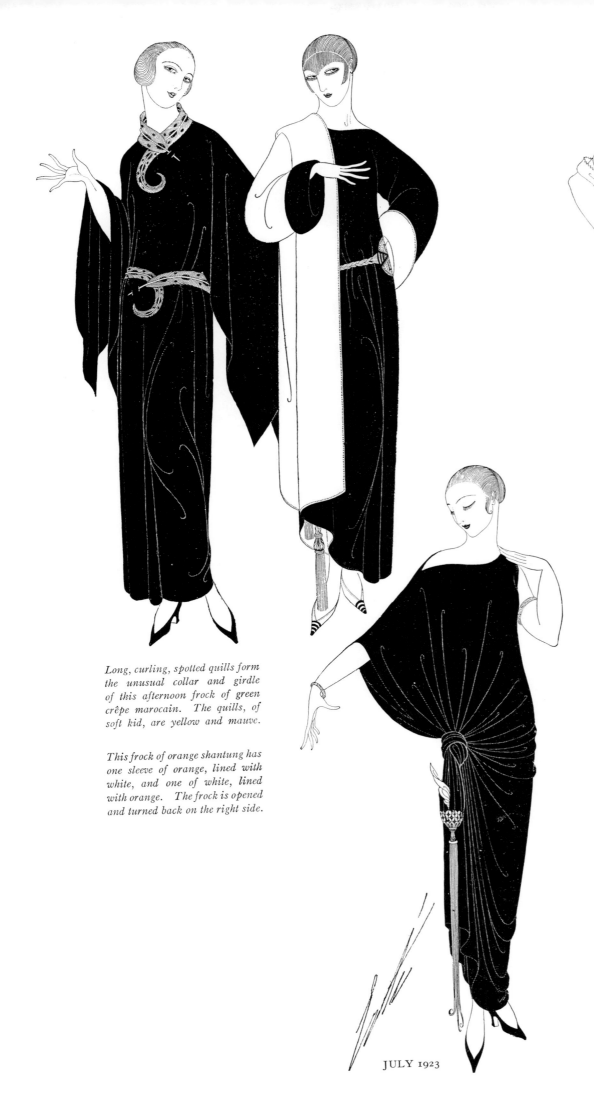

Long, curling, spotted quills form the unusual collar and girdle of this afternoon frock of green crêpe marocain. The quills, of soft kid, are yellow and mauve.

This frock of orange shantung has one sleeve of orange, lined with white, and one of white, lined with orange. The frock is opened and turned back on the right side.

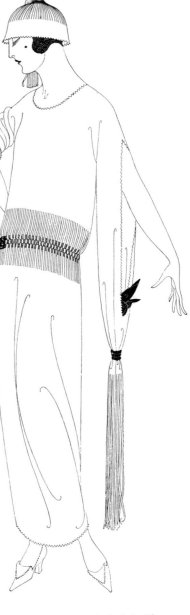

A white cloth tailleur is "pinked" on the edges. The right sleeve is short, while the left hangs long, and is knotted to form a pocket. The tassel is of the material.

Coral-colored crêpe marocain, all in one piece, forms an evening gown knotted on the right side to form a pocket ending in a gray silk tassel, topped by embroidery.

JULY 1923

(Right) This remarkable motor hat of fine gabardine is held closely to the head by a ring of jade. Next to the hat is a sleeved motor scarf of gray fabric lined with red leather. A rectangle of material, with a slit for each arm, covers the back.

SEPT. 1923

(Left, above) A head-band consisting of strips of moleskin holding together disks of greenish glass forms decorative motor goggles. Two of the disks are lenses; two are carved ornaments. (Below) A scarf head-dress to match the smart gray scarf.

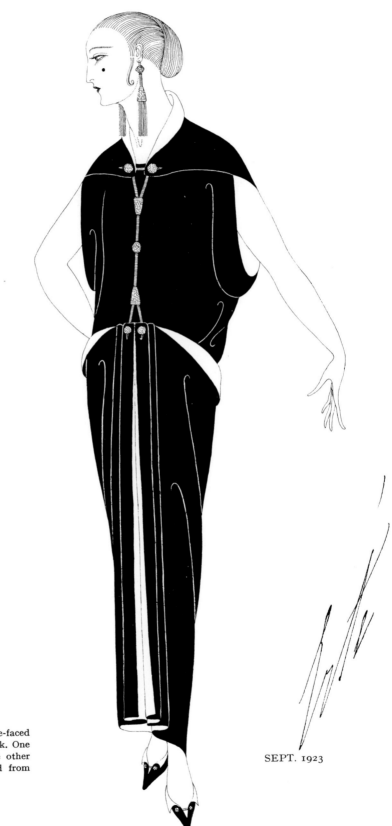

Two rectangles of double-faced material form this frock. One makes the bodice, the other the skirt. (Reproduced from the original drawing.)

SEPT. 1923

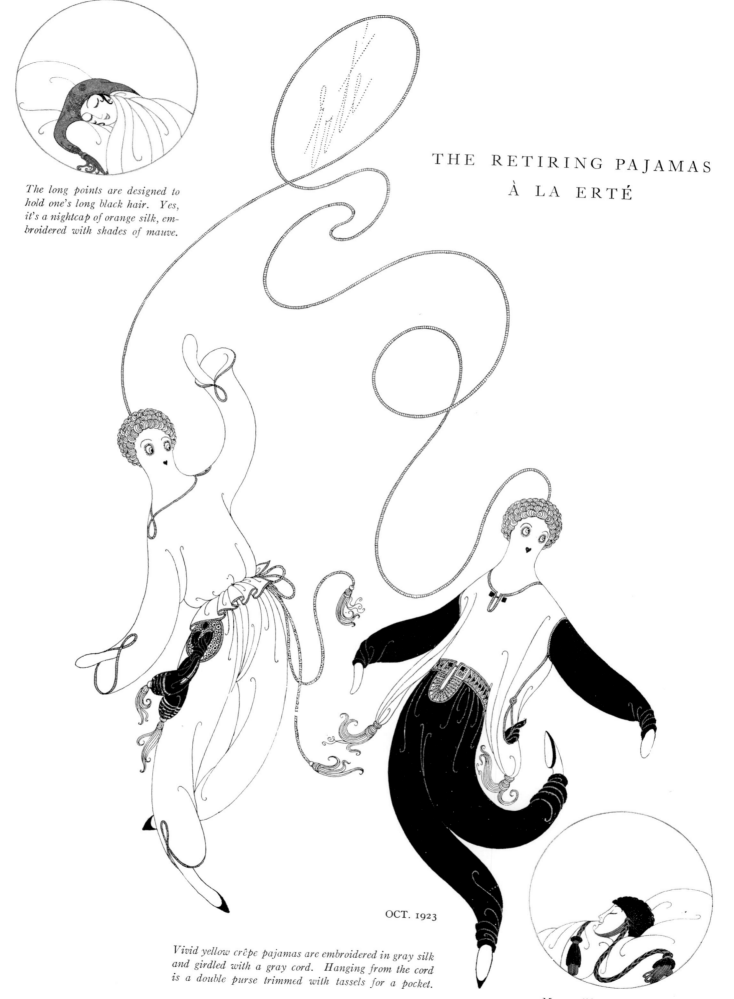

The long points are designed to hold one's long black hair. Yes, it's a nightcap of orange silk, embroidered with shades of mauve.

THE RETIRING PAJAMAS
À LA ERTÉ

OCT. 1923

Vivid yellow crêpe pajamas are embroidered in gray silk and girdled with a gray cord. Hanging from the cord is a double purse trimmed with tassels for a pocket.

(Right) Pajamas of white crêpe and green crêpe. The jacket, worn inside the trousers in front and back, has unusual hanging pockets and sleeves of green crêpe.

Mauve ribbons are arranged like a crest. Yellow ribbon, passing under the chin, is braided with mauve ribbon, ending in tassels.

DEC. 1923

ERTÉ WINKS AT COLD
HANDS AND A
WARM HEART

(Above) With Erté, accessories of
fur play a dual rôle. An ermine
scarf is worn high about the throat,
with the ends floating out behind,
and a band of otter, crossing the
ermine, is folded back in long
loops to make a sort of muff.

Little ermine tails fall like showers
of icicles from the ends of this fat
round snowball of a muff. Bands of
moleskin around the ermine strips
hold them together. One wears this
muff with an ermine jacket, for
black-and-white is very smart.

Again, a muff may be merely an
enormous bow of otter perched at
the front of one's jacket. The
philosophy of cold hands and a
warm heart does not disturb Erté
in the pleasure of designing one
delightful little muff after another.

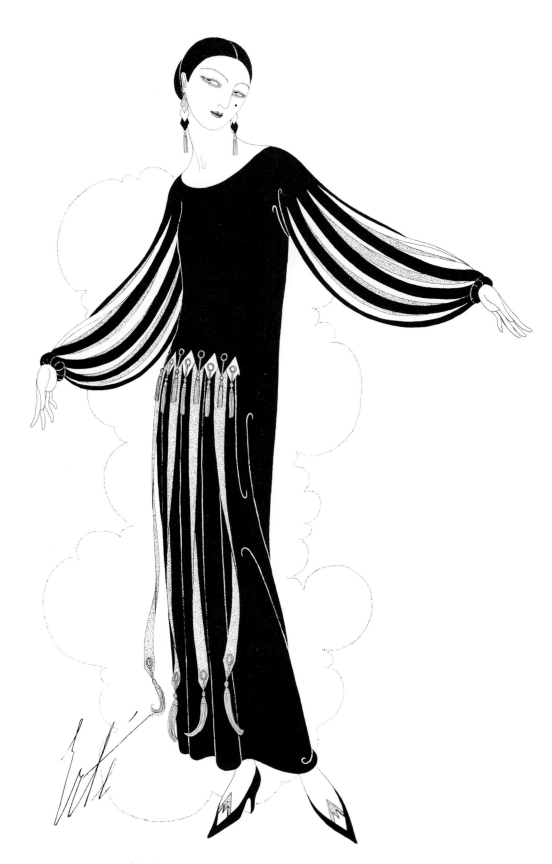

A brilliant sparkle of black and white and green is achieved by having an afternoon frock of black crêpe de Chine lined with green and white crêpe de Chine. The sleeves are split to show the white and green crêpe lining, and there are streamers of green-dotted white crêpe. (Reproduced from the original drawing.)

MAY 1924

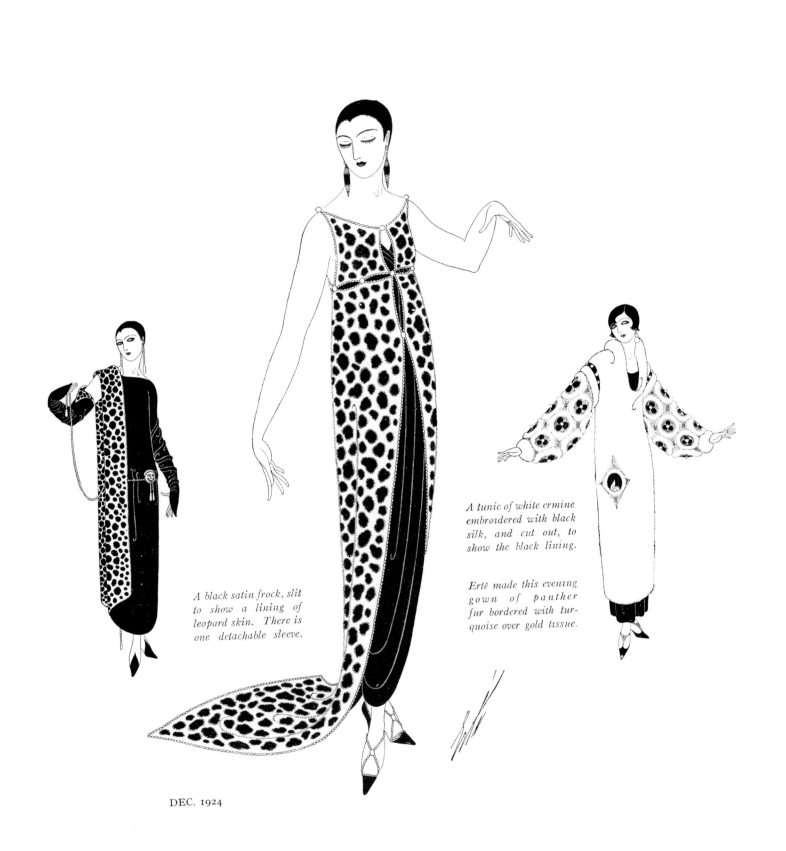

A black satin frock, slit
to show a lining of
leopard skin. There is
one detachable sleeve.

A tunic of white ermine
embroidered with black
silk, and cut out, to
show the black lining.

Erté made this evening
gown of panther
fur bordered with tur-
quoise over gold tissue.

DEC. 1924

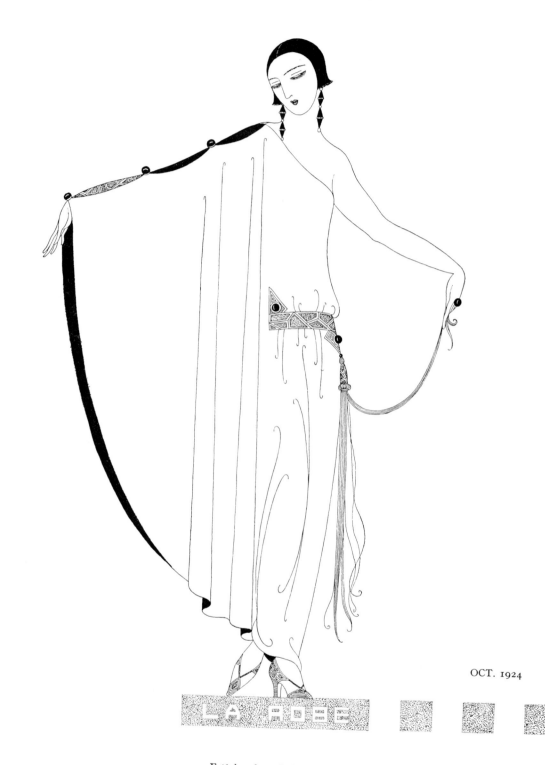

OCT. 1924

Erté has here designed a gown and
wrap in one. A clinging robe of
green crêpe, lined with mauve, has
its long cape-like sleeve clasped over
the right arm with ornaments of
uncut polished malachite. Shoes
and girdle are embroidered in
silver, natural gold, and green gold.

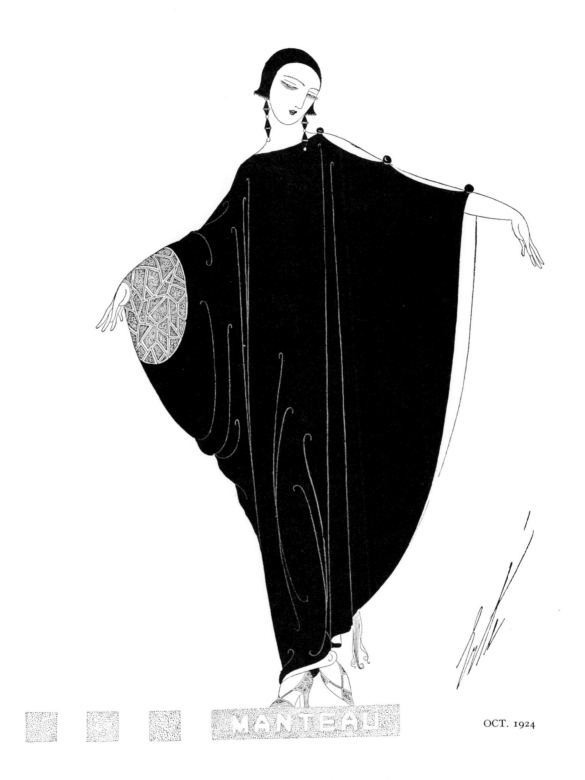

MANTEAU

OCT. 1924

When the malachite clasps over the right arm of the robe on the opposite page are unfastened and the cape-like sleeve is drawn across and clasped over the left arm, it becomes an enveloping mauve wrap with one arm opening richly embroidered in silver, natural gold, and green gold.

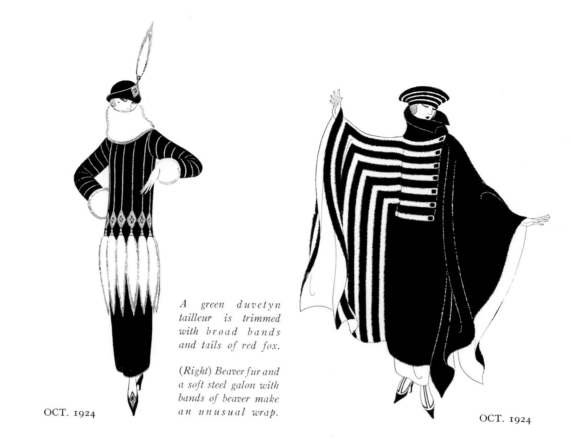

A green duvetyn tailleur is trimmed with broad bands and tails of red fox.

(Right) Beaver fur and a soft steel galon with bands of beaver make an unusual wrap.

OCT. 1924

OCT. 1924

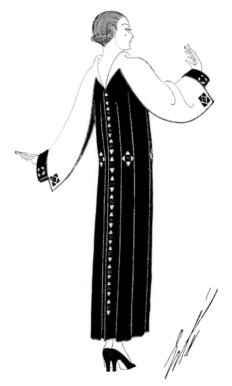

A beautifully draped black satin wrap is held at waist and sleeves by complete skins of white ermine.

OCT. 1924

Black and white satin are combined to form an afternoon gown that repeats the black and white note by geometric bits of ivory and black ornament.

DEC. 1924

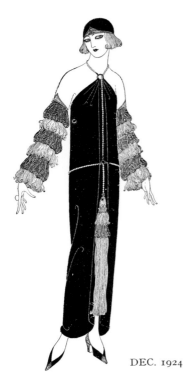

DEC. 1924

Fuchsia-colored velvet in a straight slip, held up by a strand of pearls about the neck, has sleeves of ostrich in shades of mauve and a long ostrich tassel.

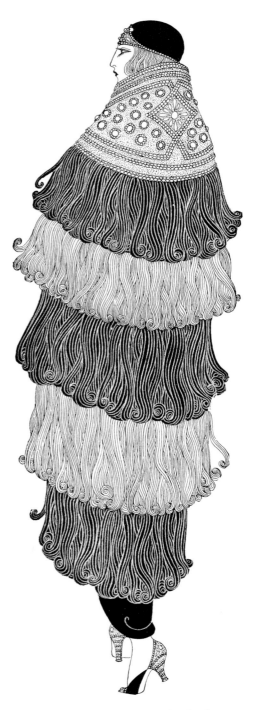

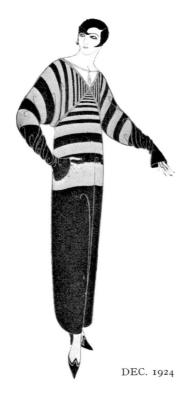

DEC. 1924

The fabric of this frock is crêpe printed gray and orange. The sleeves are cut so that the fabric forms strips contrasting with the blouse in an amusing effect.

From a yoke of cream-colored velvet, gorgeously embroidered with pearl and gold, fall cascade after cascade of long and only slightly curling ostrich feathers in shades of yellow and orange. There is a foundation of deep mauve-colored velvet underneath for warmth.

DEC. 1924

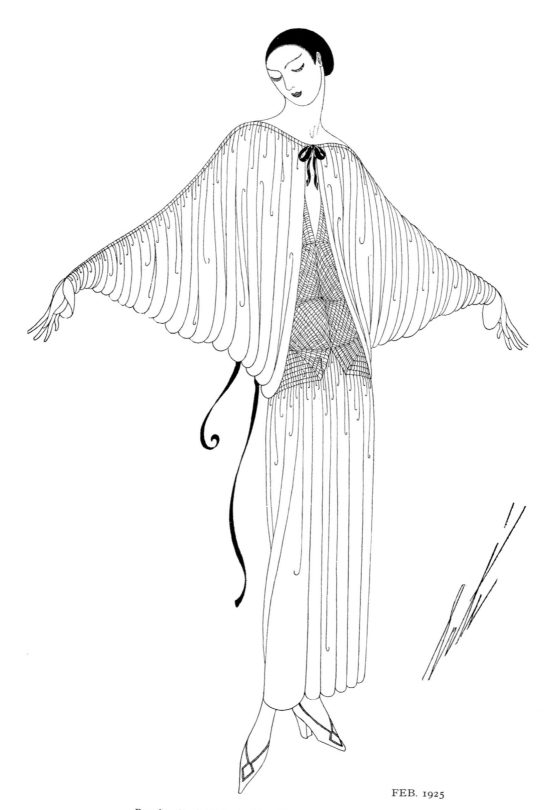

FEB. 1925

Purple crêpe de Chine is shirred in an extraordinary pattern to form a waistcoat-like blouse for an afternoon frock. The detachable sleeves are gathered on an orange ribbon tied in front and in back.

ERTÉ HAS GIVEN EACH
OF THESE GOWNS
EXTRAORDINARY DETAIL

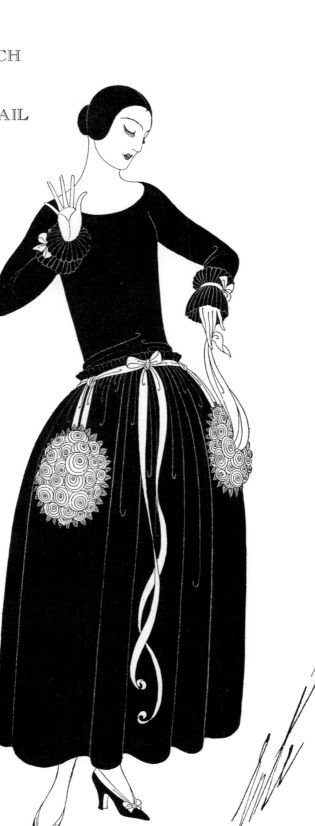

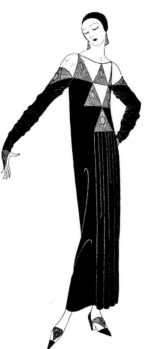

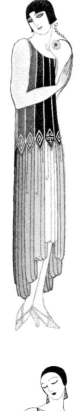

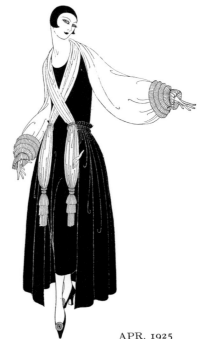

Two enormous orange plumes form the interesting and graceful feature of this brown velvet gown.

The scarf and sleeves of this black satin dress are of white chiffon. The pockets are lined with orange.

A plain quaint gown of brown taffeta has elaborate pockets in the shape of an old-fashioned bouquet in various tones of rose. The leaves of the bouquet are embroidered on the gown in brown and gold thread.

The shadow evening dress at the left above is of black, white, and many shades of gray crêpe de Chine. The shading bands, edged in gold, are of various lengths, making the skirt longer at both sides and the back.

Erté designs a rather elaborate dinner-gown of steel metal fabric with long draped sleeves. The triangular motifs, arranged to leave the shoulders bare, are finely embroidered in heavy gold, silver and coral.

APR. 1925

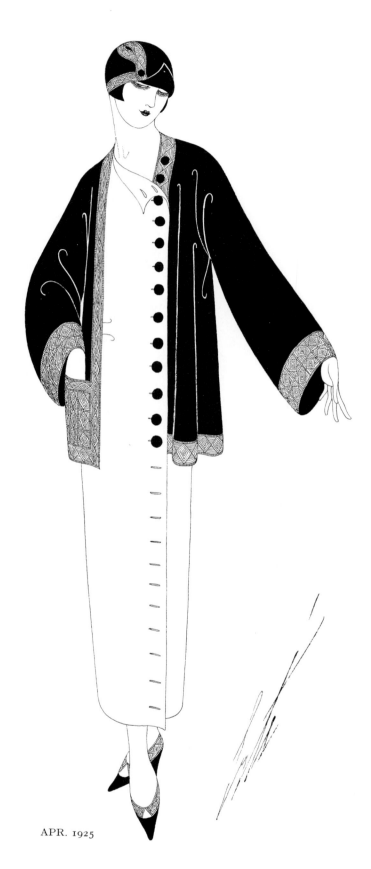

APR. 1925

An attractive street suit of white surah has
a straight black velvet jacket bound and
lined with the surah. Buttons of black.
(Reproduced from the original drawing.)

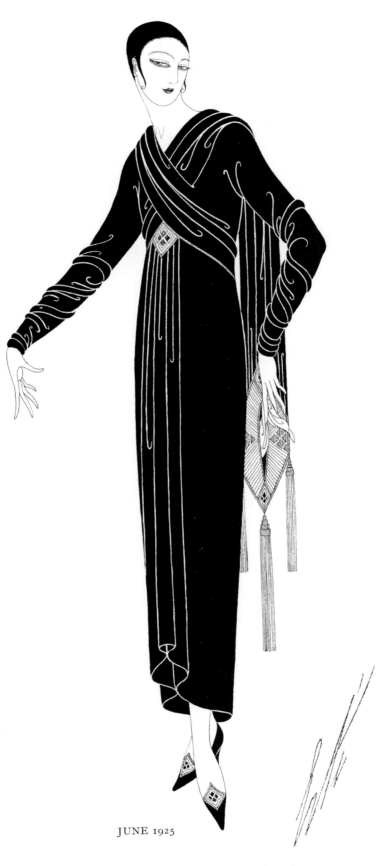

JUNE 1925

Here Erté swings his material in such a fashion as to make the deftly designed motif the chief note of this smoky gray gown. The motif is in silver and purple. (Reproduced from the original drawing.)

"What lovely woman could compare with this noblest excitement of strength against strength? What white arms around his neck could match this wild love-affair between Dionysus and the sea!" (Illustration for Richard Le Gallienne's serialized novel *There Was a Ship*.)

OCT. 1929

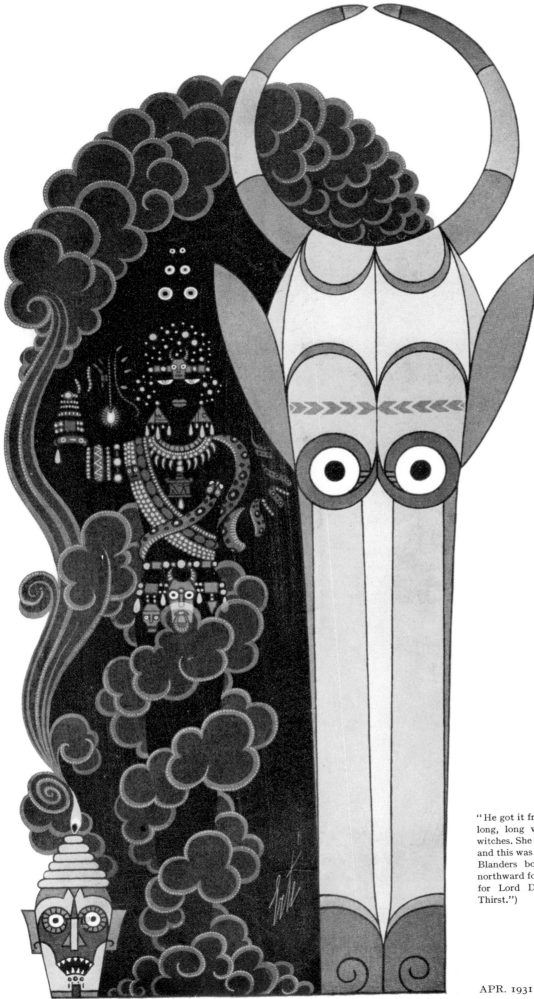

"He got it from a witch in Africa," said Jorkens. "A long, long way up the Nile, where they worship witches. She had a lot of charms for various purposes, and this was to prevent you from ever dying of thirst. Blanders bought this one because he was going northward for a long trip in the Sahara." (Illustration for Lord Dunsany's story "The Charm Against Thirst.")

APR. 1931

123

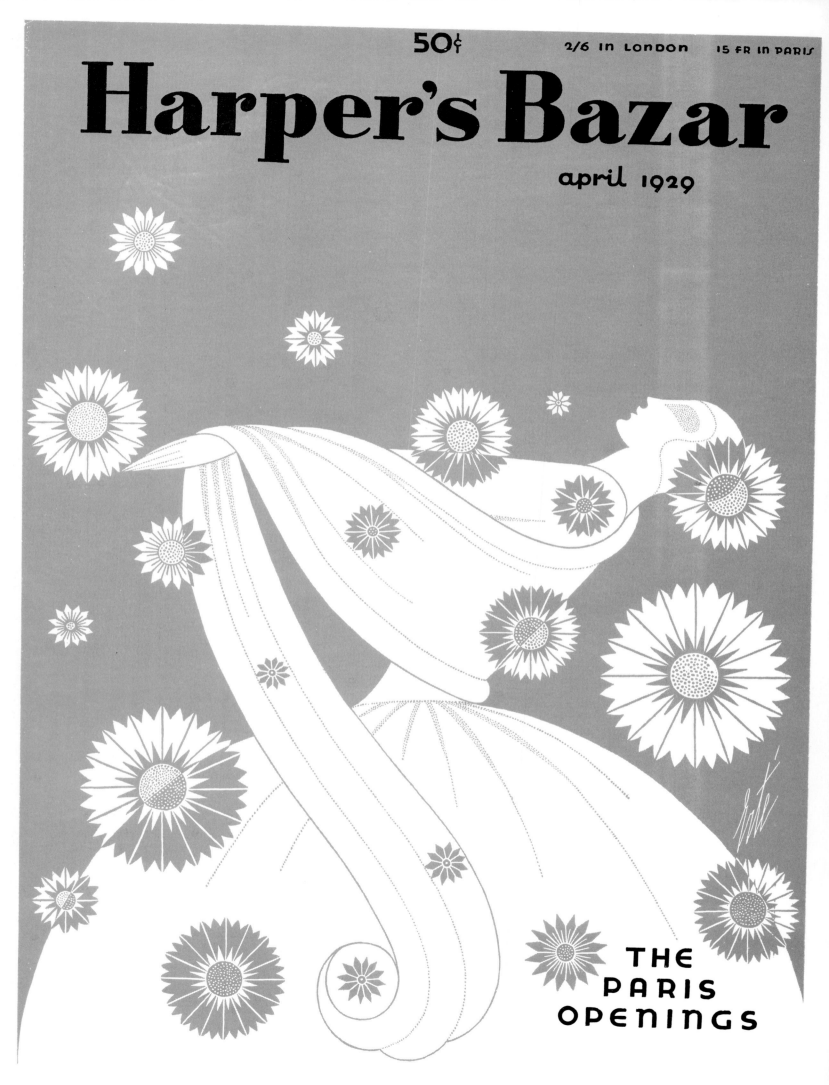

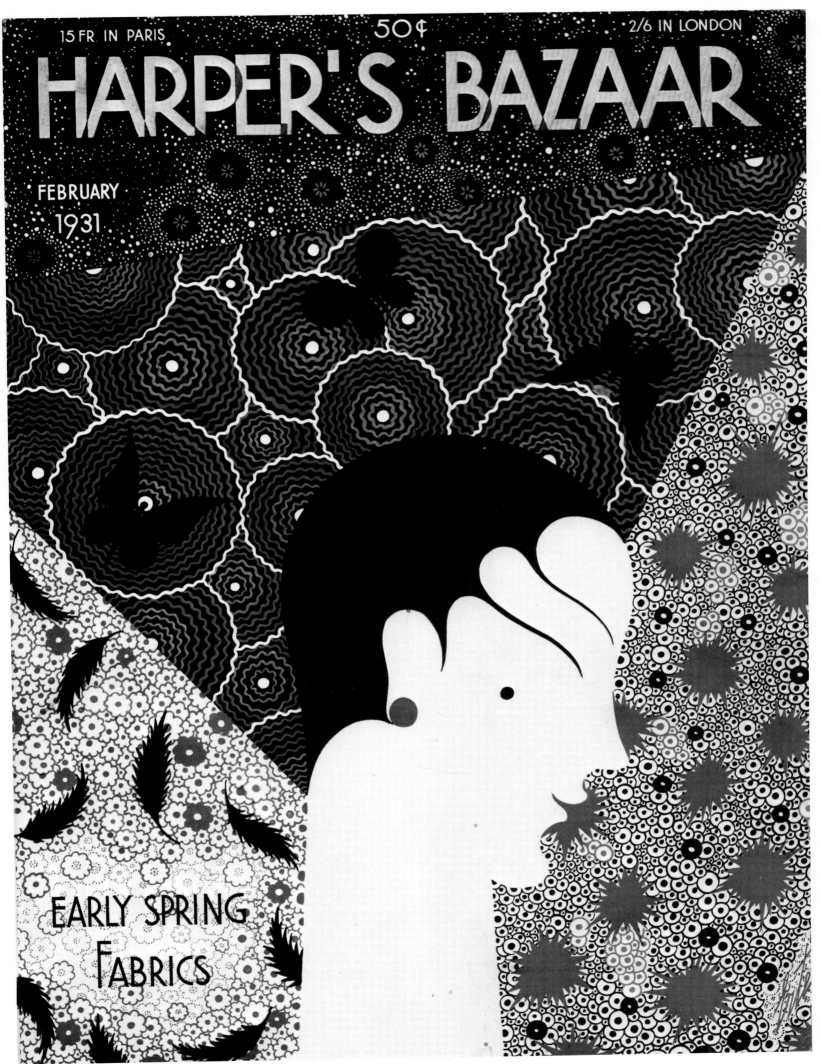

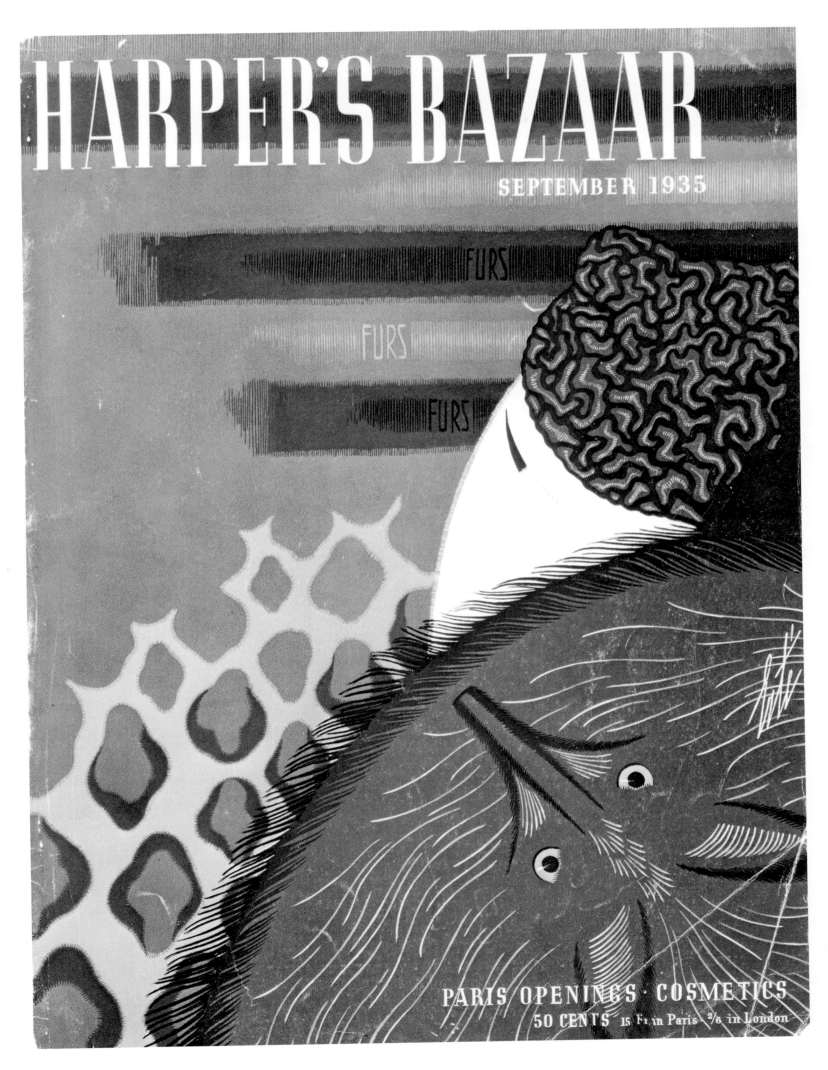

HARPER'S BAZAAR

SEPTEMBER 1935

FURS

FURS

FURS

PARIS OPENINGS · COSMETICS
50 CENTS 15 Fr in Paris 2/6 in London

127

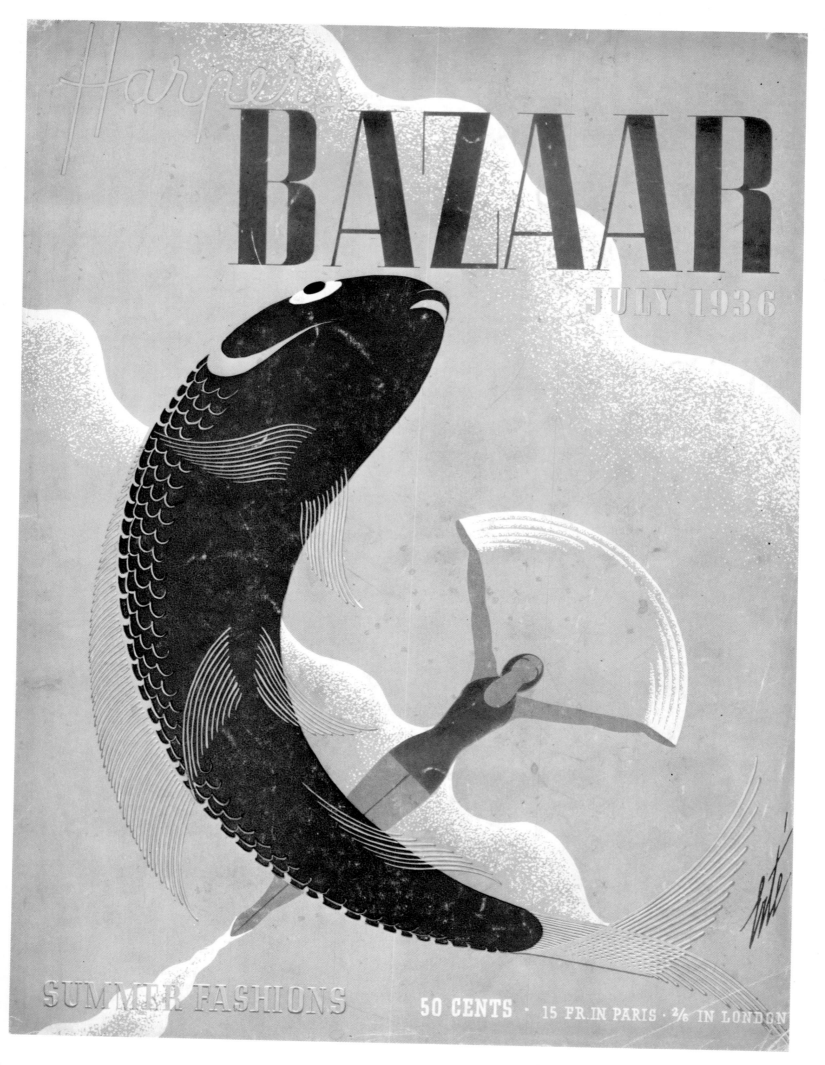

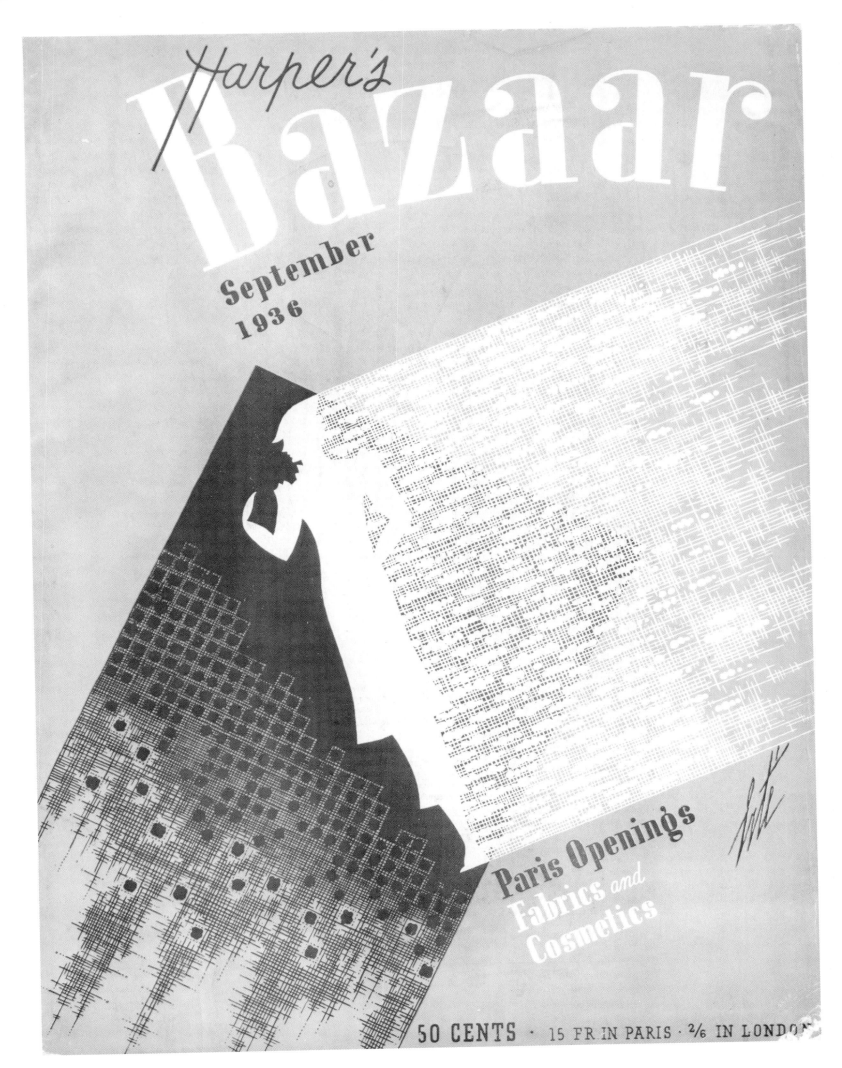

Harper's Bazaar

September 1936

Paris Openings
Fabrics and Cosmetics

50 CENTS · 15 FR IN PARIS · 2/6 IN LONDON